LAOCOÖN

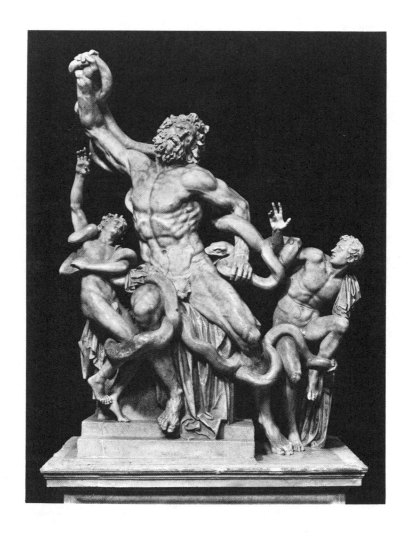

The Laocoön Group (Alinari-Scala)

LAOCOÖN

An Essay on the Limits of
Painting and Poetry

GOTTHOLD EPHRAIM LESSING

Translated, with an Introduction and Notes, by
EDWARD ALLEN MCCORMICK

THE JOHNS HOPKINS UNIVERSITY PRESS
BALTIMORE AND LONDON

© 1962 by The Bobbs-Merrill Company, Inc.
Foreword © 1984 by The Johns Hopkins University Press
All rights reserved
Printed in the United States of America

Originally published, 1766
English translation published by Bobbs-Merrill Company, Inc., 1962
Johns Hopkins Paperbacks edition, 1984

The Johns Hopkins University Press
Baltimore, Maryland 21218
The Johns Hopkins Press Ltd., London

Library of Congress Cataloging in Publication Data

Lessing, Gotthold Ephraim, 1729–1781.
Laocoön : an essay on the limits of painting and
poetry.

Translation of: Laokoon.
Includes bibliographical references.
1. Aesthetics—Early works to 1800. I. McCormick,
Edward Allen. II. Title.
N64.L742 1984 700′.1 83–23880
ISBN 0–8018–3139–3

CONTENTS

LAOCOÖN

FOREWORD

TO THE JOHNS HOPKINS EDITION

For some time now Lessing's *Laocoön* has been unavailable in English translation. This has been frustrating, but it has also been surprising in that the past decade or so has seen a resurgence of interest in Lessing's great treatise on several fronts.

First and most important, historians of systems of signification, inspired in part by recent work in linguistic theory, have recognized in the *Laocoön* an impressively coherent esthetic semiotics that at once sums up classical thinking about the nature of the sign and, in Tzvetan Todorov's phrase, "explodes the framework of classical esthetics." What produces that explosion is Lessing's fundamental tenet that "the signs of art must . . . bear a suitable relation to the thing signified" (ch. 16) —as we would say, the signs of art must be *motivated*—which quickly leads to a powerful, if deeply problematic, distinction between painting and poetry as well as to a further distinction, the *Laocoön*'s masterstroke, between language as a medium of communication and language as a medium of poetry. The influence of the first distinction upon subsequent esthetic theorizing has been prodigious, while the terms of the latter distinction (though not its specific content) have haunted poetic theory ever since.

A second basis of revived interest in the *Laocoön* has been the emergence of new interpretations of mid- and later-eighteenth-century painting which give more weight than ever before to contemporaneous developments in art criticism and theory and which indeed make a point of reading each in terms of the other. Such an approach also goes a long way toward exposing the ahistorical bias of various traditional objections

to Lessing's system. For example, both Lessing's famous doctrine of the "pregnant moment" and his insistence that a work of visual art be intelligible to a viewer at first glance turn out to have close analogues not only in the writings of Diderot and Grimm but also in the paintings of Greuze and David. It follows that the common criticism that Lessing's strictures on painting are excessively narrow lacks all force, or at any rate would have to be leveled as well against two of the leading painters of the age, a dubious proposition.

Furthermore, during the past ten or fifteen years a host of discourses, "artistic" as well as critical, going under the general rubric of postmodernism have called into question the central modernist emphasis on the uniqueness and autonomy of the individual arts, an emphasis that in important respects ultimately derives from Lessing's invention of the modern concept of an artistic medium. Far from devaluing Lessing's achievement, however, the postmodernist critique of modernist notions of the purity of the arts has served to point up the liveness of issues he was the first to formulate.

Finally, the contrastive logic of the *Laocoön*, with its oppositions between painting and poetry, the visual and the verbal, and instantaneousness and successiveness, provides a rich field for deconstructive readings of crucial passages and metaphors. In fact, it might be said that at certain junctures the *Laocoön* all but invites readings of this type, for example, in its elevation of imagination over seeing (ch. 3), its defense of what it takes to be the joining of distinct moments in Raphael (ch. 18), or the striking geopolitical figure near the beginning of that chapter which represents painting and poetry as separate but bordering *realms*. Here, too, it seems clear that the advent of such readings will in no way lessen our conviction of the *Laocoön*'s significance. On the contrary, it is likely that we will find in the very features of Lessing's text that ultimately threaten, but also in a sense ground, the coherence of his system a hitherto unacknowledged legacy to his successors and perhaps also a key to conceptual difficulties and ideological investments that many today are trying to think through.

MICHAEL FRIED

TRANSLATOR'S INTRODUCTION

1. LAOCOÖN IN CLASSICAL LITERATURE AND SCULPTURE

The story of the Trojan priest of Apollo who, with his sons, was strangled by two monstrous serpents has been variously told in classical literature. One of the earliest versions, dating from the end of the second century B.C. and attributed to the Greek poet Euphorion, tells how the priest Laocoön is attacked and killed by two serpents sent by Apollo, whom Laocoön had offended by desecrating his temple. Another Greek, Arctinus, says that Laocoön and *one* of his sons perished, while Sophocles' lost tragedy presumably had both sons dying with their father.

All such accounts of the death of Laocoön agree in representing it as an atonement for some religious crime, but with Virgil's *Aeneid* the moral or religious element disappears and the motive for Laocoön's destruction becomes the priest's presumptuousness in attempting to thwart the purpose of the gods. Virgil's account of Laocoön's death apparently supplanted the older versions, and it is to the second book of the *Aeneid* that we must look in order to find the version which made the story so well known.

The Greeks, having been unable to take Troy by force of arms, resort to the stratagem of leaving a huge wooden horse behind and pretending to sail for home. When the Trojans leave their city walls and gather around the horse, Laocoön tries to warn them against taking it into the city. He hurls his spear against it, causing the horse to emit a hollow sound. The Greeks' ruse is thus about to be discovered when Sinon, a crafty Greek who pretends to have broken with his countrymen, persuades the Trojan king to take the horse into the

ix

city. He tells the king that it is an offering to Pallas Athena
and will bring good fortune to the Trojans.

While the king is still hesitating, something happens which
confirms his belief in Sinon's words. As Laocoön is preparing
a sacrifice on the shore, two enormous serpents glide up out
of the waves and attack his two sons. He hurries to their aid
but is unable to save them, and becomes trapped himself in
the serpents' deadly coils. His struggles to free himself are in
vain, and amidst screams of agony he dies from their bites.

The subject of this story was also represented by ancient
sculptors; Pliny (*Natural History* XXXVI. 37) speaks of a
group of statuary in the palace of the emperor Titus depicting
the destruction of Laocoön and his sons. According to Pliny,
it was the work of Agesander of Rhodes and his sons, Atheno-
dorus and Polydorus, but for many hundreds of years there
was absolutely no trace of any such statue, which Pliny called
"the greatest perfection of art."

Then, in 1506, a certain Felix de Fredis came upon the ruins
of an apartment of the so-called "Sette Sale" while digging in
his vineyard on the Esquiline Hill in Rome. In a walled-up
room he discovered a marble group depicting Laocoön's de-
struction. Since Pliny had spoken of the Laocoön as being in
the palace of the emperor Titus, and since the "Sette Sale"
were known to have once formed a part of the palace, there
has been no serious attempt to question the authenticity of
this work.

Although the statue was generally well preserved, certain
parts which were either damaged or missing were restored.
The right arm of the father and that of the younger son were
broken off, some of the serpents' coils were missing, and most
of the older son's left hand was chipped off.[1] There has been
considerable uncertainty as to who undertook the restoration,
but that the position of the restored arms is incorrect seems
beyond doubt. The father's right arm, holding one of the ser-

[1] A photograph of the Laocoön group appears on p. vi. For a complete
list of restorations see Walter Amelung, *Die Sculpturen des vaticanischen
Museums* (Berlin, 1903-1908; continued by G. Lippold), II, 181-84.

pent's coils, is raised high over his head, as is that of the younger son. The discovery in 1906 of an ancient Laocoön arm holding the coil of a snake indicates that the father's right arm in our group should properly be bent back over his head, depicting a state of exhaustion. This was most likely the approximate position of the younger son's arm also, although in this latter case the arm should be thought of as being in a state of relaxation.

The date of the group, long open to conjecture, is now generally agreed to be approximately 50 B.C.[2] Lessing himself places it in a much later time, i.e., during the age of Titus in the latter part of the first century; and despite the current popularity of the date 50 B.C. there are still those who favor the age of the Pergamene Altar, i.e., the second century B.C.[3] The group, in its incorrectly restored condition, is now in the Vatican Museum in Rome.

2. THE HISTORICAL BACKGROUND OF LESSING'S *LAOCOÖN*

The origins of the problem which Lessing attempts to solve in his *Laocoön* reach back to the very beginnings of art criticism. Among the ancients, it was Aristotle with his doctrine

2 Cf. Margarete Bieber, *Laocoön* (New York, 1942), p. 12: "Epigraphical investigations of Rhodian inscriptions have established the definite date 80-20 B.C. for the masters of the Laocoön. . . . The exact date of the group is probably *c.* 50 B.C." See also M. Bieber, *The Sculpture of the Hellenistic Age* (New York, 1955), p. 135; Gerhart Rodenwaldt, *Die Kunst der Antike* (Berlin, 1938), p. 718.

3 See Gisela M. A. Richter, *The Sculpture and Sculptors of the Greeks* (New Haven, 1950), p. 301: "The date currently assigned to the group is 50 or even 25 B.C., on the evidence that the name of a sculptor Athanodoros—son or brother of a Hagesandros—occurs in inscriptions datable in that period. But since both these names are common in Rhodes from the fourth century B.C. on, there is no cogent reason why the group should not be dated in the second century B.C." See also W. G. Howard, *Laokoon* (New York, 1910), p. ix.

that all arts are arts of imitation who first attempted a separation and classification of the arts. In his *Poetics* he distinguishes between the rhythmical arts (dancing, poetry, and music) and the arts of rest (painting and sculpture). Unfortunately, however, he says nothing further about the basic differences between poetry and painting.

The first direct reference to the problem of the relation of the arts to one another is the often quoted and more often misunderstood saying of Simonides that poetry is a speaking picture and painting a mute poem. This "witty antithesis," as one critic has called it,[1] attained such popularity that its validity was for many centuries hardly ever seriously questioned. Needless to say, its effect was a virtual obliteration of the demarcation line between the two arts.

Another attempt to formulate the relationship between painting and poetry is to be found in the *Ars Poetica* of the Apulian poet Horace. This work, which was quite obviously not intended to present a complete theory of poetry, made the seemingly harmless statement that both poet and painter have equal freedom to attempt whatever they deem worthy of portraying in their works. His actual words, however,

> pictoribus atque poetis
> quidlibet audendi semper fuit aequa potestas,[2]

were taken to mean that both arts were basically alike, and hence their aims and achievements likewise. To make matters worse, his *ut pictura poesis* was snatched out of context and made into the argument par excellence for the homogeneous nature of painting and poetry:

> Ut pictura poesis; erit, quae, si propius stes,
> Te capiat magis, et quaedam, si longius abstes.[3]

This, later aestheticians maintained, implies only that Horace extends the similarity between visual art and poetry to include

[1] W. G. Howard, *Laokoon* (New York, 1910), p. xxiii.

[2] *Ars Poetica*, line 9. "Poets and painters have always had an equal license to venture anything at all."

[3] *Ibid.*, lines 361f. "Poetry is like painting: one work seizes your fancy if you stand close to it, another if you stand at a distance."

everything except the obvious fact that the one employs color and lines and the other words and rhythm.[4]

There are a few additional writers of antiquity who might be mentioned in connection with Lessing's essay, but none of them goes beyond a few general remarks on the distinctions between the arts, nor do they ever develop a reasonably clear system of aesthetics. Plutarch, it is true, devotes considerable space to the differences between poetry and the visual arts,[5] but he comes to the conclusion that such differences lie principally in the material with which the two arts work rather than in their nature and aims. Another Greek author, Philostratus the Elder, remains for the most part in the narrow tradition of avoiding any excursion into the field of aesthetic philosophy, with one exception. In his *Life of Apollonius* he suggests that the visual arts owe their origin not only to the imagination, but also to imitation. This latter, we are told,[6] can work only with that which it sees, while the imagination can go further and express the unseen also.

The list of classical authors who broached the problem treated in Lessing's *Laocoön* might be enlarged—Longinus, Pliny the Elder, Quintilian, and Lucian, for example, all made various remarks of a very general nature which touched on some aspect of the theory of arts—but their contribution to the development of a critical art theory was extremely limited. Indeed, it can be said that of all the writers of antiquity only one made a serious attempt to get at the real nature of and inherent differences between the arts. In his twelfth *Olympian Oration*, Dio Chrysostomus (born *c.* A.D. 40) compared Homer with the sculptor Phidias in their treatment of the god Zeus. Some of the conclusions reached by the Greek rhetor anticipate Lessing's *Laocoön* to such a degree that, despite Lessing's failure to mention this writer in his essay, we may safely assume that he was acquainted with the *Orations* at the time the *Laocoön* was written. A comparison of the two works,

4 H. Blümner, *Lessings Laokoon* (Berlin, 1880), p. 7.
5 In his work, *On the Glory of Athens*, chap. 3.
6 *Life of Apollonius of Tyana* VI. 19.

which would not be to our purpose here, shows quite clearly that a number of Dio Chrysostomus' propositions, although generally not pursued very far, contain the essence of what Lessing later says in his *Laocoön*.[7]

As has been pointed out, however, Dio represents a singular exception among the ancients in his attempt to confront the problem of the relationship of the arts to one another in a critical manner. The bulk of the evidence is unfortunately on the other side: *Ut pictura poesis* and Simonides' "witty antithesis" held the field for many hundreds of years, and the confusion that reigned in the arts, especially with respect to poetry and its dependence on painting, tended rather to increase until the time of Winckelmann and Lessing.

From the end of the first century until the close of the Middle Ages there was scarcely any attempt to develop a critical theory of the arts or to continue what the ancients had begun. Architecture, painting, and sculpture, which had long held supremacy in the arts under the ever growing influence of Christianity, were obliged to overstep their natural limitations time and time again in order to express ideas not aesthetically compatible with their inherent nature. Christian concepts of virtue, constancy, etc., had to be personified and thus made accessible to the Christian flock. Medieval literature, too, as soon as it shed its Latin garb and became "popular," joined the other arts, especially painting, in admitting allegory and symbolism on a grand scale. Painting was still considered the nobler art, however, and so poets borrowed freely from it and attempted to "paint" in their works.

This was the state of affairs at the close of the Middle Ages. [Painting, or more precisely the visual arts in general, had succumbed to what Lessing terms the mania for allegory, and poetry to the mania for painting or description, as well as for allegory.] During the Renaissance we again encounter attempts to cope with aesthetic problems in a critical way but, as was to be expected, the writers of the sixteenth century and later those of the seventeenth sanctioned the practice of ignoring

7 W. G. Howard, *Laokoon*, p. xxvi.

the limits of poetry as opposed to painting. The Italian Luigi Dolce, for example, examines in his *Dialogo della Pittura* [8] the works of Titian, Michelangelo, and Raphael with respect to invention, design, and use of color. A number of his conclusions do not differ sharply from the views held by the ancients. According to Dolce, a poet is at the same time a painter, and hence a good poet will necessarily be a good painter. Common to both is the element of imitation; the painter imitates by means of lines and colors, the poet by means of words. The former is limited to what his eyes can see, while the latter is able to represent not only what he sees, but also what is revealed to his spirit. Despite the fact that Dolce calls good poets good painters and asserts that Virgil based his account of Laocoön's death on the statue, which he had before him, he is prepared to accept a mutual dependency of one art on the other to a considerable degree. Painters, he stresses, get their subject matter ("invention") from the poets and vice versa. He does not, however, inquire into the basic dissimilarity of the two arts, and in this important respect at least he fails to modify the common doctrine of the Renaissance as it had been inherited from antiquity.

Medieval allegory and the mania for description, meanwhile, continued to hold sway in poetry and, to a lesser degree, in painting.[9] Some thirty years after Dolce's *Dialogo* appeared, Edmund Spenser published the first three books of his *Faerie Queene* (1590), in which both tendencies, or manias, as Lessing

[8] The complete title is: *Dialogo della Pittura di M. Ludovico Dolce, intitulato l'Aretino, nel quale si ragiona della dignità di essa pittura e di tutte le parti necessarie, che a perfetto pittore si convengono, con esempi di pittori antichi e moderni; e nel fine si fa menzione delle virtù e delle opere del divino Tiziano* (Venice, 1557). A second edition of this work appeared in Florence in 1735 with introduction and French translation by N. Vleugels, and it was this edition which Lessing used (see Blümner, p. 15).

[9] Despite continued stress on allegorical subject matter, Renaissance painting clearly evidences developments and innovations in form, color, technique, and materials which transcend the limitations of medieval painting.

calls them, are everywhere evident. To a greater or lesser degree Drayton, Dryden, Milton, and Pope all followed this tradition, which reached its high point in the eighteenth century with the publication of Thomson's *Seasons* (see Appendix Note a, p. 212, and Biographical Notes). In the field of criticism the dictum *ut pictura poesis* was closely adhered to in eighteenth-century England, notably by Addison, Hurd, and Joseph Spence (see Biographical Notes). The last-named, a good friend of Alexander Pope, attempted to explain the Greek and Roman poets through an examination of the relics of ancient art.[10] While Lessing's attack on Spence is not always fully justified (for example, Spence actually anticipated Lessing in his dictum that the poet was superior to the artist in his power to imitate the transitoriness of motion; and he is generally not quite so willing to identify poetry with painting as Lessing claims), the English critic does seem to go rather far in his attempt to prove that every poetic description was based on some ancient statue or picture.

Another Englishman of considerable importance to the development of aesthetic theory was James Harris (1709-80), whose *Three Treatises, the first concerning Art, the second concerning Music, Painting, and Poetry, the third concerning Happiness,* was published in 1744.[11] In the second treatise he attempts to show the similarities and dissimilarities of music, painting, and poetry, and to determine which is to be considered superior to the other two. Proceeding from Aristotle's statement that all arts are arts of imitation, he shows how the media of each limit its powers to imitate fully. Painting, says Harris, can imitate only by means of color and figure. It can represent only one moment in time. Although it is motionless it can indicate motions and sounds as well as actions which are known (i.e., history). Poetry imitates by means of sound

[10] "I think . . . that some of the best comments we could have on the ancient poets might be drawn from the works of the artists who were their contemporaries . . ." (*Polymetis* [2nd ed., 1755], p. 325).

[11] A German translation appeared in 1756, and presumably Lessing was acquainted with it.

and motion, but since sounds stand for ideas, poetry is able to imitate to the extent that language can express things. Consequently, poetic imitation includes everything. Its materials are words, and words are "symbols by compact of all ideas." Harris concludes that poetry is superior to painting because it is not restricted to the depiction of short, momentary events but may imitate subjects of any duration. In sentiments, too, it is the only medium. From the summary just given it is obvious that Harris follows tradition in most respects and has little to say that is strikingly original. His claim of the greater power of poetry to represent actions and express feelings is, however, new and was no doubt of some influence on the *Laocoön* (see Chapter Sixteen).

In France, too, we find a continuing belief in the dependence of poetry on art, although there was no lack of attempts to develop a critical theory of the arts. One of the earliest such attempts in modern times was the Latin poem, *De arte graphica*, by Charles du Fresnoy, which appeared in 1668. Its opening words, *ut pictura poesis*, betray its message. Fresnoy accepts both this saying of Horace and the antithesis of Simonides and goes on to show how the arts of painting and poetry are similar in their essential features. Other early critics, e.g., de Piles, Watelet, and Coypel fail to break with the doctrinal tradition taken over from Dolce and his contemporaries. There is, however, a shift of emphasis (such as we have already seen in Harris' *Treatises*) which becomes evident from the eighteenth century on. In the work of Abbé Jean Baptiste du Bos, *Réflexions critiques sur la poésie et la peinture* (1719), we encounter the usual belief in the equality and homogeneous nature of poetry and painting as well as the Horatian *ut pictura poesis*, which he uses as the motto of his work. Despite this apparently slavish acceptance of the traditional theory of aesthetics, however, du Bos attaches special significance to the ability of the two arts to arouse emotion. Both poetry and painting, du Bos claims, seek to arouse passions, or rather are copies of real passions, and these copies or imitations should affect us in the same way as would the objects

imitated. But there are differences between the two arts in the means through which they arouse our emotions. Painting represents only a single moment, and its signs are coexistent; poetry, on the other hand, produces its effect in a series of instants. Accordingly, the poet may depict a more complex passion than may the painter, who can treat only subjects in which effects are due to relatively simple causes and are revealed in some visible aspect of the body. Du Bos thus shows the superiority of poetry over painting in the representation of the sublime, and it is in this most important point that we can see how deeply indebted Lessing was to this French critic's work.

Another Frenchman to whom Lessing owes a considerable debt is Philippe de Tubières, Count Caylus, whose *Tableaux tirés de l'Iliade, de l'Odyssée d'Homère et de l'Énéide de Virgile, avec des observations générales sur le costume* is severely criticized in the *Laocoön*. It is unnecessary to comment here on the contents of this important work since Lessing himself discusses it at considerable length. It should be pointed out, however, that his aim of opening up new sources of inspiration for contemporary artists—the real purpose of Caylus' book—and the tendency on the part of many critics to see in the *Tableaux* a striking anticipation of Lessing's own conclusions tend to offset what is undoubtedly too harsh a judgment in the *Laocoön*.

In eighteenth-century Germany, where most writers followed the models of contemporary English poets and turned with passion to painting in poetry, two Swiss-German critics raised descriptive writing to the dignity of a theory. In their struggle to uphold the ideals of English poetry, Johann Jakob Bodmer and Johann Jakob Breitinger, in their *Discourses of the Painters* (1771-22), turned against a French-inspired pseudo-classicism in German literature, represented by Johann Christian Gottsched. Rejecting Gottsched's doctrine (which owed a great deal to Boileau) that poetry must be restricted to the realm of the natural and ruled by the intellect, they argued for the admission of the supernatural and the acceptance of

emotions as vital forces in poetry. Valuable as were the critical works of these two men to the progress of German literature, and despite the fact that they occasionally made some clear distinctions between painting and poetry, *ut pictura poesis* still lay at the base of their program. [According to them, poetry is a kind of painting, and the poet is simply a painter who appeals to the imagination and has a greater range of subjects than the painter or sculptor.]

Two other Germans, Mendelssohn and Winckelmann, must be added to this list of critics who dealt with the problem which Lessing attempts to solve in his *Laocoön*. The first of these, Moses Mendelssohn, was a contemporary and friend of Lessing. His essay, *On the main principles of fine arts and belles-lettres* (first version in 1757), produced a deep impression on Lessing. In the second part of this work, which deals with the kinds of art which produce aesthetic pleasure, we encounter ideas and definitions which were to pass directly into the *Laocoön*. Mendelssohn classifies the arts according to their media of expression:

> Symbols, by means of which an object may be expressed, may be either natural or arbitrary. They are natural if the association of the symbol with the object designated is derived from the nature of the object itself. Conversely, those symbols which we call arbitrary have in their very nature nothing in common with the object designated. . . . The fine arts, under which we generally understand poetry and rhetoric, express objects by means of arbitrary symbols, through audible tones and words [pp. 290-91].

The subject matter of the fine arts is, according to Mendelssohn, more limited than that of belles-lettres (*schöne Wissenschaften*). Its symbols affect either the sense of hearing or that of sight. Natural symbols, which appeal to the sense of sight, are either consecutive or simultaneous (coexistent) and express beauty either through motion or through form. The former is the case in the art of dancing, the latter in those arts which employ lines and figures. Painting employs surfaces; sculpture and architecture employ bodies. Since the painter

and the sculptor express beauties as they exist motionless side
by side, they must choose that moment which serves their
aims to best advantage.

It is perhaps significant that little of Mendelssohn's theory
and classification of the arts is actually new or original. Du
Bos, as we have seen, also defines aesthetic symbols as natural
and arbitrary, or artificial, and a number of other critics not
touched on in this brief survey, e.g., Diderot, Shaftesbury, or
de Piles, were at least as advanced in their approach to the
Laocoön problem as was Mendelssohn. Despite these short-
comings, if they can be termed that, Mendelssohn represents
the "supreme moment in a stage of transition," as one critic
aptly says:

> He came nearer than his predecessors—even Diderot—to a
> systematic separation of the arts on the basis of their sym-
> bols of expression. . . . moreover, he suggested the very ex-
> ample with which Lessing begins his discussion, and at the
> same time first called Lessing's attention to the epoch-mak-
> ing work in which these examples were used in support of
> an opinion with which Lessing could take issue.[12]

The work with which Lessing takes issue in his Laocoön is
the Thoughts on the Imitation of Greek Works in Painting
and Sculpture (1755) by Joachim Winckelmann. This disciple
of Greek beauty and simplicity in art was instrumental in
leading the arts out of the artificialities of baroque and rococo
into which they had fallen in the seventeenth and eighteenth
centuries. However, he was at the same time as one-sided in
his doctrine as any of his predecessors had been. Most of his
observations on art were based on Greek statuary that he had
seen himself. Logically they should have been applied to the
other arts with extreme caution, but this was unfortunately
not the case. Winckelmann tended to ignore the differences
between painting and sculpture. Beauty was beauty of form,
especially of human form, and of contour; the all-important
aspects of pictorial art, color and light, were neglected in his
eagerness to apply the laws of sculpture to painting and poetry

[12] W. G. Howard, Laokoon, pp. cxxviii-cxxix.

as well For these arts, he says, are merely different ways of expressing the same thing. And as to their limits, he explains, "It does not seem contradictory that painting should have as wide boundaries as poetry, and that consequently it ought to be possible for the painter to follow the poet, just as music is able to do this."

It is against this claim of inherent similarity among the arts as well as against the now deeply rooted tradition of granting painting the first place among them that Lessing speaks out in his *Laocoön*. Each of the arts is subject to its own laws, and if one art is actually superior to the others, then it is not painting, but poetry with its infinitely wider domain.

3. LESSING'S LIFE AND WORK

Gotthold Ephraim Lessing was born in 1729 in Kamenz, Saxony, where his father, following a long family tradition of law and theology, was serving as pastor. The oldest of thirteen children, Lessing spent the first twelve years of his life in the crowded parsonage under the influence of his father's love of learning and books. Shortly before his thirteenth birthday he entered the monastic school at Meissen, but left after five years because, as he says, there was nothing more to learn there. At seventeen, strikingly mature for his years, he entered the University of Leipzig as a student of theology. One year later he changed faculties, to medicine, and a year after that, universities, to Wittenberg. After a few months, however, he decided to give up his studies and take up the precarious profession of writing, and so in November of 1749 he joined his cousin and friend, Christlob Mylius (1722-54), an early follower of Gottsched and a member of the Leipzig *Dichterkreis,* in Berlin.

The next years were taken up with a friendship with Voltaire, who was then at the court of Frederick II of Prussia, a number of dramatic attempts, and the first of many literary

feuds. It was in 1752 (Lessing had meanwhile returned to Wittenberg long enough to earn a master's degree) that he published his *Vademecum for Samuel Gotthold Lange, Pastor in Laublingen,* a vitriolic attack on the author of a very inferior translation of Horace. The whole affair would have been as insignificant as it deserved to be, had not Pastor Lange dedicated the translation to Frederick II. The ruler's vexation at Lessing for utterly demolishing the dubious literary and scholarly fame of Lange was of no immediate import to the young critic, but it was to make itself felt in later years.

The year 1755 saw the publication of Lessing's first important work, the first bourgeois tragedy in German literature, *Miss Sara Sampson,* which was the fruit of his study of English literature, to which Voltaire had led him, and of the new movement in German letters away from Gottsched and French influence. In the autumn of that year Lessing left Berlin and settled at Leipzig, at that time the cultural center of Germany. His friendship with a young patrician, Gottfried Winkler, brought him the offer to serve as travel companion during a three years' tour, a *Bildungsreise,* of England. The following spring Lessing and his friend set out, traveling through North Germany and Holland on their way to the English Channel. As they reached Amsterdam, however, the Seven Years' War broke out, the trip was hastily canceled, and both men returned to Leipzig, where Prussian troops had already occupied the city.

Among the officers quartered in that city was a young Prussian, Ewald von Kleist, with whom Lessing formed an intimate friendship. When Kleist left Leipzig in May, 1758, to take part in a campaign farther to the north, Lessing decided to quit the city also and resettle in Berlin. It was there that his close collaboration with Friedrich Nicolai and Moses Mendelssohn began, a union which resulted in one of the most significant publications of that age, *Briefe, die neueste Literatur betreffend (Letters on the Most Recent Literature,* 1759-65). In the *Briefe* Lessing discussed the works of Wieland and Klopstock, attacked the school of Gottsched in German drama,

praised Shakespeare as the greatest of all dramatists, published a scene from his unfinished Faust drama (Letter 17) and in general offered the Germans what Friedrich Schlegel once called an unparalleled example of productive criticism. During these Berlin years he also published a life of Sophocles, an essay on the fable, the first three books of his *Fables*, a short and comparatively unsuccessful drama, *Philotas*, and translations of Diderot's plays. However, the uncertainty about his future as a writer—he was constantly plagued by debts, not at all an unusual occurrence for an independent writer in an age of patronage—and the desire to devote himself to larger projects without the constant pressure of writing for money caused him to accept the post of private secretary to General Tauentzien, Governor of Silesia. His decision proved to be a wise one, for the five years spent with General Tauentzien at Breslau were fruitful ones. His comedy, *Minna von Barnhelm*, which is perhaps the best of all his dramas, and his most important critical work, the *Laocoön*, were written in this period. On the latter work Lessing placed hopes of procuring the post of Royal Librarian in Berlin, and in 1765 he returned to that city. But Frederick II had different ideas as to the choice of a new librarian. He appointed neither Winckelmann, who was ready to exchange his post in Rome for Berlin at the same salary of 2000 Talers ("half as much would be enough for a German"), nor Lessing, whose attack on Pastor Lange had not been forgotten or forgiven, but chose instead a relatively obscure Frenchman.

Bitterly disappointed, Lessing left Berlin in May, 1767, to take up the duties of director at the new National Theater in Hamburg. As it turned out, the theater collapsed after only two years, but it rightly deserves a claim to fame as being the source (external, at least) of one of Lessing's most important works. The critical notes which Lessing wrote for the printed programs of the theater's productions were collected under the title *Hamburgische Dramaturgie*, which, together with the *Briefe antiquarischen Inhalts*, represent the fruits of what were for Lessing otherwise disappointing and frustrating years.

With his call to Wolfenbüttel in 1770 as librarian, Lessing finally achieved the long-sought security of a permanent post. In the years that followed, he published a tragedy, *Emilia Galotti;* a series of essays *(Axiomata, Anti-Goeze,* etc.) against the Hamburg pastor Goeze, with whom Lessing had become embroiled in a violent controversy resulting from the latter's publication of the writings of the radical, antirationalist Reimarus *(Fragmente eines Ungenannten);* the dramatic poem *Nathan der Weise* (1779), his last and, next to *Minna von Barnhelm,* perhaps his greatest dramatic achievement; and two works, *Ernst und Falk* (1778-80) and *Die Erziehung des Menschengeschlechts (The Education of the Human Race,* 1780), which show him to be moving away from the prevalent ideas of German rationalism toward the idealism of a new world brotherhood based on morality.

The final years were overshadowed by deep personal tragedy. His marriage to Eva König, which, after long years of waiting, finally took place in 1776, was to give him only brief happiness. On Christmas Day, 1777, his wife bore him a son, who died three days later. Then, on January 10, 1778, just two weeks after that, Lessing buried his wife, and with her the contentment which had been his for one short year. His health broken by the experience, Lessing lived only three more years and died on February 15, 1781, while on a visit to friends in Braunschweig.

It is not an easy task to draw the sum of Lessing's total work and estimate its influence on German literature and, in a few cases, on Western literature in general. Except for *Minna von Barnhelm,* and to a lesser degree *Nathan der Weise,* his works have not lasted as outstanding examples of artistic creation. They seem to lack that immediacy which the great classics of literature have preserved. *Emilia Galotti,* for example, a major achievement for its time, now seems outdated. And much of Lessing's other literary work (fables, epigrams, odes, poems) is of concern chiefly to literary historians and students of German literature.

What has achieved permanence, however, is his immense

critical gift of reasoning, his clear-sightedness. His *Laocoön*, for example—and this is but one of his vital services to German letters—is dated in its conclusions. But as an act of criticism it is to an almost unparalleled degree what Ernst Cassirer, borrowing from Schlegel, has called "productive," that is to say, it "fosters and inspires artistic creation by acting as an external influence." ¹ Lessing was the first in modern times to define clearly the distinctiveness of the spheres of art and poetry and at the same time to penetrate deeply into the nature of these two arts. The results, not merely for German literature but for the whole Age of Enlightenment in Europe, have been to open up new realms and new possibilities for poetry and "a new horizon of artistic creation in general." Critical history has justly ranked him as the first modern aesthetician.

4. LESSING'S *LAOCOÖN*

The *Laocoön* as we have it is only a fragmentary composition. Lessing planned a second and a third part, and the entire work was to represent a detailed criticism of all the fine arts. However, from a number of preliminary sketches which have been preserved we are able to form a reasonably clear notion of how the finished work would most likely have appeared, and at the same time this fragmentary evidence serves to remind us that the text published in 1766 does not contain all that Lessing wanted to say on this important subject. The second part was to have treated the relation of music to poetry, and the third the relation of dancing to music and of the different kinds of poetry to each other.

Despite the fact that in the fifteen years remaining to him Lessing did not actually complete the *Laocoön*, there is much to indicate that he fully intended to do so at least as late as 1770, and perhaps even later. He seems to have been aware of

¹ Ernst Cassirer, *The Philosophy of the Enlightenment*, tr. F. C. A. Koelln and James P. Pettegrove (Boston, 1955), p. 359.

certain deficiencies in the first part and to have intended to correct them—as little inclined as he was to heed the reproaches of some of his critics (he writes on one occasion of the many fools who are attacking his *Laocoön*).[1] One of the more important of his critics, Christian Garve (1742-98), published a lengthy review of the *Laocoön* in 1769 which was generally favorable to the work but did contain a number of objections, most of them of a relatively minor nature.[2] In a letter to a friend, Lessing expresses satisfaction at Garve's review and adds, "When he has read the continuation of my book he will find that his objections do not apply to me. I grant him that certain things in it are not definite enough. But how could they be, since I have scarcely begun to examine even the *one* difference between poetry and painting which arises from the use of their symbols. . . . The further exposition will be contained in the third part of my *Laocoön*." [3]

Fortunately, however, we do not have to resort to the hazardous practice of interpreting the preliminary sketches of parts two and three nor indulge in pure speculation as to what might have been in order to arrive at a proper evaluation of the achievements and shortcomings of the *Laocoön*. For even if Lessing had carried his project to completion, the indications (as we are able to determine them from the sketches, the *Hamburgische Dramaturgie,* his extensive correspondence, and his later critical work) [4] are that neither its merits nor its deficiencies would have been radically altered. The method and general conclusions are already unmistakably laid out in the first part which we possess. We might, finally, briefly summarize these merits and deficiencies as follows:

[1] In a letter to Friedrich Nicolai dated April 13, 1769.

[2] The review was included in Vol. IX of the *Allgemeine deutsche Bibliothek* (Berlin, 1769), pp. 328-58. There is also a reprint in Blümner's *Lessings Laokoon* (Anhang), pp. 683-703.

[3] Written to Nicolai on May 26, 1769.

[4] It should be mentioned here that his *Hamburgische Dramaturgie* actually carries out in good part what Lessing originally planned for the third part of *Laocoön*.

Lessing's avowed aim was to re-establish poetry in its proper place among the arts, and this he managed to do with considerable success. His condemnation of descriptive poetry and allegory goes perhaps too far—his basically unlyrical nature simply could not permit him to accept the sentimental word-painting of a Thomson or a von Haller—but the degree to which German literature had fallen victim to the rage for poetic painting and puzzle-making surely justified his uncompromising stand. It cannot be denied, nevertheless, that his argument is definitely one-sided in favor of poetry over painting, just as his use of the term "painting" is dangerously arbitrary. We are told, for example, in the Preface (p. 6) that [he understands under the heading of painting all the visual arts. It does not occur to him, nor did it to Winckelmann, that just as painting and poetry are different from each other and hence subject to different laws, so do sculpture and painting differ, and what he derives as laws from ancient works of sculpture do not necessarily apply to painting as well.] The reason for this one-sidedness is evident. The number of ancient paintings that have survived is infinitesimally small compared with the extant works of classical sculpture. Not only are painting materials less durable than stone, but it is quite possible that sculpture attained a much higher degree of perfection in ancient Greece and Rome than did the art of painting, and it is this obvious fact which Lessing overlooks in his *Laocoön*.[5] He simply did not possess an adequate knowledge of classical painting, and so he let sculpture speak for all the visual arts.

Another weakness in the work arises from the fact that his arguments are based on reason rather than direct experience. Not only was Lessing inadequately acquainted with ancient painting, which is understandable in view of the circumstances mentioned above, but he also lacked the direct knowledge of ancient sculpture which Winckelmann possessed. Without this technical acquaintance with his subject he was forced

[5] Cf. A. Hamann, *Lessing's Laokoon* (Oxford, 1878), p. xxvi.

to deal with it only indirectly, through its literature and history. He had never even seen the Laocoön group,[6] but only a series of engravings made from it. It is possibly because of this fact that he overstressed the element of beauty—which he regards as the ultimate aim of all the arts—and limited his definition of it to that of form. He shows little or no understanding for the function of color, and, according to the trend of the classicist period, neglects a vital trait, expression in art. Having placed such a high value on contour, he was unfortunately blinded to what is perhaps one of the outstanding contributions of the Middle Ages (for which Lessing, as an eighteenth-century rationalist, had only contempt), the beauty of expression, which is what Winckelmann meant by the sublime.

However, these shortcomings, which merely indicate that he unconsciously confined himself to the sphere of art which he knew most about and was hence unfair in his judgment of the others, are more than outweighed by the principles which he demonstrated in a singularly brilliant display of style and method, and by the new era in art and literature which he ushered in with his *Laocoön*. In proclaiming that description as such does not belong to the domain of poetry, he laid the way for a new movement in both lyric poetry and drama:

[Action became henceforth the watchword of German poetry. The childish and empty lyric poetry of the period also received its deathblow. Movement and action were henceforth to characterize the lyrical effusions of the heart. . . . The great epoch of German poetry ushered in by Lessing opens with a movement, the very name of which breathes this spirit: it is the period of "Sturm und Drang"; its master genius is Goethe.[7]]

E. A. McCORMICK

[6] Nor even a plaster cast of the group, such as the one Goethe, whose essay *Über Laokoon* was published in 1798, saw in Mannheim in 1771 (cf. *Dichtung und Wahrheit*, XI).

[7] Hamann, *Lessing's Laokoon*, p. xxix.

NOTE ON THE TEXT

The translation for this edition is based on the text of
Hugo Blümner's German edition of *Laocoön* (*Lessings Lao-
koon*, published, with a commentary, by Hugo Blümner [2nd
edition; Berlin, 1880]). In the few instances where Blümner's
text seemed questionable, I have adopted Franz Muncker's
reading (*Lessings sämtliche Schriften*, published by Karl Lach-
mann [3rd edition; Stuttgart, 1893], Vol. IX). Since the differ-
ences in these two editions are few and minor, departures from
Blümner's text have not been indicated.

In preparing the Introduction, I have made liberal use of
Blümner's notes and extensive Introduction, as well as the
excellent summary given by W. G. Howard in his Introduc-
tion to *Laokoon. Lessing, Herder, Goethe* (New York, 1910).
Considerable portions of the translator's Footnotes and Ap-
pendix Notes, particularly the numerous translations of Latin
and Greek passages, are based on material taken from some of
the most widely accepted editions, especially those of Blümner,
Boxberger, Cosack, Hamann, Howard, Phillimore, Schmarsow,
and Witkowski.

In addition to Lessing's own extensive notes, annotation has
been added which elucidates points in Lessing's text and notes,
and provides translations of Greek, Latin, Italian, and French
quoted by Lessing. The longer notes, both Lessing's and those
contributed especially for this edition, are collected in an Ap-
pendix (p. 159). References to these Appendix Notes are made
by superior letters in the text. Throughout the text, Footnotes,
and Appendix Notes, all material not included by Lessing is
bracketed.

This edition also includes, in a separate section, Biograph-
ical Notes, which identify mythological and historical figures
mentioned in the text and notes.

It should be noted that Lessing used Greek and Latin names interchangeably for the gods and goddesses of classical antiquity. In this translation, the particular rendering used by Lessing has been retained in each case.

<div align="right">E. A. Mc.</div>

LAOCOÖN

PREFACE

The first person to compare painting with poetry was a man of fine feeling who observed that both arts produced a similar effect upon him. Both, he felt, represent absent things as being present and appearance as reality. Both create an illusion, and in both cases the illusion is pleasing.

A second observer, in attempting to get at the nature of this pleasure, discovered that both proceed from the same source. Beauty, a concept which we first derive from physical objects, has general rules applicable to a number of things: to actions and thoughts as well as to forms.

A third, who examined the value and distribution of these general rules, observed that some of them are more predominant in painting, others in poetry. Thus, in the one case poetry can help to explain and illustrate painting, and in the other painting can do the same for poetry.

The first was the amateur, the second the philosopher, and the third the critic.

The first two could not easily misuse their feelings or their conclusions. With the critic, however, the case was different. The principal value of his observations depends on their correct application to the individual case. And since for every one really discerning critic there have always been fifty clever ones, it would have been a miracle if this application had always been made with the caution necessary to maintain a proper balance between the two arts.

If Apelles and Protogenes,[1] in their lost writings on painting, confirmed and explained its laws by applying already established rules of poetry, we may be certain that they did so with the same moderation and accuracy with which the principles and lessons of painting are applied to eloquence and

[1] [For further information on persons mentioned in the text and notes, see the Biographical Notes, p. 243.]

poetry in the works of Aristotle, Cicero, Horace, and Quintilian. It is the prerogative of the ancients never to have done too much or too little in anything.

But in many respects we moderns have considered ourselves far superior when we transformed their pleasant little lanes into highways, even though shorter and safer highways themselves become mere footpaths as they lead through wildernesses.

The brilliant antithesis of the Greek Voltaire [2] that painting is mute poetry and poetry a speaking painting was doubtless not to be found in any textbook. It was a sudden fancy—among others that Simonides had—and the truth it contains is so evident that one feels compelled to overlook the indefinite and untrue statements which accompany it.

The ancients, however, did not overlook them. In restricting Simonides' statement to the effect achieved by the two arts, they nevertheless did not forget to stress that, despite the complete similarity of effect, the two arts differed both in the objects imitated as well as in the manner of imitation (ὕλῃ καὶ τρόποις μιμήσεως).

Still, many recent critics have drawn the most ill-digested conclusions imaginable from this correspondence between painting and poetry, just as though no such difference existed. In some instances they force poetry into the narrower limits of

2 [Lessing is referring to Simonides of Ceos (died 469 B.C.), whose famous saying that painting is mute poetry and poetry a speaking picture is found in Plutarch's *De Gloria Atheniensium* 346f.: τὴν μὲν ζωγραφίαν ποίησιν οιωπῶσαν προσαγορεύει, τὴν δὲ ποίησιν ζωγραφαν λαλοῦσαν. Just why Lessing calls Simonides "the Greek Voltaire" is uncertain, for there is little in the Greek writer's works to remind one of Voltaire. One commentator has suggested that Lessing is attempting to discredit Simonides by such a comparison, "for Voltaire was then notorious for shiftiness and frivolity" (W. G. Howard, *Lessing's Laokoon* [New York, 1910], p. 341). It seems more probable, however, that Lessing was struck by the fact that both were men of great intellectual power and versatility and both long enjoyed favor at court, Simonides at the court of Hiero of Syracuse, and Voltaire at the court of Frederick of Prussia.]

painting; in others they allow painting to fill the whole wide sphere of poetry. Whatever one is entitled to must be permitted to the other also; whatever pleases or displeases in one must necessarily please or displease in the other. And so, full of this idea, they pronounce the shallowest judgments with the greatest self-assurance and, in criticizing the work of a poet and a painter on the same subject, they regard the differences of treatment observed in them as errors, which they blame on one or the other, depending on whether they happen to prefer painting or poetry.

Indeed, this spurious criticism has to some degree misled even the masters of the arts. In poetry it has engendered a mania for description and in painting a mania for allegory, by attempting to make the former a speaking picture, without actually knowing what it could and ought to paint, and the latter a silent poem, without having considered to what degree it is able to express general ideas without denying its true function and degenerating into a purely arbitrary means of expression.

To counteract this false taste and these unfounded judgments is the principal aim of the following chapters. They were written as chance dictated and more in keeping with my reading than through any systematic development of general principles. Hence they are to be regarded more as unordered notes for a book than as a book itself.

Yet I flatter myself that even in this form they will not be treated wholly with contempt. We Germans suffer from no lack of systematic books. We know better than any other nation in the world how to deduce anything we want in the most beautiful order from a few postulated definitions.

Baumgarten acknowledged that he owed the greater part of the examples in his *Aesthetics* to Gesner's dictionary. Although my reasoning may not be so compelling as Baumgarten's, my examples will at least smack more of the source.

Since I started, as it were, with the Laocoön and return to it a number of times, I wished to give it a share in the title

too. Other short digressions on various points of ancient art history contribute less to my intent and are included only because I can never hope to find a more suitable place for them.

I should like to remark, finally, that by "painting" I mean the visual arts in general; further, I do not promise that, under the name of poetry, I shall not devote some consideration also to those other arts in which the method of presentation is progressive in time.

CHAPTER ONE

The general and distinguishing characteristics of the Greek masterpieces of painting and sculpture are, according to Herr Winckelmann, noble simplicity and quiet grandeur, both in posture and in expression. "As the depths of the sea always remain calm," he says "however much the surface may be agitated, so does the expression in the figures of the Greeks reveal a great and composed soul in the midst of passions."

Such a soul is depicted in Laocoön's face—and not only in his face—under the most violent suffering. The pain is revealed in every muscle and sinew of his body, and one can almost feel it oneself in the painful contraction of the abdomen without looking at the face or other parts of the body at all. However, this pain expresses itself without any sign of rage either in his face or in his posture. He does not raise his voice in a terrible scream, which Virgil describes his Laocoön as doing; [1] the way in which his mouth is open does not permit it. Rather he emits the anxious and subdued sigh described by Sadolet. The pain of body and the nobility of soul are distributed and weighed out, as it were, over the entire figure with equal intensity. Laocoön suffers, but he suffers like the Philoctetes of Sophocles; [a] his anguish pierces our very soul, but at the same time we wish that we were able to endure our suffering as well as this great man does.

Expressing so noble a soul goes far beyond the formation of a beautiful body. This artist must have felt within himself that strength of spirit which he imparted to his marble. In Greece artists and philosophers were united in one person, and there was more than one Metrodorus. Philosophy extended its hand to art and breathed into its figures more than common souls. . . . [2]

[1] [Virgil, *Aeneid* I. 222.]

[a] [Notes indicated by a superior letter are printed in the Appendix, p. 159.]

[2] *Von der Nachahmung der griechischen Werke in der Malerei und Bildhauerkunst*, pp. 21, 22.

7

The remark on which the foregoing comments are based, namely that the pain in Laocoön's face is not expressed with the same intensity that its violence would lead us to expect, is perfectly correct. It is also indisputable that this very point shows truly the wisdom of the artist. Only the ill-informed observer would judge that the artist had fallen short of nature and had not attained the true pathos of suffering.

But as to the reasons on which Herr Winckelmann bases this wisdom, and the universality of the rule which he derives from it, I venture to be of a different opinion.

I must confess that the disparaging reference to Virgil was the first cause of my doubts, and the second was the comparison with Philoctetes. I shall proceed from this point and record my thoughts as they developed in me.

"Laocoön suffers like the Philoctetes of Sophocles." But how does Philoctetes suffer? It is strange that his suffering should have left such different impressions. The laments, the cries, the wild curses with which his anguish filled the camp and interrupted all the sacrifices and sacred rites resounded no less terribly through the desert island, and it was this that brought about his banishment there. What sounds of despondency, of sorrow and despair in the poet's presentation ring through the theater! It has been found that the third act of his work is much shorter than the others. From this, the critics claim,[3] we may conclude that the ancients were little concerned with having acts of equal length. I agree with this, but I should prefer to rely on some other example than this for support. The cries of anguish, the moaning, the disjointed ἆ ἆ, φεῦ, ἀπαταῖ, ὤμοι μοι! the whole lines of παπᾶ, παπᾶ of which this act consists and which must be spoken with prolonged stresses and with pauses quite different from those of connected speech, have in actual performance doubtless made this act just about as long as the others. It seems much shorter on paper to the reader than it probably did to a theater audience.

A cry is the natural expression of physical pain. Homer's wounded warriors not infrequently fall to the ground with a

[3] Brumoy, _Théâtre des Grecs_, II, 89.

cry. Venus shrieks aloud at a mere scratch,[4] not because she must be made to represent the tender goddess of sensuality, but because suffering nature must have her due. Even iron Mars screams so horribly on feeling the lance of Diomedes that it sounds like the shouting of ten thousand raging warriors and fills both armies with terror.[5]

High as Homer raises his heroes above human nature in other respects, he still has them remain faithful to it in their sensitiveness to pain and injury and in the expression of this feeling by cries, tears, or invectives. In their deeds they are beings of a higher order, in their feelings true men.

I know that we more refined Europeans of a wiser, later age know better how to govern our mouths and our eyes. Courtesy and propriety force us to restrain our cries and tears. The aggressive bravery of the rough, early ages has become in our time a passive courage of endurance. Yet even our ancestors were greater in the latter than the former. But our ancestors were barbarians. To master all pain, to face death's stroke with unflinching eye, to die laughing under the adder's bite, to weep neither at the loss of one's dearest friend nor at one's own sins: these are the traits of old Nordic heroism.[6] Palnatoko decreed that his Jomsburghers were not to fear anything nor even so much as mention the word "fear."

Not so the Greek! He felt and feared, and he expressed his pain and grief. He was not ashamed of any human weakness, but it must not prevent him from attaining honor nor from fulfilling his duty. The Greek acted from principles whereas the barbarian acted out of his natural ferocity and callousness. In the Greek, heroism was like the spark hidden in the flint, which sleeps quietly as long as no external force awakens it, and robs it of its clarity or its coldness. In the barbarian, hero-

4 *Iliad* V. 343: ‘Η δὲ μέγα ἰάχουσα. ["now the goddess cried loudly." Diomedes wounded Venus very slightly with his spear while the goddess was pursuing Aeneas.]

5 *Iliad* V. 859.

6 Th. Bartholinus, *De causis contemptae a Danis adhuc gentilibus mortis*, chap. 1.

ism was a bright, consuming, and ever-raging flame which de-
voured, or at least blackened, every other fine quality in him.
When Homer makes the Trojans march to battle with wild
cries, while the Greeks go in resolute silence, the commenta-
tors rightly observe that the poet thereby intends to depict the
former as barbarians and the latter as civilized peoples. I am
surprised that they did not notice a similar contrast of char-
acter in another passage.[7] Here the opposing armies have
agreed to a truce and are busy burning their dead, which does
not take place without the shedding of hot tears on both sides
(δάκρυα θερμὰ χέοντες).[8] But Priam forbids his Trojans to weep
(οὐδ᾿ εἴα κλαίειν Πρίαμος μέγας).[9] He does this, Madame Dacier
says, because he is afraid they may grow too softhearted and
take up the battle on the following day with less courage.
True! But why, may I ask, should only Priam fear this? Why
does Agamemnon not issue the same command to the Greeks?
The poet's meaning goes deeper: he wants to tell us that only
the civilized Greek can weep and yet be brave at the same
time, while the uncivilized Trojan, to be brave, must first
stifle all human feeling. Νεμεσσῶμαί γε μὲν οὐδὲν κλάιειν is the re-
mark that Homer has the sensible son of wise Nestor make on
another occasion.[10]

It is worthy of note that among the few tragedies which
have come down to us from antiquity there are two in which
physical pain is not the least part of the misfortune that befalls
the suffering heroes, Philoctetes and the dying Hercules.[11] And
Sophocles lets even the latter wail and moan, weep and cry
out. Thanks to our well-mannered neighbors,[12] those masters

[7] *Iliad* VII. 421.
[8] ["shedding hot tears."]
[9] ["but mighty Priam forbade them to weep."]
[10] *Odyssey* IV. 195. ["Weeping does not make me indignant." Spoken by
Peisistratus, son of Nestor, about the tears we shed for the deceased.]
[11] [Lessing is alluding to the hero of one of Sophocles' tragedies, *The
Women of Trachis*, who, after being poisoned by a garment given him by
his wife Deianeira, burns himself to death on Mount Aetna in Thessaly.]
[12] [The French, of whom Lessing once said (*Hamburgische Dramaturgie*,
No. 80) that they had no genuine tragedies at all.]

of propriety, a wailing Philoctetes or a bawling Hercules today would be the most ridiculous and unbearable figure on stage. One of their most recent poets has, to be sure, ventured on a Philoctetes,[13] but did he dare to show his audience the *true* Philoctetes? There is even a Laocoön among the lost plays of Sophocles. If only fate had saved this one for us! From the slight references of some of the ancient grammarians we cannot determine how the poet treated his subject. But of this much I am certain: he did not portray Laocoön as more stoical than Philoctetes and Hercules. Stoicism is not dramatic, and our sympathy is in direct proportion to the suffering of the object of our interest. If we see him bearing his misery with nobility of soul, he will, to be sure, excite our admiration; but admiration is only a cold sentiment whose barren wonderment excludes not only every warmer passion but every other clear conception as well.

I come now to my conclusion: if, according to the ancient Greeks, crying aloud when in physical pain is compatible with nobility of soul, then the desire to express such nobility could not have prevented the artist from representing the scream in his marble. There must be another reason why he differs on this point from his rival the poet, who expresses this scream with deliberate intention.

13 Chataubrun [Chateaubrun].

CHAPTER TWO

Whether it be fact or fiction that Love inspired the first artistic effort in the fine arts,[1] this much is certain: she never tired of guiding the hands of the old masters. Painting, as practiced today, comprises all representations of three-dimensional bodies on a plane. The wise Greek, however, confined it to far narrower limits by restricting it to the imitation of beautiful bodies only. The Greek artist represented only the beautiful, and ordinary beauty, the beauty of a lower order, was only his accidental subject, his exercise, his relaxation. The perfection of the object itself in his work had to give delight, and he was too great to demand of his audience that they be satisfied with the barren pleasure that comes from looking at a perfect resemblance, or from consideration of his skill as a craftsman. Nothing in his art was dearer to him or seemed nobler than its ultimate purpose.

"Who would want to paint you when no one even wants to look at you?" an old epigrammatist [2] asks of an exceedingly deformed man. Many an artist of our time would say, "Be as ugly as possible, I will paint you nevertheless. Even though no one likes to look at you, they will still be glad to look at my picture, not because it portrays you but because it is a

1 [Pliny (*Natural Histories* XXXV. 151) tells the story of a Corinthian potter, Dibutades, whose daughter fell in love with a youth who was to depart on a long journey the following day. While sitting beside him on the evening before the journey, she noticed the outline of his face reflected on the wall and quickly traced it in order to keep the memory of her lover fresh. Dibutades filled in the outline with clay and fired it with his clay wares, thus becoming the inventor of the art of bas-relief. It is to this story that Lessing alludes here.]

2 Antiochus (*Antholog[ia Graeca]* II. 4). In his commentary on Pliny (XXXV. 36), Hardouin credits this epigram to a certain Piso, but among all the Greek epigrammatists there is no such name to be found.

proof of my art, which knows how to present such a monster so faithfully."

To be sure, the propensity to this wanton boasting of mere skills, not ennobled by the intrinsic worth of their subjects, is too natural for even the Greeks not to have had their Pauson and their Pyreicus. They had them, but they treated them with stern justice. Pauson, whose subjects did not even have the beauty of ordinary nature and whose low taste made him enjoy best the portrayal of what is faulty and ugly in the human form,[a] lived in the most abject poverty.[3] And Pyreicus, who painted barbershops, filthy workshops, asses, and kitchen herbs with all the zeal of a Dutch artist—as if such things in nature had so much charm or were so rare!—acquired the name of Rhyparographer,[4] or the painter of filth. Indeed, the debauched rich paid their weight in gold for his paintings, as if to offset their intrinsic worthlessness by putting a fictitious value upon them.

The authorities themselves did not deem it beneath their dignity to force the artist to remain in his proper sphere. It is well known that the law of the Thebans commanded idealization in art and threatened digression toward ugliness with punishment. This was no law against bunglers, which has been generally supposed, even by Junius himself.[5] It condemned the Greek Ghezzis,[6] that unworthy artistic device through which a likeness is obtained by exaggerating the ugly parts of the original—in a word, the caricature.

The law of the Olympic judges [7] sprang from the same idea of the beautiful. Every victor in the Olympic games received a statue, but only the three-time winner had a portrait-statue

[3] Aristophanes, *Plutus* 602, and *Acharnians* 854.

[4] Pliny, XXXV. 37, ed. Hard[ouin].

[5] *De Pictura vet[erum]* II. iv. § 1.

[6] [A term given to caricaturists. Count Pierleone Ghezzi (1674-1755) was a Roman painter and engraver of caricatures who was well known in Lessing's time.]

[7] [The *Hellanodicae* (ἐλλανοδίκαι) were the nine chief judges at the Olympic games. Three were assigned to the track events, three to the pentathlon, and the others to the remaining contests.]

erected in his honor.[8] This was to prevent the increase of mediocre portraits among works of art, for a portrait, although admitting idealization, is dominated by likeness. It is the ideal of one particular man and not of man in general. We laugh when we hear that among the ancients even the arts were subject to the civil code. But we are not always right when we do so. Unquestionably, laws must not exercise any constraint on the sciences, for the ultimate goal of knowledge is truth. Truth is a necessity to the soul, and it is tyranny to impose the slightest constraint on the satisfaction of this essential need. But the ultimate goal of the arts is pleasure, and this pleasure is not indispensable. Hence it may be for the lawmaker to determine what kind of pleasure and how much of each kind he will permit.

The plastic arts in particular—aside from the inevitable influence they exert on the character of a nation—have an effect that demands close supervision by the law. If beautiful men created beautiful statues, these statues in turn affected the men, and thus the state owed thanks also to beautiful statues for beautiful men. (With us the highly susceptible imagination of mothers seems to express itself only in producing monsters.)

From this point of view I believe I can find some truth in some of the ancient tales which are generally rejected as outright lies. The mothers of Aristomenes, Aristodamas,[9] Alexander the Great, Scipio, Augustus, and Galerius all dreamed during pregnancy that they had relations with a serpent. The serpent was a symbol of divinity,[10] and the beautiful statues

[8] Pliny, XXXIV. 9.

[9] [Lessing has confused Aristodamas with Aratus, son of Aristodama. The passage to which Lessing refers is Pausanius, IV. 14. 5. Aratus of Sicyon was a famous statesman and founder of the Achaean League (271-213 B.C.).]

[10] It is an error to suppose that the serpent was the symbol only of a healing deity. Justin Martyr (*Apolog.*, II, 55, ed. Sylburg) says expressly: παρὰ παντὶ τῶν νομιζομένων παρ' ὑμῖν θεῶν, ὄφις σύμβολον μέγα καὶ μυστήριον ἀναγράφεται;* and it would be a simple matter to name a

and paintings depicting Bacchus, Apollo, Mercury, or Hercules
were seldom without one. Those honest mothers had feasted
their eyes on the god during the day, and their confused
dreams recalled the image of the reptile. Thus I save the
dream and abandon the interpretation born of the pride of
their sons and the impudence of the flatterer. For there must
be some reason why the adulterous fantasy was always a ser-
pent.

But I am digressing. I wanted simply to establish that among
the ancients beauty was the supreme law of the visual arts.
Once this has been established, it necessarily follows that what-
ever else these arts may include must give way completely if
not compatible with beauty, and, if compatible, must at least
be subordinate to it.

Let us consider expression. There are passions and degrees
of passion which are expressed by the most hideous contor-
tions of the face and which throw the whole body into such
unnatural positions as to lose all the beautiful contours of its
natural state. The ancient artists either refrained from de-
picting such emotions or reduced them to a degree where it is
possible to show them with a certain measure of beauty.

Rage and despair did not degrade any of their works. I ven-
ture to say that they never depicted a Fury.[11, b] Wrath was
reduced to seriousness. In poetry it was the wrathful Jupiter
who hurled the thunderbolt; in art it was only the stern
Jupiter.

whole series of monuments on which the serpent accompanies deities who
had no connection whatever with healing.

 * [*Apologia Secunda (pro Christianis ad Senatum Romanum*), chap.
27: "Near every one of the divinities worshiped by you a serpent is
painted on as an important symbol and mystery."]

11 [The Furies, also called "Eumenides," were the avenging deities in
classical mythology. They are represented as the daughters of Earth or of
Night, and as winged maidens with serpents twined in their hair and
blood dripping from their eyes. It was their duty to punish men, both in
life and after death. Later writers usually speak of three Furies, Tisiphone,
Alecto, and Megaera.]

Anguish was softened into sadness. Where this softening was impossible, where anguish would have been disparaging as well as distorting—what did Timanthes do? We know the answer from his painting of the sacrifice of Iphigenia: he imparted to each bystander the particular degree of sadness appropriate to him but concealed the face of the father, which should have shown the most intense suffering. Many clever things have been said about this. One critic,[12] for instance, says that he had so exhausted himself in depicting the sorrowful faces of the bystanders that he despaired of his ability to give a still more sorrowful one to the father. Another says that by so doing he admitted that the anguish of a father in such circumstances is beyond expressing.[13] For my part, I see no incapacity on the part of either the artist or his art. The intensity of the emotions intensifies the corresponding expression in the features of the face; the highest degree will cause the most extreme expression, and nothing is easier in art than to express this. But Timanthes knew the limits which the Graces had set for his art. He knew that the anguish appropriate to Agamemnon as the father would have to be expressed through distortions, which are always ugly. He went as far as he could in combining beauty and dignity with the expression of anguish. He would have preferred to pass over the ugly or to soften it, but since his composition did not permit him to do either, there was nothing left him but to veil it. What he might not paint he left to conjecture. In short, this concealment is a sacrifice that the artist has made to beauty; it is an example, not of how one pushes expression beyond the limits of art,

12 Pliny, XXXV. 35[36]: "Cum moestos pinxisset omnes, praecipue patruum, et tristitiae omnem imaginem consumpsisset, patris ipsius vultum velavit, quem digne non poterat ostendere." ["After he had painted them all with melancholy expressions, and especially the uncle, and had exhausted every possible picture of sadness, he concealed the face of the father, being unable to depict it in a worthy manner."]

13 "Summi moeroris acerbitatem arte exprimi non posse confessus est." Valerius Maximus, VIII. 11. ["He confessed that the bitterness of greatest grief could not be expressed by art."]

but how one should subject it to the first law of art, the law of beauty.

If we apply this now to the Laocoön, the principle which I am seeking becomes apparent. The master strove to attain the highest beauty possible under the given condition of physical pain. The demands of beauty could not be reconciled with the pain in all its disfiguring violence, so it had to be reduced. The scream had to be softened to a sigh, not because screaming betrays an ignoble soul, but because it distorts the features in a disgusting manner. Simply imagine Laocoön's mouth forced wide open, and then judge! Imagine him screaming, and then look! From a form which inspired pity because it possessed beauty and pain at the same time, it has now become an ugly, repulsive figure from which we gladly turn away. For the sight of pain provokes distress; however, the distress should be transformed, through beauty, into the tender feeling of pity.

The wide-open mouth, aside from the fact that the rest of the face is thereby twisted and distorted in an unnatural and loathsome manner, becomes in painting a mere spot and in sculpture a cavity, with most repulsive effect. Montfaucon showed little taste when he pronounced an old bearded head with gaping mouth to be Jupiter uttering oracles.[14] Must a god shout when he reveals the future? Would a pleasing outline of the mouth cast suspicion on his words? Nor do I believe Valerius when he says that Ajax was represented as screaming in the above-mentioned picture of Timanthes.[15]

14 *Antiquité expliquée*, I, 50.

15 That is to say, he specifies the degree of sadness actually expressed by Timanthes in this way: "Calchantem tristem, moestum Ulyssem, clamantem Ajacem, lamentantem Menelaum." † The screaming Ajax must have been an ugly figure, and since neither Cicero [*ad M. Brutum Orator*, sec. 22 ‡] nor Quintilian [*Institutio Oratoria* II. 13. 12] mention it in their descriptions of this painting, I have all the more reason to believe it to be an addition, by which Valerius thought he could enrich the picture from his own imagination.

† ["Calchas sad, Ulysses deeply troubled, Ajax crying out, Menelaus loudly wailing."]

Far inferior painters, in a period when art was already in
decay, did not allow even the most savage barbarians to open
their mouths wide enough to scream though they were seized
with terror and fear of death beneath the victor's sword.[16]
 It is certain that this softening of extreme physical pain to
a less intense degree is observable in a number of ancient art
works. The suffering Hercules in the poisoned garment, by an
unknown master, was not the Hercules of Sophocles, who
screamed so horribly that the rocks of Locris and the head-
lands of Euboea resounded. He was sullen rather than wild.[17]
The Philoctetes of Pythagoras Leontinus seemed to communi-
cate his pain to the spectator, and yet the effect of this pain
would have been destroyed by any feature even slightly sug-
gestive of horror. One might ask how I know that this master
made a statue of Philoctetes. From a passage in Pliny, which
is so obviously interpolated or mutilated that it should not
have had to wait for me to emend it.[c]

 ‡ [The passage in the *Orator*, as it is called in English, runs: ". . .
when we say that a thing is unbecoming (and if a poet avoids this as
the greatest of faults [and he also errs if he puts an honest sentiment
in the mouth of a fool], or if that painter saw that, when Calchas was
sad at the sacrifice of Iphigenia, and Ulysses still more so, and Menelaus
in mourning, that Agamemnon's head required to be veiled altogether,
since it was quite impossible to represent such grief as his with a paint-
brush. . . .)" *Orations of Cicero*, tr. C. D. Yonge (London, 1852), IV,
403.]
16 Bellorii *Admiranda*, tab. 11, 12.
17 Pliny, XXXIV. 19.

CHAPTER THREE

As I have already said, art has been given a far wider scope in modern times. It is claimed that representation in the arts covers all of visible nature, of which the beautiful is but a small part. Truth and expression are art's first law, and as nature herself is ever ready to sacrifice beauty for the sake of higher aims, so must the artist subordinate it to his general purpose and pursue it no farther than truth and expression permit. It is enough that truth and expression transform the ugliest aspects of nature into artistic beauty.

But even if we were willing to leave these ideas for the moment unchallenged as to their value, we would still have to consider, quite independently of these ideas, why the artist must nevertheless set certain restraints upon expression and never present an action at its climax.

The single moment of time to which art must confine itself by virtue of its material limitations will lead us, I believe, to such considerations.

If the artist can never make use of more than a single moment in ever-changing nature, and if the painter in particular can use this moment only with reference to a single vantage point, while the works of both painter and sculptor are created not merely to be given a glance but to be contemplated—contemplated repeatedly and at length—then it is evident that this single moment and the point from which it is viewed cannot be chosen with too great a regard for its effect. But only that which gives free rein to the imagination is effective. The more we see, the more we must be able to imagine. And the more we add in our imaginations, the more we must think we see. In the full course of an emotion, no point is less suitable for this than its climax. There is nothing beyond this, and to present the utmost to the eye is to bind the wings of fancy and compel it, since it cannot soar above the impression

made on the senses, to concern itself with weaker images, shunning the visible fullness already represented as a limit beyond which it cannot go. Thus, if Laocoön sighs, the imagination can hear him cry out; but if he cries out, it can neither go one step higher nor one step lower than this representation without seeing him in a more tolerable and hence less interesting condition. One either hears him merely moaning or else sees him dead.

Furthermore, this single moment, if it is to receive immutable permanence from art, must express nothing transitory. According to our notions, there are phenomena, which we conceive as being essentially sudden in their beginning and end and which can be what they are only for a brief moment. However, the prolongation of such phenomena in art, whether agreeable or otherwise, gives them such an unnatural appearance that they make a weaker impression the more often we look at them, until they finally fill us with disgust or horror. La Mettrie, who had himself portrayed in painting and engraving as a second Democritus, seems to be laughing only the first few times we look at him. Look at him more often and the philosopher turns into a fop. His laugh becomes a grin. The same holds true for screaming. The violent pain which extorts the scream either soon subsides or else destroys the sufferer. When a man of firmness and endurance cries out he does not do so unceasingly, and it is only the seeming perpetuity of such cries when represented in art that turns them into effeminate helplessness or childish petulance. This, at least, the artist of the Laocoön had to avoid, even if screaming had not been detrimental to beauty, and if his art had been allowed to express suffering without beauty.

Among the ancient painters Timomachus seems to have been the one most fond of subjects that display extreme passion. His raving Ajax and his infanticide Medea were famous paintings, but from the descriptions we have of them it is clear that he thoroughly understood and was able to combine two things: that point or moment which the beholder not so much sees as adds in his imagination, and that appearance

which does not seem so transitory as to become displeasing through its perpetuation in art. Timomachus did not represent Medea at the moment when she was actually murdering her children, but a few moments before, when a mother's love was still struggling with her vengefulness. We can foresee the outcome of this struggle; we tremble in anticipation of seeing Medea as simply cruel, and our imagination takes us far beyond what the painter could have shown us in this terrible moment. But for this very reason we are not offended at Medea's perpetual indecision, as it is represented in art, but wish it could have remained that way in reality. We wish that the duel of passions had never been decided, or at least had continued long enough for time and reflection to overcome rage and secure the victory for maternal feelings. This wisdom on the part of Timomachus has earned him lavish and frequent praise and raised him far above another, unknown painter who was foolish enough to depict Medea at the height of her rage, thus endowing her brief instant of madness with a permanence that is an affront to all nature. The poet, who reproaches him for this, says quite sensibly, in addressing the picture itself: "Art thou then constantly thirsting for the blood of thy young? Is there ever a new Jason, a new Creusa there to incense you endlessly?—A curse on you, even in the painting!" he adds angrily.[1]

We are able to form some judgment of Timomachus' raging Ajax from the account given by Philostratus.[2] Ajax did not appear raging among the herds, binding and slaughtering cattle and rams, mistaking them for men. He was depicted sitting there exhausted after these deeds of insane heroism, and contemplating suicide. That is really the raging Ajax, not

1 Philippus (Anthol[ogia Graeca] IV. 9. 10).

 Ἀεὶ γὰρ διψᾷς βρέφεων φόνον. ἢ τις Ἰήσων

 Δεύτερος, ἢ Γλαύκη τις πάλι σοὶ πρόφασις;

 Ἔρρε καὶ ἐν κηρῷ παιδοκτόνε . . .

[Lessing himself translates this passage from Philippus in the preceding four lines of the text.]

2 Vita Apoll[onius], II. 22.

because he is raging at this moment, but because we see that he has been raging and because we can recognize the enormity of his madness most vividly from the desperate shame he himself now feels at his actions. We see the tempest in the wrecks and corpses which it has cast ashore.

CHAPTER FOUR

[I review the reasons given why the master of the Laocoön was obliged to exercise moderation in expressing physical pain and find that all of them have been derived from the special nature of the visual arts, their limitations, and their requirements. Hence any one of those causes could scarcely be applied to poetry.

Without investigating here the extent to which the poet is able to depict physical beauty, we may accept this much as unquestionable: since the whole infinite realm of perfection lies open to his description, this external form, beneath which perfection becomes beauty, can at best be only one of the least significant means by which he is able to awaken our interest in his characters. Often he ignores it entirely, being convinced that once his hero has won our favor his other qualities will either occupy us to such a point that we do not think of his physical form or, if we do think of it, we will be so captivated that we give him of our own accord if not a beautiful form, at least an ordinary one.

Least of all will he have to consider the sense of sight in any single trait that is not expressly intended to appeal to it. When Virgil's Laocoön screams, does it occur to anyone that a wide-open mouth is necessary in order to scream, and that this wide-open mouth makes the face ugly? Enough that *clamores horrendos ad sidera tollit* [1] has a powerful appeal to the ear, no matter what its effect on the eye! He who demands a beautiful picture here has failed to understand the poet.

Moreover, there is nothing to compel the poet to compress his picture into a single moment. He may, if he so chooses, take up each action at its origin and pursue it through all

[1] [*Aeneid* I. 222: "He lifted up his voice in horrible cries to the heavens."]

possible variations to its end. Each variation which would cost the artist a separate work costs the poet but a single pen stroke; and if the result of this pen stroke, viewed by itself, should offend the hearer's imagination, it was either anticipated by what has preceded or is so softened and compensated by what follows that it loses its individual impression and in combination achieves the best effect in the world. Thus, if it were really improper for a man to cry out in the violence of pain, what prejudice can this slight and transitory impropriety create in us against a man whose other virtues have already inclined us in his favor?

Virgil's Laocoön cries out, but this screaming Laocoön is the same man whom we already know and love as a prudent patriot and loving father. We do not relate his cries to his character, but solely to his unbearable suffering. It is this alone which we hear in them, and it was only by this means that the poet could convey it clearly to our senses.

Who, then, would still censure him? Who would not have to confess, rather, that while the artist was right in not permitting Laocoön to cry out, the poet has done equally well in having him do so? But Virgil is writing here as an epic poet. Will the dramatic poet be included in this justification as well? The reporting of someone's scream produces one impression and the scream itself another. The drama, designed for living representation by the actor, might perhaps for that very reason have to conform more strictly to material representation in painting. In it we do not merely believe that we see and hear a screaming Philoctetes, we do actually see and hear him. The closer the actor approaches nature, or reality, the more our eyes and ears must be offended; for it is an incontrovertible fact that they are offended in nature itself when we perceive loud and violent expressions of pain. Besides, we are generally unable to respond with the same degree of sympathy to physical pain as to other suffering. Our imagination can discern too little in such pain to allow the mere sight of it to arouse in us anything of a corresponding feeling. Consequently, Sophocles may easily have violated not a merely con-

ventional sense of propriety, but one that is grounded in the very nature of our feelings, when he made Philoctetes and Hercules moan and weep, scream and howl to such a degree. The bystanders cannot possibly have shared their suffering to the extent that these intemperate outbursts would seem to demand. To us as spectators these onlookers will appear comparatively cold, and yet we cannot help but regard their sympathy as the standard by which to measure our own. Add to this that the actor can rarely, if ever, carry his presentation of physical pain to the point of illusion. And who can say whether the modern dramatic poets should not be praised rather than criticized for either avoiding this cliff altogether or else skirting it lightly?

How many things would seem incontestable in theory had not genius succeeded in proving the opposite by fact! None of the above considerations is without foundation, and still the *Philoctetes* remains one of the masterpieces of the stage. For some of these objections do not actually apply to Sophocles, and only by disregarding the rest has he attained a beauty which timid critics, but for this example, would never have dreamed of. The following remarks will show this more precisely.

1. How marvelously the poet has strengthened and enlarged the idea of physical pain! He chose a wound—for the circumstances of the story may also be considered as depending on his choice insofar as he chose the story because it contained circumstances that fitted his needs—I say he chose a wound and not an internal malady, because sickness, no matter how painful, cannot impress us as much as a wound. The inner sympathetic fire which consumed Meleager when his mother sacrificed him in the fatal fire of her sisterly rage would hence be less dramatic than a wound. Moreover, Philoctetes' wound was a divine punishment. A supernatural poison raged unceasingly within it, interrupted at intervals by a more violent attack of pain which was always followed by a benumbing sleep, allowing his exhausted body to regain its strength in

order to set out again on the same path of suffering. But Chateaubrun has him wounded simply by the poisoned arrow of a Trojan. What extraordinary result could one expect from such an ordinary occurrence? In the ancient wars everyone was exposed to that. How did it happen, then, that it had such terrible consequences only in the case of Philoctetes? Besides, a natural poison that works for nine whole years without killing the victim is far more improbable than all the fabulous wonders with which the Greek dramatist decked out his piece!

2. However great and terrible he made the physical pain of his hero, Sophocles still knew full well that it was in itself not enough to excite any appreciable degree of pity. He therefore combined it with other ills which likewise could not in themselves greatly move us, but which receive from this combination a coloring just as melancholy as that which they in their turn impart to physical pain. These ills were complete isolation from human society, hunger, and all the hardships of life to which one is exposed in such a state of privation and in a raw climate.[a] Picture a man in these circumstances, but give him health, strength, and energy, and he becomes a Robinson Crusoe whose fate, although it lays little claim to our sympathy, does not leave us indifferent. For we are rarely so satisfied with human society that the quiet we enjoy without it does not have a special appeal to us, particularly in view of the notion—so flattering to every individual—that he can gradually learn to do without the help of others. On the other hand, imagine a man with the most painful, incurable disease but at the same time surrounded by kind friends, who see to it that he does not lack anything, who ease his suffering as much as they can, and to whom he may openly complain and lament. We undoubtedly feel sympathy for such a man, but our sympathy does not last; in the end we shrug our shoulders and admonish him to be patient. It is only when both predicaments are combined—when the isolated individual has no control over his own body and when the sick man neither receives help from others nor is able to help himself, and his laments are wasted on the desert air—it is then that we see

every misery that can beset the human race close over the unfortunate man's head, and only then does the very thought of putting ourselves in his situation excite horror and dread. We see despair in its most terrifying form, and no pity is so strong, none melts our very soul so much as that which is mingled with despair. This is the kind of pity we feel for Philoctetes, and we feel it most strongly at the moment when he is deprived of his bow, the only thing that could save his wretched life.

Oh, the folly of the Frenchman [Chateaubrun] who hadn't the sense to consider this nor the heart to feel it! Or, if he had, was petty enough to sacrifice all this to the poor taste of his country. Chateaubrun provides his Philoctetes with company. He has a princess come to him on his desert island; nor does she come alone: her lady-in-waiting is with her, and I don't know who needed her most, princess or poet. He has left out the whole splendid scene with the bow, and to make up for this he introduces the play of pretty eyes. No doubt bows and arrows would have seemed a comic sport to the heroic French youth, but nothing could be more serious to them than the scorn of lovely eyes. The Greek harrows us with the horrible fear that poor Philoctetes will have to remain on the desert island without his bow and perish miserably there. The Frenchman knows a surer way to our hearts; he makes us fear that the son of Achilles will have to march off without his princess. As might be expected, the Parisian critics called this "triumphing over the ancients," and one of them suggested that Chateaubrun's piece be called "La difficulté vaincue." [2]

3. Having considered the effect of the whole, let us turn to those scenes in which Philoctetes no longer appears as the abandoned sick man, but has hopes of leaving the bleak desert island and returning to his kingdom; that is to say, in those scenes where his entire misfortune is restricted to his painful wound. He moans, he shrieks, he falls into the most horrible convulsions. It is against this that the objection of offended decorum is justly raised; it is an Englishman [Adam Smith]

[2] ["Difficulty overcome."] *Mercure de France*, April, 1755, p. 177.

who makes the objection—a man, therefore, not readily sus-
pected of false delicacy. And as indicated, he gives very good
reasons for his objection. All feelings and passions, he says, for
which others can find but little sympathy become offensive if
too violently expressed. "For this reason nothing is more in-
decent and unmanly than weeping and crying out with physi-
cal pain however intolerable it may be. But there is, to be
sure, a sympathy for physical pain. When we see that someone
is about to receive a blow on his arm or shin, we naturally
start and draw back our own arm or leg, and if the blow
actually falls, we too feel it in some measure and are hurt by
it as well as the sufferer. However, our actual pain is very
slight, and so when the person who is struck cries out violently
we are invariably contemptuous of him since we are not able
to cry as violently as he." [3]

Nothing is more deceptive than the laying down of general
laws for our emotions. Their texture is so delicate and intricate
that even the most cautious speculation can hardly pick out a
single thread and follow it through all its interlacing. But even
if such speculation were to succeed, what could we gain by
it? In nature there are no single, unmixed emotions; with each
one thousands of others spring up at the same time, and the
least of these is able to change the original feeling completely,
so that one exception after another arises until the supposedly
general law itself is finally reduced to a mere personal experi-
ence in some individual cases. We despise a man, says the
Englishman, whom we hear cry out violently under physical
pain. But not always; not the first time; not when we see that
the sufferer is making every attempt to suppress it; not when
we know him to be a man of firmness in other respects; and
less when we see him offer proofs of his steadfastness even
while suffering; when we see that his pain can force him to
cry out but not go one single step further than that; when
we see that he would rather submit to a continuation of his
pain than change his way of thinking or his resolve in the

[3] Adam Smith, *The Theory of Moral Sentiments* (London, 1761), Pt. I,
sec. 2, chap. 1, p. 41.

slightest degree, even though he knows that such a change would end suffering altogether. We find all this in the case of Philoctetes. With the ancient Greeks, moral greatness consisted just as much in unchanging love for one's friends as in unflagging hatred of one's enemies. Philoctetes preserves this greatness throughout all his agonies. His pain has not so dried his eyes that they have no tears to shed for the fate of his old friends, nor has it subdued his spirit so much that, to be rid of it, he could forgive his enemies and willingly let himself be used for their selfish ends. And were the Athenians to despise this rock of a man because the waves, which were powerless to shake him, could at least wrest from him a moan?

I confess that I have little liking for the philosophy of Cicero, and still less for that part of it where, in the second book of the Tusculan Questions, he drags out the problem of the endurance of physical pain. One would think he wanted to train a gladiator, so violently does he inveigh against giving utterance to pain. Only in the manifestation of pain does he seem to find a lack of endurance, without stopping to think that it is often anything but voluntary, and that true bravery can show itself in voluntary actions only. In Sophocles' play he hears only Philoctetes' cries and laments, and overlooks entirely his steadfast bearing in other respects. But where else would he have found an excuse for his rhetorical sally against the poets? "Their object is to make us softhearted by introducing the bravest men weeping." They have to let them weep, for the theater is no arena. It was the duty of the condemned or hired gladiator to suffer everything with grace. No sound of complaint should be heard, no painful convulsion seen, for since his wounds and his death were intended to amuse the audience, it was part of his act to conceal all show of feeling. The slightest expression of it would have awakened pity; and pity, frequently awakened, would soon have put an end to these heartless and cruel shows.

But pity, the very thing which should not be aroused here, is the sole aim of the tragic stage and consequently demands a diametrically opposed attitude. Its heroes must show feeling,

must give utterance to their pain and let nature work una-
dorned. If they betray any training and constraint, they leave
our hearts cold, and boxers in buskins can at best expect only
admiration for their stoicism. All the characters in the trag-
edies ascribed to Seneca deserve to be admired. I am firmly
convinced that the holding of gladiatorial games was the prime
reason why the Romans always remained so far below the
level of mediocrity in the art of tragedy. The spectators lost
all understanding of nature in the bloody amphitheater, where
at best a Ctesias [b] might have studied his art, but never a
Sophocles. The greatest tragic genius, grown accustomed to
these artificial death scenes, could not help but degenerate
into bombast and rodomontade. But such bragging can no
more inspire true heroic courage than Philoctetes' complaints
can produce softheartedness. The complaints are those of a
man, but the actions those of a hero. Both enter into the
make-up of the human hero, who is neither effeminate nor
hard, but appears now the one and then the other, just as now
nature, now duty and principles demand. He is the highest
type that wisdom can produce and art reproduce.

4. Sophocles was not content simply to secure his sensitive
Philoctetes from all contempt; he has at the same time fore-
stalled all adverse criticism based on the remarks of the Eng-
lishman. For though we are not always contemptuous of the
man who cries out under physical pain, it is an indisputable
fact that we do not feel as much pity for him as his cry would
seem to demand. How then should those who are with the
screaming Philoctetes conduct themselves? Should they pre-
tend to be deeply moved? That would be contrary to nature.
Should they appear cold and embarrassed, as one actually
tends to be in such a situation? That would create a most un-
pleasant dissonance in the mind of the spectator. As I have
said, Sophocles has precluded this possibility also by impart-
ing to the bystanders an interest of their own. Philoctetes'
screams are not the only thing that occupies them. Hence,
the spectators' attention is arrested not so much by the lack of
proportion between their sympathy and these screams as by

the change which pity causes, or ought to cause, in the by-standers' sentiments, whether this pity be weak or strong. Neoptolemus and the chorus have deceived the unfortunate Philoctetes; they realize into what despair their deceit will plunge him. Now, before their very eyes, he falls into his par-oxysm, and if this access of pain cannot excite any appreciable degree of sympathy in them, it can at least induce them to look into their own hearts, to have respect for so much misery, and to be reluctant to increase it through treachery. This the spectator expects, and he is not disappointed by the noble-minded Neoptolemus. Had Philoctetes been master of his pain, he would have confirmed Neoptolemus in his subterfuge; Phil-octetes, whose pain renders him incapable of all pretense, how-ever necessary it may seem to him to prevent his traveling com-panions from repenting their promise to carry him away with them, brings Neoptolemus back to his natural self by his own complete naturalness. This conversion is excellent and all the more moving since it is brought about by sheer humanity. In the Frenchman's drama beautiful eyes again play their part.[4] But I do not want to pay any more attention to this parody. In the *Trachiniae,* Sophocles shows the same skill in combin-ing some other emotion in the bystanders with the pity that should be felt at hearing a cry of pain.

Hercules' pain does not exhaust him but rather drives him into a rage in which he thirsts only for revenge. In his frenzy he has already seized Lichas [5] and dashed him against the rocks. The chorus is composed of women, and so it is all the more natural that it be overcome by fear and horror. This and the suspense of not knowing whether a god will yet come to the aid of Hercules or if he will be overcome by his misfortune are what create the true universal interest here, in which sym-pathy is but a slight element. As soon as the outcome is de-cided by comparing the oracles,[c] Hercules becomes calm, and admiration for his final show of resolution supplants all other

[4] Act II, scene 3: "De mes déguisemens que penseroit Sophie?" asks the son of Achilles. ["What would Sophia think of my disguises?"]

[5] [The messenger who brought the fateful garment to Hercules.]

feelings in us. However, in comparing the suffering Hercules with the suffering Philoctetes we should not forget that the former is a demigod and the latter only a man. A man is never ashamed of giving vent to his complaints, but the demigod is ashamed that his mortal nature so prevailed over his immortal part that he was forced to cry and whimper like a girl.[6] We moderns do not believe in demigods and yet we expect the most insignificant hero to feel and act like one.

Whether or not the actor is able to bring the screams and convulsions of pain home to us forcefully enough to create an illusion, I do not venture to affirm or deny. If I found that our actors could not, I should first have to know if it were also impossible for a Garrick; and even if this were so, I should still be at liberty to assume that the ancients attained a perfection in declamation and in the art of acting which we can scarcely conceive of today.

6 *Trachiniae* 1088-89:

ὅστις ὥστε παρθένος
Βέβρυχα κλαίων . . .

["who cries and whimpers like a girl."]

CHAPTER FIVE

There are scholars of antiquity who believe the Laocoön group to be the work of a Greek master but who date it from the time of the emperors [1] on the grounds that Virgil's Laocoön must have served as its model. Of the older scholars who hold this view I shall mention only Bartholomew Marliani,[2] and of the more recent ones, Montfaucon.[3] No doubt they found such agreement between the work of art and the poet's description that it seemed inconceivable to them that both could have accidentally lighted on the same set of circumstances, which do not by any means naturally suggest themselves. They assumed that if the question were raised as to the honor of the invention and the first idea, probability would speak much more strongly for the poet than for the artist.

However, they seem to have forgotten that a third possibility exists: the poet may no more have copied from the artist than the artist from the poet, but both may have drawn from an older, common source. According to Macrobius, this older source would have been Pisander,[a] for when the works of this Greek poet were still extant it was common knowledge,

1 [Reference is to the Roman emperors, or Caesars, beginning with Augustus.]

2 *Topographiae Urbis Romae* IV. 14: "Et quanquam hi (Agesander et Polydorus et Athenodorus Rhodii) ex Virgilii descriptione statuam hanc formavisse videntur," etc. ["And although they (the Rhodians Agesander, Polydorus, and Athenodorus) appear to have designed this statue according to Virgil's description," etc.]

3 *Suppl. aux Ant. Expliq.*, I, 242: "Il semble qu'Agésandre, Polydore et Athénodore, qui en furent les ouvriers, ayent travaillé comme à l'envie, pour laisser un monument, qui répondoit à l'incomparable déscription qu'a fait Virgile de Laocoon," etc. ["It seems that Agesander, Polydorus, and Athenodorus, the sculptors of the group, worked in emulation to leave a monument that would correspond to Virgil's incomparable description of Laocoön."]

pueris decantatum, that the Roman did not so much imitate as faithfully translate the whole account of the conquest and destruction of Troy, which constitutes his entire second book. Hence, if Pisander had been Virgil's predecessor in the story of Laocoön, the Greek artists would not have needed the guidance of a Latin poet; and the conjecture as to the dating of the work loses its support.

However, if I had to take the position of defending the opinion of Marliani and Montfaucon, I should offer them the following means of extricating themselves from their difficulty. Pisander's poems are lost. What his version of the Laocoön story was we cannot say with certainty, but in all probability it was the same as the one of which we can still find traces in the Greek writers. But these versions have nothing in common with Virgil's account, and so the Latin poet must have recast the Greek tradition to suit himself. His account of Laocoön's misfortune is his own invention; consequently, if the artists' versions are in agreement with his, we must conclude that they lived at a later time and used his work as their model.

It is true that Quintus Calaber agrees with Virgil in making Laocoön express suspicion of the wooden horse; but Minerva's wrath, which he draws upon himself by so doing, expresses itself in Calaber's work in quite a different way. The earth trembles beneath the feet of the warning Trojan; terror and dread take possession of him; a burning pain rages in his eyes; his brain is affected; he goes mad and is struck blind. But only when, though blind, he persists in advising the burning of the wooden horse does Minerva send two terrible serpents which, however, seize only Laocoön's children. They stretch out their hands toward their father in vain; the poor blind man cannot help them, they are torn to shreds, and the serpents disappear in the ground. Laocoön himself suffers no injury from them. That this version is not peculiar to Quintus [4]

4 *Paralip.* [*Peri ton paralipomenon Homeri,* "On Things Omitted by Homer"], XII. 398-408, 439-474.

but was generally accepted is shown by a passage from Lyco-phron, where the serpents [5] are called "child-eaters."

But if this version had been commonly accepted by the Greeks, it is unlikely that Greek artists would have been so bold as to deviate from it, and equally unlikely that they would have done so in exactly the same way as a Roman poet. Unless, that is to say, they had already become acquainted with him or perhaps had been directly commissioned to use his version as their model. In my opinion, one would have to in-sist on this point in order to defend Marliani and Montfaucon. Virgil is the first and only writer [b] to have the serpents kill the father as well as the children; [c] the sculptors do this, too, but since it would not be typical for them as Greeks to have done so, it is probable that Virgil's description suggested it to them.

I am fully aware that this probability falls short of historical certainty, but as I do not intend to draw any further historical conclusions from it, I believe that we can at least admit it as a hypothesis, on which the critic may base his observations. Whether or not it has been proved that the sculptors used Virgil as a model, I shall assume it in order to determine how in such a case they would have followed him. I have already expressed myself on the subject of the screams. Perhaps a further comparison will lead to no less instructive observations.

The idea of having the father and his two sons connected in one entanglement by means of the deadly serpents is unde-niably an inspired one and gives evidence of a highly artistic imagination. Whose was it, the poet's or the artists'? Mont-faucon professes that he cannot find it in the poet's work,[d] but I find that he has not read the poet carefully enough:

> . . . Illi agmine certo
> Laocoonta petunt, et primum parva duorum

[5] Or rather serpent, for Lycophron [*Alexandra* 347] appears to have assumed that there was only one: καὶ παιδοβρῶγος πορκέως νήσους διπλᾶς. ["and the two islands of child-devouring Porceus." Porceus and Chariboea were the serpents which came from the two islands of Calydnae, near Tenedos, and killed Laocoön and his sons.]

Corpora natorum serpens amplexus uterque
Implicat et miseros morsu depascitur artus.
Post ipsum, auxilio subeuntem et tela ferentem
Corripiunt, spirisque ligant ingentibus . . .[e]

The poet has described the serpents as being of marvelous length. They have wound their huge coils around the boys and seize the father, too, when he comes to their aid (*corripiunt*). Because of their size, they could not have unwound themselves from the sons at once; there must therefore have been a moment when they had already attacked the father with their heads and front parts while still holding the sons encircled with their hind parts. This moment is necessary to the progress of the poetic picture; the poet allows us to feel it completely, but this was not yet the time to depict it in full detail. A passage in Donatus[f] seems to prove that the ancient commentators also sensed this. How much less likely that it could have escaped the attention of the artists, whose keen eyes perceive quickly and clearly in one penetrating flash everything that may be useful to them!

The poet is careful to leave Laocoön's arms free from the coils which have encircled his body, and thus his hands have perfect freedom:

Ille simul manibus tendit divellere nodos.[6]

In this point the artists necessarily had to follow his example. Nothing is more expressive and lively than the action of the hands; especially when emotions are in play, the most mobile face is meaningless without such movement. Arms locked to the body by the serpents' coils would have cast an air of stillness and death over the whole group, but we see the arms in full freedom, both in the principal and the secondary figures; and their activity is greatest where the pain is most violent.

But this freedom of the arms was the only point in regard to the coiling of the serpents that the artists found expedient to borrow from the poet. Virgil winds the serpents twice

[6] [See Appendix Note c, p. 170.]

around the body and neck of Laocoön and has their heads
project high above him:

> Bis medium amplexi, bis collo squamea circum
> Terga dati, superant capite et cervicibus altis.[7]

This picture satisfies our imagination fully; the most essential
parts of the body are squeezed to the point of strangulation,
and the venom is aimed toward the face. However, this is no
picture for the artist, whose object is to show the physical ef-
fects of the venom and the pain. To show these effects the vital
parts must be left as free as possible and external pressure
completely avoided, for this might change and weaken the ac-
tivity of suffering nerves and laboring muscles. The double
coils would have concealed all of the trunk, and the painful
contraction of the stomach, which is so expressive, would have
been invisible. Those parts still exposed above or below or
between the coils would have been seen amid constrictions and
distensions caused not by inner pain but by the external pres-
sure. So many coils around the neck would have destroyed the
pyramidal effect of the group, which is so pleasing to the eye,
and the pointed heads of the serpents projecting from the mass
into the air would have been such a violation of proportion as
to render the effect of the whole extremely repulsive. Some
designers have nevertheless been foolish enough to follow the
poet too closely. And, as we might expect, the disgusting re-
sults can be seen only too clearly in an engraving by Franz
Cleyn,[g] to take one example. The ancient sculptors saw im-
mediately that their art required a completely different treat-
ment. They transferred all the coils from the body and neck
to thighs and feet, where they could conceal and squeeze as
much as necessary without detriment to the expression, and
where at the same time they could awaken the idea of sud-
denly arrested flight and a kind of immobility which is highly
advantageous to the apparent continuation of that posture.

I do not know why the critics have treated with complete

[7] [See Appendix Note c, p. 170.]

silence this difference between the serpents' coils in the statue and in the poem. It reveals the wisdom of the artists just as much as another difference which they have all recognized but have attempted to justify rather than ventured to praise. I refer to the difference in regard to clothing. Virgil's Laocoön is clad in his priestly robe while in the statue he and his sons appear naked. Some people, I am told, find it absurd for a king's son [8] and a priest to be represented in this way at a sacrificial ceremony. To these objectors art critics answer in all earnestness that it is a departure from conventionality, to be sure, but the artists were forced to this because they could not attire the figure appropriately. Sculpture, they say, cannot imitate fabrics; thick folds produce a bad effect; and so one must choose the lesser evil and violate truth rather than be censured because of the drapery.[h] If ancient artists had smiled at the objection, I cannot imagine what their reaction to the reply would have been. Nothing could be more disparaging to the arts than this remark. For even if we supposed that sculpture could imitate fabrics as well as painting, would it have been necessary for Laocoön to be clad? Would we lose nothing by this drapery? Is a garment, the work of our poor human hands, as beautiful as an organic body, the work of eternal wisdom? Does it require the same talents, is it of the same merit, does it bring just as much honor to imitate the former as it does the latter? Is it only deception that our eyes require, and is it a matter of indifference to them with what they are deceived?

In poetry a garment is not a garment; it conceals nothing; our imagination sees right through it. Whether Virgil's Laocoön wears robes or not, his suffering is just as evident in one part of the body as in another. To the imagination his brow is encircled but not hidden by the priestly fillet. Indeed, this fillet is not only no hindrance, it actually strengthens the idea we form of the sufferer's misfortune. "Perfusus sanie vittas

8 [Laocoön was the son of Antenor, one of the princes of Troy.]

atroque veneno." [9] His priestly dignity avails him nothing. Even its emblem, which assures him honor and respect everywhere, is soaked and desecrated by the poisonous slaver. But the artist must give up this subordinate association of ideas if the main theme is not to suffer. Had he left Laocoön so much as the fillet he would have greatly weakened the expression, for the brow, the seat of expression, would have been partly covered. As in the case of the scream he sacrificed expression for beauty, here he gives up conventionality for expression. On the whole, conventionality was considered quite unimportant by the ancients. They felt that the highest aim of their art called for a complete rejection of conventionality. Beauty was their highest goal; necessity was the inventor of clothing, and what has art to do with necessity? I grant that there is also such a thing as beauty in clothing, but what is that when compared to the beauty of the human form? And will he who can attain the greater be content with the lesser? I fear that the greatest master in the rendering of drapery shows by this very talent wherein his weakness lies.

[9] [See Appendix Note c, p. 170.]

CHAPTER SIX

My hypothesis that the artists imitated the poet does not tend to lessen their merit. On the contrary, this imitation shows their wisdom in the most favorable light. They followed the poet without letting themselves be led astray even in the smallest details. The poets gave them a model, to be sure, but since it had to be translated from one art to another, they found ample opportunity to think for themselves. And the original ideas which the artists reveal in their deviations from the model prove that they were as great in their art as the poet in his.

Now reverse my hypothesis: let us say that the poet followed the artists. There are scholars who defend this hypothesis as truth,[a] but I know of no historical evidence to support it. However, since they found this sculpture[1] to be so supremely beautiful, they could not persuade themselves that it belonged to so late a period. They insisted rather that it belonged to the time when art was at its height, because it was worthy of that period.

We have seen that despite the excellence of Virgil's description the artists were unable to make use of several of its features. Thus there are certain limitations to the axiom that a good poetic description must also make a truly good painting and that the poet's description is good only if the artist is able to follow it in all its details. We surmised these limitations before having been given proof through examples, merely in consideration of the wide sphere of poetry, the limitless field of our imagination, and the incorporeal nature of its forms, which, though varied and great in number, may exist simultaneously without concealing or damaging each other, as would the objects themselves or their natural symbols in the narrow confines of space or time.

[1] [The marble group of Laocoön.]

But if the lesser cannot contain the greater, it can itself be contained in the greater. In other words, if not every trait used by the descriptive poet can have as good an effect on the painter's canvas or sculptor's marble, could not every trait of the artist be equally effective in the poet's work? Undoubtedly, for that which we find beautiful in a work of art is beautiful not to our eyes but to our imagination through our eyes. Thus, just as the same image may be conjured up in our imagination by means of arbitrary or natural symbols, the same pleasure will be aroused, though not always to the same degree.

But having granted this, I must confess that the idea of Virgil's having imitated the artists is, to me, far more incomprehensible than the contrary assumption. If the artists followed the poet, I can account for all their deviations. They had to deviate because those very features found in harmonious relationship in the poet's work would have revealed some infelicities in their own. But why did the poet have to deviate? If he had faithfully followed the group in each and every detail, would he not still have given us an excellent picture? [b] I can well understand how his imagination could suggest this or that detail to him but I simply cannot see why his critical judgment should compel him to change into these different ones the beautiful traits that were before his eyes.

It seems to me even that if Virgil had had the Laocoön group as his model he would hardly have contented himself with leaving to mere conjecture whether or not all three bodies were entwined in one close-knit group. It would have struck him too forcefully and have had too positive an effect on him for this not to have found a conspicuous place in his description. I have already said that this was not the proper time to dwell upon the way the group was entwined. True; but one single word more might well have put an important stress on it without actually removing it from the background in which the poet was forced to leave it. What the artist could reveal without this word, the poet, had he seen it in the artist's work, would not have refrained from at least mentioning.

The artist had most compelling reasons for not permitting
Laocoön's suffering to find expression in a scream. But if the
poet had seen before him so moving a combination of pain
and beauty in the work of art, what could have so irresistibly
compelled him to leave unexpressed the idea of manly bear-
ing and noble patience which arises from such a combination
and suddenly to terrify us instead with the horrible screams
of his Laocoön? Richardson says, "Virgil's Laocoön has to cry
out because the poet's aim is not so much to excite pity for
him as to instill fear and terror in the Trojans." This I will
concede, although Richardson seems not to have considered
the fact that the poet does not present his narrative in the first
person, but represents Aeneas as telling the story—and telling
it to Dido, whose sympathy he could not assail too strongly.
However, it is not the scream that disturbs me, but the absence
of any intermediate stages of emotion, which the work of art
would naturally have suggested to the poet if, as we assume,
he did use it as a model. Richardson adds, "The story of La-
ocoön is intended only to lead up to the pathetic description
of the final destruction; hence the poet could not allow him-
self to make it more interesting lest our attention, which this
last horrible night fully demands, be diverted by the misfor-
tune of an individual citizen." [c] But that is attempting to look
at the scene from the point of view of pictorial art, from which
it cannot possibly be viewed. In the poem, Laocoön's misfor-
tune and the ensuing destruction of Troy are not two pictures
side by side; they do not form a whole which our eyes can or
should be able to survey at a glance, in which case alone one
would have to fear that our eyes might dwell more on Laocoön
than on the burning city. The description of one follows the
other, and no matter how moving the first may be, I do not
see how it can adversely affect its successor unless this latter
is in itself not sufficiently moving.

The poet would have had still less reason for changing the
way in which the serpents are coiled. In the work of art the
serpents occupy the hands and bind the feet of the figures.
Pleasing as this arrangement is to the eye, the image which it

leaves in the imagination is equally vivid. It is so expressive and distinct that its depiction in words is but little weaker than its representation by natural means:

> ... micat alter, et ipsum
> Laocoonta petit, totumque infraque supraque
> Implicat et rabido tandem ferit ilia morsu
>
> At serpens lapsu crebro redeunte subintrat
> Lubricus, intortoque ligat genua infima nodo.[2]

These lines are by Sadolet. They would doubtless have come more graphically from Virgil if a visible model had fired his imagination, and would then have been better than those he gives us in their stead:

> Bis medium amplexi, bis collo squamea circum
> Terga dati, superant capite et cervicibus altis.[3]

These traits fill our imagination, to be sure, but we must not tarry there; we must not attempt to set them in due order. We must see first only the serpents and then Laocoön; we must not attempt to picture to ourselves how both would look together, for as soon as we attempt to do that we begin to take offense at Virgil's picture and find it highly inartistic.

Granted that Virgil's changes of the model were not unfortunate, they were nevertheless arbitrary. One imitates in order to achieve likeness. Can one, however, achieve likeness if one makes changes beyond the necessary? Such changes rather clarify the poet's intention; he did not strive for likeness, hence there was no imitation.

One might argue that he did not want to imitate the whole, but merely this or that part. Very well. But which individual parts correspond so exactly in the description and the marble that the poet might appear to have borrowed them from the sculptor? The father, the children, the serpents—all this was

2 [The entire poem is translated in Appendix Note b, p. 178. The passage beginning with *micat alter* coincides with lines 23-35 of the translation.]

3 [See Appendix Note c, p. 170.]

given by tradition to the poet as well as to the artist. Except for the historical facts, poet and sculptor do not agree in anything but that the children and the father are entangled in a single serpent-knot. But the idea for this came from the altered circumstance that the same calamity struck the father as well as his children. As I have mentioned earlier, however, this innovation seems to have been made by Virgil, for the Greek tradition offers an entirely different version. Consequently, if in the light of the entanglement of father and sons—a fact which both poet and artist have in common—we must assume an imitation on one side or the other, it is more reasonable to believe that the artist imitated the poet. In all other respects they differ from one another, but with the distinction that when the artist makes the changes, his intention to imitate the poet is still compatible with his changes since the aims and limits of his arts have compelled him to do so; but on the other hand, if the poet is supposed to have imitated the artist, then the above-mentioned deviations disprove this assumed imitation, and those who insist on supporting this theory in spite of the deviations can mean only that they consider the work of art to be of an earlier date than the poetic description.

CHAPTER SEVEN

When we say that the artist imitates the poet or the poet the artist, we can mean one of two things: either that the one takes the other's work as his model, or that both work from the same model and one borrows his manner of presentation from the other. When Virgil describes the shield of Aeneas,[1] he is "imitating" the artist who made it, in the first meaning of the term. The work of art, not what it represented in it, is his model, and even if at the the same time he describes what we see represented in it, he is only describing it as a part of the shield and not as the thing itself. But if Virgil had imitated the statue of Laocoön, this would have been an imitation in the second meaning of the term. For he would have imitated not the statue, but what the statue represents, and only the details of his imitation would have been borrowed from the statue.

In the first case the work of the poet is original, in the second it is a copy. The first is a part of that general imitation which is the very essence of his art, and whether his subject is a work of other arts or a work of nature, he creates as a genius. But the second kind robs him completely of any dignity. Instead of representing the thing itself, he imitates an imitation and gives us lifeless reflections of the style of another man's genius rather than his own.

If, as not infrequently happens, the poet and the artist must contemplate those objects common to both from the same point of view, the inevitable result is that their representations will correspond to one another in many points without there having been even the slightest imitation or emulation. These points of agreement between contemporaneous artists and poets in regard to things that no longer exist may lead to mu-

[1] [*Aeneid* VIII. 626-731.]

tual illumination; but to try to lend authority to explanations of this kind by representing an accidental agreement as an intentional imitation, and particularly by ascribing to the poet in all sorts of detail an intentional reference to this statue or that picture is indeed to render him a very doubtful service. And not only him, but the reader as well, to whom the most beautiful passages are thereby, at best, made very clear but also perfectly lifeless.

This is the aim and the failing of a famous English work. Spence's writing of *Polymetis*[2] was based on a great deal of classical learning and an intimate knowledge of the extant works of classical art. In his attempt to explain the Roman poets from these works and to extract from the poets, in turn, information concerning hitherto unexplained ancient art works, he was often quite successful. But I nevertheless maintain that his book must be absolutely unbearable to every reader of taste.

When Valerius Flaccus describes the winged lightning on the Roman shields,

> (Nec primus radios, miles Romane, corusci
> Fulminis et rutilas scutis diffuderis alas)[3]

it is natural that this description will seem far more meaningful to me if I see the representation of such a shield on an ancient monument.[4] It is possible that the ancient armorers may have represented Mars on their helmets and shields in the same hovering attitude that Addison believed he saw him

[2] The first edition is dated 1747, the second 1755, and bears the title: "Polymetis, or an Enquiry concerning the Agreement between the works of the Roman poets, and the Remains of the ancient Artists, being an Attempt to illustrate them mutually from one another, In ten Books, by the Rev. Mr. Spence. London, printed for Dodsley. fol." An abridgment of this work by N. Tindal has already had more than one printing.

[3] ["Roman soldier, you were not the first to show on your shield the ruddy wings of gleaming lightning." Earlier, in a passage not quoted by Lessing, Flaccus says that the soldiers of Colaxes, king of Scythia, wore the insignia of Jove on their breast armor. This is the "lightning" of the lines quoted.]

[4] Valerius Flaccus, VI. 55, 56. *Polymetis*, Dial. VI, p. 50.

above Rhea on a coin.[a] It is also possible that Juvenal had just such a helmet or shield in mind when he alluded to it with a word that has been a problem to all commentators up to the time of Addison. I think that the passage in Ovid where the exhausted Cephalus calls to the cooling breezes;

Aura . . . venias . . .
Meque iuves, intresque sinus, gratissima, nostros![5]

and his Procris takes this *Aura* to be the name of a rival— this passage, I say, I find more natural when I learn from the works of art of the ancients that they actually personified the gentle breezes and worshiped certain female sylphs under the name of *Aurae*.[b] I agree that when Juvenal compares a good-for-nothing of high family with a herma [6] one would have great difficulty in finding any similarity in this comparison unless he had actually seen such an image and knew it to be a poorly shaped pillar bearing only the head or, at the most, the torso of the god and which, because of the absence of hands and feet, suggests the notion of inactivity.[c] Illustrations of this sort are not to be disdained, even though they may not always be necessary or even sufficient. The poet had the work of art before him, not as an imitation but as a thing existing in its own right. Or else artist and poet had the same ideas in common which resulted in a similarity of the representations. From this similarity we can infer that those ideas were held quite generally.

But when Tibullus paints Apollo as he appeared to him in a dream: a most beautiful youth, his temples encircled by the chaste laurel, Syrian fragrances floating from the golden locks that hung about his slender neck, gleaming white and rich-hued red blended over his whole body, like the tender cheeks of the bride being led to her beloved—why should these charms have been borrowed from famous ancient paintings!? Echion's *nova nupta verecundia notabilis* [newlyweds distinguished by

[5] ["Dear Aura, come and comfort me; receive me in your most welcome graces" (*Metamorphoses* 7. 817f., tr. H. Gregory).]

[6] [The Hermes column, or *herma*, was a boundary stone, a shaft surmounted by a head, dedicated to the god Hermes.]

their modesty] may have been in Rome, may have been copied a thousand times and more, but does that mean that bridal modesty itself had vanished from the earth? And after the painter had seen it, was no poet ever to see it except in the painter's imitation? [7] Or when another poet [8] describes Vulcan as weary and his face, scorched red by the forge, as burning, did he first have to learn from the painter that work tires and heat reddens? [9] Or when Lucretius describes the change of seasons and moves them past our eyes in their natural succession with their whole train of effects on sky and earth, are we to believe that he was an ephemeral who had never lived through one whole year and experienced all these changes himself, and hence had to copy them from a procession in which statues of the seasons were carried? Did he first need to learn from statues the old poetic device of making such abstractions into real beings? [d] Or take Virgil's *pontem indignatus Araxes*,[10] that splendid poetic picture of a river bursting its banks and tearing away a bridge that spans it: does it not lose all its beauty when we are told that the poet is alluding to a work of art in which the river god is represented as really destroying a bridge? [11] What can we gain from such explanations that deprive the poet of his share of credit even in the most obvious passage just so that some artist's idea may glimmer through?

The *Polymetis* unfortunately has foisted some other man's genius on the ancient poets in place of their own. Because of this tasteless whim the work, which might otherwise have been so useful, becomes most obnoxious and far more prejudicial to the needs of classical writers than the insipid commentaries of spiritless etymologists could ever have been. And I regret

[7] Tibullus, *Elegies* III. 4. *Polymetis*, Dial. VIII, p. 84.

[8] [Publius Papinius Statius (c. A.D. 45-96). He is noted primarily for his *Thebais*, an epic poem, and his *Sylvae*, five books of occasional poems. Lessing is referring to one of the poems from this collection.]

[9] Statius, Bk. I, *Sylvae* V. 8; *Polymetis*, Dial. VIII, p. 81.

[10] ["Araxes showing his contempt for the bridge." Araxes is the river Kur in Armenia and was represented in the shield of Aeneas.]

[11] *Aeneid* VIII. 725; *Polymetis*, Dial. XIV, p. 230.

still more that in this respect Spence was preceded by Addison who, in the laudable attempt to raise an acquaintanceship with classical works of art to the level of interpretation, has no less failed to distinguish where the imitation of the artist enhances the poet and where it belittles him.[12]

[12] In various passages of his Travels [*Remarks on Several Parts of Italy*] and his Dialogues on Ancient Medals. [*Dialogues on the Usefulness of Medals*. Lessing objects to the praise which Addison bestows on descriptive poetry in his *Remarks* and *Dialogues*. See ADDISON in Biographical Notes, p. 243.]

CHAPTER EIGHT

Spence has the strangest notions about the similarity between poetry and painting. He holds that the ancients considered both arts so closely united that they always went hand in hand and that the poet never lost sight of the painter, nor the painter of the poet. But that poetry has a wider range, that there are beauties at its command which painting is never able to attain, that it frequently has reason to prefer inartistic to artistic beauties—these things seem never to have occurred to him, and as a result the slightest differences he may observe between the ancient poets and artists cause him an embarrassment which forces him to resort to the strangest subterfuges in the world.

The ancient poets usually described Bacchus as having horns. "Therefore," says Spence, "it is most surprising that one so rarely sees horns on his statues." [1] He looks for this, that, and the other reason—the ignorance of antiquarians, the smallness of the horns themselves which might have been concealed under the clusters of grapes and ivy leaves which were the constant headdress of the god. He wanders round and round the real reason without ever suspecting it. The horns of Bacchus were not natural ones like those of fauns and satyrs,[2] but an ornament for the brow [3] which he could put on and take off at will.

[1] *Polymetis,* Dial. IX, p. 129.

[2] [Forest deities, who were the companions of Bacchus. Originally, the fauns were Italic mythological figures and the satyrs Greek, but in later times they came to be identified with each other.]

[3] [Lessing is in error here. Bacchus' horns were not merely adornments which he could put on or take off at will, but natural horns. Bacchus, like any other god, was able to assume any form he chose. Horace (*Odes* II. 19ff.) tells of the war between the gods and the giants, in which Bacchus assumed the form of a lion.]

Tibi, cum sine cornibus adstas
Virgineum caput est [4]

is Ovid's festive invocation of Bacchus.[5] Thus he could show himself without horns, and he did so whenever he wanted to appear in his virgin beauty. This was the way the artists wished to depict him, and they were therefore compelled to avoid all accessories that would produce an evil effect. These horns, which were fastened to his diadem, just as they can be seen on a head in the Royal Cabinet of Berlin,[6] were such an accessory, as was the diadem itself, which concealed his beautiful brow. For that reason the diadem occurs as rarely as the horns themselves in the statues of Bacchus, although, as its inventor, he is often crowned with it by the poets. The horns and the diadem provided the poet with subtle allusions to the deeds and character of the god, but to the artist, on the contrary, they were impediments which prevented the revealing of greater beauties. If Bacchus, as I believe, was given the name *Biformis,* Δίμορφος, because he could make himself beautiful as well as terrifying, it is only natural that the artists should have chosen among his appearances that which was best adapted to the aims of their art.

In Roman poetry Minerva and Juno often hurl the thunderbolt. Then why, asks Spence, do they not do so in their statues as well?[7] And he answers, "Because this was a special privilege of the two goddesses, the reason for which was perhaps learned only in the Samothracian mysteries.[8] But since artists were regarded as inferior people by the ancient Romans and hence

[4] ["Virginal is thy head when thou appearest without horns."]

[5] *Metamorph.* IV. 19, 20.

[6] *Begeri Thes. Brandenb.* [*Begerii Thesaurus Brandenburgiens*] III, 242 [Lorenz Beger, 1655-1705].

[7] *Polymetis,* Dial. VI, p. 63.

[8] [Little is known of the obscure religious rites of the cult of the Cabiri on Samothrace, an island in the Aegean. They are said to be a remnant of the Pelasgic religion, and Strabo speaks of the Cabiri as representing the mysterious powers of nature. Goethe ridicules the subject in his *Faust* (Part Two, Act II). Cf. A. Hamann, *Lessing's Laokoon* (Oxford, 1878), p. 244.]

were rarely initiated into these mysteries, they doubtless knew nothing about it—and what they did not know, they could not portray." However, I might ask Spence in turn: did these inferior people work independently or under the orders of superiors who might have been instructed in these mysteries? Were Greek artists also treated as inferiors? And were not Roman artists for the most part native Greeks? and so on.

Statius and Valerius Flaccus depict an enraged Venus with such terrifying features that at this moment she might be taken for a Fury rather than for the goddess of love. Spence searches in vain for such a Venus among the ancient works of art. And what conclusions does he draw? That the poet has greater freedom than the sculptor and painter? That is what he ought to have concluded, but he had adopted the principle, once and for all, that in a poetic description nothing is good that would appear inappropriate in a painting or a statue.[9] Hence the poets must have erred. "Statius and Valerius lived at a time when Roman poetry was already in its decline. Here too they betray their corrupted taste and their bad judgment. Such violations of the laws of artistic expression are not found among the poets of a better age." [10]

One needs precious little power of discrimination to make such a statement as this. In this case, however, I shall not take up the defense of either Statius or Valerius, but simply make a general observation. The gods and spiritual beings, as the artist portrays them, are not precisely those whom the poet needs in his work. To the artist they are personified abstractions which must always retain the same characteristics if they are to be recognized. To the poet, on the other hand, they are real, acting beings who, in addition to their general character, possess other qualities and feelings which, as circumstances demand, may stand out more prominently than the former. To the sculptor Venus is simply Love; hence he must

9 *Polymetis*, Dial. XX, p. 311: "Scarce any thing can be good in a poetical description, which would appear absurd, if represented in a statue or picture."
10 *Polymetis*, Dial. VII, p. 74.

give her all the modest beauty and all the graceful charm which delight us in an object we love and which we therefore associate with our abstract conception of love. The slightest deviation from this ideal makes its form unrecognizable to us. Give it beauty, but with more majesty than modesty, and we have not a Venus, but a Juno. Give it charms, but those which are more commanding and masculine than graceful, and we have not a Venus, but a Minerva. Worst of all, a wrathful Venus, a Venus driven by fury and the desire for revenge, is, to the sculptor, a complete contradiction in terms, for love as such is never wrathful or vengeful. To the poet, on the other hand, Venus is, to be sure, Love, but she is also the goddess of love who has, besides this characteristic, her own individual personality and hence must be just as capable of the impulses of aversion as those of affection. It is no wonder, then, that in his depiction she is inflamed with indignation and rage, especially when offended love itself has excited these feelings in her.

It is of course true that in works representing several figures the artist as well as the poet can introduce Venus or any other divinity as a real, acting person, independent of her own particular character. But in that case her actions must at least not be contradictory to her character, even though they may not be the direct consequence of it. Venus handing over the divine armor to her son is a subject equally suitable to artist and poet. There is nothing here to prevent the artist from bestowing on Venus all the charm and beauty which are properly hers as goddess of love. On the contrary, in his work she becomes all the more recognizable through these qualities. But when Venus, wanting to take revenge on those who have scorned her, the men of Lemnos,[11] wild, colossal in shape,

11 [The women of Lemnos had neglected to pay homage to Venus for a number of years. In her wrath the goddess sent a plague on them, causing their husbands to desert them and marry Thracian captives. Impelled by Venus herself, the women then banded together and killed all the men on the island. In his *Fables,* Hyginus mentions one exception; Hypsipyle secretly brought her father, Thoas, to a boat and helped him to escape.]

and with flushed cheeks and disheveled hairs seizes the torch,
throws a black robe about her and stormily descends on a dark
cloud—this is not the moment for the artist to select because
there is nothing by which he can make her recognizable at
this very moment. For the poet this is only one moment, since
he has the special privilege of combining it with another in
which the goddess is entirely Venus, so accurately and so com-
pletely that we never lose sight of her, even in the Fury. This
Flaccus does:

> . . . Neque enim alma videri
> Iam tumet; aut tereti crinem subnectitur auro,
> Sidereos diffusa sinus. Eadem effera et ingens
> Et maculis suffecta genas; pinumque sonantem
> Virginibus Stygiis, nigramque simillima pallam.[a]

And Statius does the same:

> Illa Paphon veterem centumque altaria linquens,
> Nec vultu nec crine prior, solvisse iugalem
> Ceston, et Idalias procul ablegasse volucres
> Fertur. Erant certe, media qui noctis in umbra
> Divam, alios ignes maioraque tela gerentem,
> Tartarias inter thalamis volitasse sorores
> Vulgarent: utque implicitis arcana domorum
> Anguibus, et saeva formidine cuncta replerit
> Limina.[b]

Or may we say that the poet alone possesses the craft of de-
scription by negative terms and, by mixing together the nega-
tive and positive, combining two appearances in one. No
longer is she the graceful Venus; no longer is her hair fastened
with golden clasps; no longer does the azure robe float about
her. Her belt is laid aside; she is armed now with other torches
and with larger arrows; she is accompanied now by other
Furies like herself. But, just because the artist must forego
seizing this moment, is that sufficient reason for the poet hav-
ing to do so too? If painting claims to be the younger sister of
poetry, at least she should not be a jealous sister and should
not deny the older one all those ornaments unbecoming to
herself.

CHAPTER NINE

If we wish to compare the painter and the poet in particular instances, we must first know whether they both enjoyed complete freedom; whether, that is to say, they could work toward producing the greatest possible effect in their respective arts without any external constraint.

Religion often represented just such an external constraint on the classical artist. His work, destined for worship and devotion, could not always be as perfect as it would have been if he had had as his sole aim the pleasure of his spectators. But superstition overloaded the gods with symbols, and the most beautiful gods were not always honored as such.

In the temple at Lemnos, from which the pious Hypsipyle rescued her father in the disguise of the god,[a] Bacchus was represented with horns. No doubt he appeared this way in all his temples since the horns were symbolic and one of his necessary attributes. Only the free artist, who did not have to create his Bacchus for some temple, omitted this symbol; and if we find none with horns among the extant statues of him,[b] we may perhaps take this as proof that none of them belongs among the consecrated ones under which he was actually worshiped. Besides this, it is highly probable that the wrath of pious iconoclasts during the first centuries of Christianity fell in great part on these latter. Only seldom did they spare a work of art, because it had not been desecrated by adoration.

However, since pieces of both kinds are to be found among the excavated objects of antiquity, I should prefer that only those be called works of art in which the artist had occasion to show himself as such and in which beauty was his first and ultimate aim. None of the others, which betray too obvious traces of religious conventions, deserves this name because in their case the artist did not create for art's sake, but his art was merely a handmaid of religion, which stressed meaning

more than beauty in the material subjects it allotted to art for execution. By this I do not mean to say that religion has not also frequently sacrificed meaning for beauty, or, out of consideration for art and the more refined taste of the period, has ceased to emphasize it to such a degree that beauty alone would seem to be the sole object.

If no such distinction is made, the critic and the classical scholar will constantly be at variance simply because they do not understand each other. If the critic, from his insight into the aims of art, maintains that the ancient artist could not have produced this or that work—not as an artist, that is to say, and not voluntarily—the classical scholar will understand him to mean that neither religion nor any other stimulus lying outside the domain of art could have brought about its execution by the artist, or, more exactly, by the artist as craftsman. Thus he believes that he can refute the critic with the first statue that comes to hand, while the critic, without scruple and to the great scandalization of the learned world, condemns that same statue to the dust from which it was dug.ᶜ

On the other hand, the influence of religion on art can be overestimated. Spence offers a unique example of this. He found that in Ovid's work Vesta was not worshiped in her temple under any personal image, and this seemed to him sufficient evidence that there had never been any statues of this goddess, and that everything considered as such up until then did not represent Vesta, but a vestal virgin.[1] A strange conclusion! Did the artist therefore lose his right to personify a being to whom the poets give a definite personality; whom they represent as the daughter of Saturn and Ops [2]; whom they represent as being in danger of falling under the ill-treatment of Priapus, and all the other things they say of her—did the artist, I say, lose his right to personify this being in his own way just because she was worshiped in one temple under the

[1] *Polymetis*, Dial. VII, p. 81.

[2] [Ops (surname of Rhea, or Cybele) was the Vesta minor of Roman mythology. As the wife of Saturn, or Chronos, she was called mother of the gods.]

sign of fire? For Spence commits at the same time the additional error of extending what Ovid says of only one particular temple of Vesta, namely the one at Rome,[d] to all the temples of this goddess without distinction, and to the worship of her in general. But she was not worshiped everywhere as she was in this temple at Rome! Not even in Italy itself until Numa built the temple. Numa did not want any deity represented in human or animal form; and the improvement which he effected in the worship of Vesta no doubt consisted in his forbidding any personal representation of her. Ovid himself tells us that before the time of Numa there were statues of Vesta in her temple which, in shame, covered their eyes with their maidenly hands when their priestess Sylvia became a mother.[e] Even the fact that in the temples of the goddess outside the city, in the Roman provinces, worship of her was not precisely of the nature ordered by Numa, appears to be borne out by various old inscriptions in which a *Pontificis Vestae* is mentioned.[3] At Corinth too there was a temple of Vesta without any statue, but with only an altar on which sacrifices were offered to the goddess.[4] But does that mean that the Greeks had no statues of Vesta whatsoever? There was one in the Prytaneum [5] at Athens near the statue of Peace,[6] and the inhabitants of Jasos [7] boasted of having one on which neither snow nor rain ever fell, although it stood in the open air.[8] Pliny also mentions a seated Vesta by Scopas. In his time it was in the Servilian garden at Rome.[f] Granted even that it is difficult for us today to distinguish a mere vestal virgin from a Vesta herself, does this prove that the ancients were not able to make this distinction either, or perhaps did not actually want to? Certain attributes manifestly point more

3 Lipsius, *de Vesta et Vestalibus* 13.

4 Pausanias, *Corinth* XXXV, p. 198 (ed. Kuhn.).

5 [The town hall of Athens, meeting place of the magistrates.]

6 [Pausanias], *Attica* XVIII, p. 41.

7 [A town situated on an island off the coast of Caria in Asia Minor.]

8 Polybius, *Histories* XVI. 11; Opus [Vol.] II, p. 443, ed. Ernest. [Johann August Ernesti (1707-1781). Ernesti's edition (1764) is still considered an outstanding one.]

to the one than the other. The scepter, the torch, the pal-
ladium [9] may only be presumed to be in the hand of a god-
dess. The tympan which Codinus attributes to her is perhaps
hers only in her symbolic representation of the earth—or
Codinus himself did not know exactly what he saw.[g]

[9] [A statue of Pallas Athene, symbol of public welfare and freedom,
thought to have been preserved in the temple of Vesta in Rome. Here
Lessing intends to say that Vesta was carrying or holding a small statue
of Pallas Athene in her hand.]

CHAPTER TEN

I comment on an expression of astonishment in Spence which clearly shows how little thought he must have given to the limits of poetry and painting. "As to the muses in general," he says, "it is strange that the poets are so brief in describing them, far briefer in fact than might be expected for goddesses to whom they are so greatly indebted."[1] What can this mean but that he is amazed that when poets speak of the muses they do not use the mute language of painters? To the poets Urania is the muse of astronomy; we recognize her office from her name and her functions. The artist, in order to make her recognizable, must show her pointing with a wand to a celestial globe. The wand, the globe, and the pointing position are his letters, from which he lets us spell out the name Urania. But when the poet wishes to say that Urania had foreseen his death long ago in the stars,

Ipsa diu positis lethum praedixerat astris Uranie . . .[2]

why should he, out of respect for the painter, add: "Urania, her wand in hand, the celestial globe before her"? It is as though a man who can and may speak were at the same time using those signs which the mutes in the Turkish seraglio invented among themselves for lack of a voice.

Spence again expresses the same astonishment when speaking of the moral beings, those divinities whom the ancients made preside over the virtues and the conduct of human life.[3] "It should be remarked," he says, "that the Roman poets have far less to say about the best of these moral beings than one would expect. On this point the artists are much more complete, and whoever wants to know what appearance each of

1 *Polymetis*, Dial. VIII, p. 91.
2 Statius, *Thebaid* VIII. 551.
3 *Polym.*, Dial. X, p. 137.

them made need only look at the coins of the Roman emperors.[4] The poets, to be sure, often speak of these beings as persons, but of their attributes, their clothing and their appearance in general they have little to say."

When the poet personifies abstractions, he characterizes them sufficiently by their names and the actions he has them perform.

The artist lacks these means and must therefore add to his personified abstractions symbols by which they may be recognized. But because these symbols are something different and mean something different, they make the figures allegorical.

The female figure with a bridle in her hand; another leaning against a pillar—these are, in art, allegorical figures. For the poet, however, Moderation and Constancy are not allegorical beings but simply personified abstractions.

Necessity invented these symbols for the artist, for only through them can he make it understood what this or that figure is supposed to represent. But why should the poet have forced upon him what the artist had to accept of necessity; a necessity which he himself has no part of?

The very thing which so surprised Spence should be prescribed to poets as a general law. They must not convert the necessities of painting into a part of their own wealth. Nor must they regard the means that art has invented in order to keep up with poetry as perfections which should give them reason for envy. When the artist adorns a figure with symbols, he raises what was a mere figure to a higher being; but if the poet employs these artistic trimmings, he turns that higher being into a puppet.

Just as this rule is confirmed by the practice of the ancients, so is its intentional violation the favorite fault of modern poets. All of their imaginary beings are masked, and those who understand such masquerades best are usually the ones who least comprehend the main task: how to let their beings act, and reveal their characters through their actions.

However, among the attributes which the artists give their

4 *Ibid.*, p. 139.

abstractions there is one type which can be used by the poet and is more worthy to be used. I am referring to those which are not strictly allegorical but are to be regarded as tools which those beings who possess them would, or could, use if they were to act as real persons. The bridle in the hand of Moderation, the pillar against which Constancy is leaning are purely allegorical and hence of no use to the poet. The scales in the hand of Justice are somewhat less so because the proper use of scales is really a part of justice. The lyre or flute in the hand of a muse, the lance in the hand of Mars, the hammer and tongs in the hands of Vulcan are not symbols at all but mere instruments without which these beings could not produce the effects that we ascribe to them. To this type belong the attributes which the ancient poets sometimes put into their descriptions and which I might for that reason term poetic, in contradistinction to allegorical. The former signify the thing itself, the latter only something resembling it.[a]

CHAPTER ELEVEN

Count Caylus, too, seems to demand that the poet adorn the creatures of his imagination with allegorical attributes.[a] The Count knew more about painting than poetry. But in the work in which he expresses this demand, I have found occasion for more important reflections, the vital points of which I note here for more careful consideration.

The artist, in the Count's opinion, should become better acquainted with the greatest descriptive poet, Homer—that second Nature. Caylus shows the artist what rich and hitherto unused material for the most superior kinds of description are afforded by the Greek's narrative and how much better the execution of his own work will be if he adheres to even the most minute details of the poet's description.

Thus the two kinds of imitation which I have distinguished up to now are confounded again in this proposition. The painter is not only to represent what the poet has represented, but he is also to use the same manner in his representation. He is to use the poet not only as narrator, but also as poet.

But this second kind of imitation, which is so degrading to the poet—why is it not equally so to the artist? If such a series of paintings as Count Caylus found in Homer had existed as paintings before Homer's time, and if we knew that the poet had derived his work from these paintings, would he not lose an immeasurable part of our admiration? Why, then, do we not withdraw any of our esteem from the artist when he actually does nothing more than express the poet's words in lines and color?

The cause for this seems to be the following: we believe that for the artist execution is more difficult than invention; but for the poet the reverse is true, and execution seems easier for him than invention. If Virgil had copied the winding of the serpents about Laocoön and his sons from the statue, his de-

62

scription would lose its merit, for what we consider the greater and more difficult part would already have been done, and only the less significant part would have remained. For it is far more important to conceive this entanglement by the serpents in the imagination than to express it in words. But if, on the other hand, the artist had borrowed this entanglement from the poet, he would still retain sufficient merit in our eyes, although the honor of invention would not be his. Expression in marble is infinitely more difficult than expression in words, and when we weigh invention and representation against each other, we are inclined to make allowances to the master in the one in exactly the same proportion as we believe that we have been given too much of the other.

There are even cases where the merit of the artist is greater when he has imitated nature by following the poet's imitation. The painter who produces a beautiful landscape from the description of a Thomson has done more than one who copies directly from nature. This is because the latter has his original model directly before him, while the former must first apply his imagination until he believes that he has it before him. The latter creates something beautiful out of indefinite and weak images of arbitrary symbols.

However, our natural readiness to excuse the artist from the merit of invention has led him equally naturally to become indifferent toward it. For when he saw that invention could never become his strong point and that his greatest strength lay in execution, it became a matter of indifference to him whether his subject was old or new, used once or a thousand times, or whether it belonged to him or to someone else. He remained within the narrow circle of subjects which had grown familiar to himself and his public and concentrated his whole inventive faculty on variations of subjects already known, viz., upon new combinations of old subjects. And that is, in point of fact, the idea which textbooks on painting connect with the word invention; for although they go so far as to divide it into artistic and poetic invention, this latter does not extend to the production of subjects themselves, but solely

to arrangement or expression.[1] It is invention, and yet it is not the invention of a whole but of individual parts and their relative positions. It is invention, but of that lesser kind which Horace recommends to his tragic poet:

> Tuque
> Rectius Iliacum carmen deducis in actus,
> Quam si proferres ignota indictaque primus.[2]

Recommends, I say, and not prescribes. Recommends as easier, more convenient, more advantageous to him—but does not prescribe as being better and nobler in itself.

As a matter of fact, the poet who treats of a well-known story or well-known characters has a great advantage. He can omit the hundred pedantic details which would otherwise be indispensable to an understanding of the whole; and the sooner he makes himself understood to his audience, the more quickly he can arouse their interest. The artist has this advantage, too, when his subject is not new to us, when we recognize at first glance the intent and meaning of his entire composition, and when we not only see that his characters are speaking, but also hear what they are saying. The greatest effect depends on the first glance, but if this forces us into laborious reflection and guessing, our desire to be moved is immediately cooled. In order to avenge ourselves on the incomprehensible artist we harden our feelings against the expression of the figures, and woe to him if he has sacrificed beauty for expression! In such a case we find nothing that induces us to linger before his work. What we see we do not like; and what the artist wants us to think, we do not know.

Let us consider both these points together: firstly, invention and originality are by no means the most important things that we demand of the painter; secondly, a well-known subject promotes and renders more accessible the effect of his art. The reason why artists so seldom select new subjects should not be sought, as Count Caylus does, in indolence, or igno-

[1] [Von Hagedorn] *Betrachtungen über die Malerei*, pp. 159ff.

[2] *Ad Pisones* 128-30. ["You would do better to dramatize the epic of Troy than to be the first to come out with unknown and heretofore untreated subjects."]

rance, or in technical difficulties of his art. We shall find the reason more deeply founded and perhaps be inclined to praise in the artist as wise self-restraint useful to ourselves what at first appears to be a limitation of art and an interference with our pleasure. I have no fear that experience will contradict me. Painters will thank the Count for his good intentions but hardly make as general use of them as he expects. But even if they should do so, a new Caylus would be needed in another hundred years to bring the old subjects back to our mind and to lead the artist back to that field where others before him earned such immortal laurels. Or do we require the public to be as learned as the critic with his books? And do we expect the public to be as familiar with all the scenes of history and fable that provide subject matter for a beautiful picture? I grant that the artists would have done better if, since Raphael's time, they had used Homer instead of Ovid as their reference book. But since this has not been the case, let us leave the public on its old track and not force it to pay more dearly for its pleasure than is necessary to make the pleasure what it is supposed to be.

Protogenes painted the mother of Aristotle. I do not know how much the philosopher paid him for it, but either instead of a payment, or in addition to it, he gave him some advice more valuable than the payment itself could have been. For I cannot imagine that his advice was given merely for the sake of flattery. I believe, rather, that because he considered it important for art to be universally intelligible he advised Protogenes to paint the deeds of Alexander—deeds which at that time all the world spoke of and which, as he could foresee, would remain unforgettable to future generations as well. But Protogenes was not mature enough to follow his advice. "Impetus animi," Pliny says, "et quaedam artis libido." [3] A certain exuberance of spirit in art, a certain craving for the curious and unknown drove him to other, utterly different subjects. He chose rather to paint the story of an Ialysus,[b] a Cydippe, and such figures, whose meaning we can no longer even guess.

[3] XXXV. 36, p. 700 (ed. Hard.). ["The impulse of his mind and a certain enthusiasm in mastering his art."]

CHAPTER TWELVE

Homer treats of two kinds of beings and actions, visible and invisible. This distinction cannot be made in painting, where everything is visible and visible in but one way. Hence, when Count Caylus makes the pictures of invisible actions follow the visible ones in an unbroken sequence, and when in his paintings showing mixed actions, i.e., those in which both visible and invisible beings take part, he does not and perhaps cannot specify how the latter (which only we who look at the picture are supposed to discover in it) are to be introduced so that the figures in the painting do not see them (or at least appear not to see them)—when Count Caylus does this, I say, the series as a whole as well as a number of single pictures necessarily become extremely confused, incomprehensible, and self-contradictory.

Still, with the book before us it would be possible to remedy this fault. The worst of it is that when painting erases the distinction between visible and invisible beings it simultaneously destroys all those characteristic features by which this latter, higher order is raised above the lower one.

For example, when the gods, who are divided as to the fate of the Trojans, finally come to blows, the entire battle is represented in the poem as being invisible.[1] This invisibility gives the imagination free rein to enlarge the scene and envisage the persons and actions of the gods on a grander scale than the measure of ordinary man. But painting must adopt a visible scene, whose various indispensable parts become the scale for the figures participating in it—a scale which the eye has ready at hand and whose lack of proportion to the higher beings makes them appear monstrous on the artist's canvas.

Minerva, whom Mars ventures to attack first in this battle, steps back and with her mighty hand seizes a large, black,

[1] *Iliad* XXI. 385.

rough stone which the united strength of men had rolled there
for a landmark in times past:

ἡ δ' ἀναχασσαμένη λίθον εἵλετο χειρὶ παχείῃ
κείμενον ἐν πεδίῳ, μέλανα, τρηχύν τε μέγαν τε,
τόν ῥ' ἄνδρες πρότεροι θέσαν ἔμμεναι οὖρον ἀρούρης· [2]

In order to form a proper estimate of the size of this stone
we should remember that Homer makes his heroes twice as
strong as the strongest men of his own time but tells us that
these again were surpassed in strength by the men whom
Nestor knew in his youth. Now I ask, if Minerva hurls a stone
which no one man, not even one from Nestor's youth, could
set up as a landmark—if Minerva hurls such a stone at Mars,
of what stature is the goddess supposed to be? If her stature is
in proportion to the size of the stone, then the element of the
marvelous disappears. A man three times my size naturally
ought to be able to hurl a stone three times as large as I can.
But if the stature of the goddess is not in proportion to the
size of the stone, an improbability for the eye arises in the
painting whose offensiveness is not removed by the cold cal-
culation that a goddess must possess superhuman strength.
Wherever I see a greater effect, I also expect to see a greater
cause.

And Mars, thrown to the ground by this mighty stone,

ἑπτὰ δ' ἐπέσχε πέλεθρα πεσών,

covered seven acres of land.[3] It is impossible for the painter
to give the god this extraordinary size, and yet if he does not
do so, it is no longer Mars—or at least not the Homeric Mars
—who is lying on the ground, but a common warrior.[a]

Longinus says that it seemed to him now and then as though
Homer raised his men to gods and reduced his gods to men.
Painting carries out this reduction. In it everything which in

[2] [*Iliad* XXI. 403-5 (tr. Lattimore):
"but Athene giving back caught up in her heavy hand a stone
that lay in the plain, black and rugged and huge, one which men
of a former time had set there as boundary mark of the cornfield."]

[3] [*Iliad* XXI. 407: "He covered seven acres (hides)."]

the poem raises the gods above godlike human creatures van-
ishes altogether. Size, strength, and swiftness—qualities which
Homer always has in store for his gods in a higher and more
extraordinary degree than that bestowed on his finest heroes [b]
—must in the painting sink to the common level of humanity.
Jupiter and Agamemnon, Apollo and Achilles, Ajax and Mars
all become exactly the same kind of beings, recognizable by
nothing more than their outward conventional symbols.

The means which painting uses to convey to us that this
or that object must be thought of as invisible is a thin cloud
veiling the side of the object that is turned toward the other
persons in the pictures. It appears that this cloud was bor-
rowed from Homer, for when in the tumult of battle one of
the more important heroes runs into great danger, from which
only a divine power can save him, the poet has the protecting
divinity envelop him in a thick cloud, or in darkness, and so
carry him away, as Paris is carried off by Venus,[4] or Idaeus by
Neptune,[5] or Hector by Apollo.[6] And Caylus never fails to
recommend heartily this mist or cloud to the artist when he
outlines for him a painting of such occurrences. And yet who
can fail to see that concealment by cloud or night is, for the
poet, nothing more than a poetic expression for rendering a
thing invisible? For that reason it has always been a source of
surprise to me to see this poetic expression actually used and
a real cloud introduced in the painting, behind which the
hero stands hidden from his enemy as behind a screen. That
was not what the poet intended. It exceeds the limits of paint-
ing, for in this case the cloud is a true hieroglyphic, a mere
symbol, which does not render the rescued hero invisible, but
says to the spectators: you must imagine to yourselves that he

[4] *Iliad* III. 381. [This occurred when Paris was fighting with Menelaus,
who had caught him by the helmet and was about to overcome him.]

[5] *Ibid.*, V. 23. [Actually, it was Vulcan who rescued Idaeus from the
battle and hid him in a cloud. Idaeus, son of the Trojan Dares, had been
fighting with his brother against Diomedes. When the former fell, Idaeus
was saved by the god.]

[6] *Ibid.*, XX. 444. [In the fight with Achilles.]

is invisible. It is no better than the scrolls that issue from the mouths of figures in old Gothic paintings.

It is true that when Apollo rescues Hector from Achilles, Homer has the latter make three further thrusts with his spear into the thick mist (τρὶς δ' ἠέρα τύψε βαθεῖαν).[7] But in the language of poetry this means only that Achilles was so enraged that he made the three additional thrusts before realizing that his enemy was no longer before him. Achilles did not see an actual mist, and the power of the gods to render invisible did not lie in any mist, but in their ability to bear the object away swiftly. It was only to show that this abduction took place too quickly for the human eye to follow the disappearing body that the poet first conceals it in a mist or cloud. And it was not because a cloud appeared in place of the abducted body, but because we think of that which is wrapped in mist as being invisible. Accordingly, Homer sometimes inverts the case, and instead of rendering the object invisible, causes the subject to be struck blind. For example, Neptune blinds Achilles when he rescues Aeneas from his murderous hands by suddenly snatching him out of the thick of the fight and placing him in the rear.[8] Actually, however, Achilles' eyes are no more blinded than, in the former example, the abducted heroes are wrapped in a cloud. The poet merely makes this or that addition in order to make more palpable to our senses that extreme rapidity of abduction which we call disappearance.

However, painters have appropriated the Homeric mist not only in those cases where Homer himself used it, or would have used it (namely, in rendering persons invisible or causing them to disappear), but in every instance where the spectator is supposed to see something in the painting which the characters themselves, or some of them, cannot see. Minerva became visible to Achilles alone when she prevented him from assaulting Agamemnon. I know of no other way to express this, says Caylus, than by concealing her from the rest of the

7 *Ibid.*, XX. 446.
8 *Ibid.*, XX. 321.

council by a cloud. But this is in complete violation of the spirit of the poet! Invisibility is the natural condition of his gods; no blindfolding, no interruption of the rays of light is needed to prevent them from being seen; [e] but an enlightenment, an increased power of mortal vision is required, if they are intended to be seen. Thus it is not only that in painting the cloud is an arbitrary and not a natural sign; but this arbitrary sign does not even possess the definite distinctness which it could have as such, for it is used both to render the visible invisible and the invisible visible.

CHAPTER THIRTEEN

If Homer's works had been completely lost to us, if we had nothing more of the *Iliad* and the *Odyssey* than a series of paintings such as those which Caylus has sketched in outline, would we be able to form from them—even assuming they were done by the most accomplished artist—the notion we now have, I do not say of the whole poet, but merely of his descriptive talent?

Let us test this with a work selected at random, with the painting of the plague, let us say.[1] What do we see on the artist's canvas? Dead bodies, burning funeral pyres, the dying busy with the dead, and the enraged god up on a cloud shooting off his arrows. The greatest wealth of this painting is poverty in the poem. For if we were to restore Homer from it, what could we make him say? "At this Apollo grew angry and shot his arrows at the army of the Greeks. Many Greeks died and their bodies were cremated." Now let us read Homer himself:

Βῆ δὲ κατ᾽ Οὐλύμποιο καρήνων χωόμενος κῆρ,
τόξ᾽ ὤμοισιν ἔχων ἀμφηρεφέα τε φαρέτρην.
ἔκλαγξαν δ᾽ ἄρ᾽ ὀϊστοὶ ἐπ᾽ ὤμων χωομένοιο,
αὐτοῦ κινηθέντος· ὁ δ᾽ ἤϊε νυκτὶ ἐοικώς.
ἕζετ᾽ ἔπειτ᾽ ἀπάνευθε νεῶν, μετὰ δ᾽ ἰὸν ἕηκεν·
δεινὴ δὲ κλαγγὴ γένετ᾽ ἀργυρέοιο βιοῖο.
οὐρῆας μὲν πρῶτον ἐπῴχετο καὶ κύνας ἀργούς,
αὐτὰρ ἔπειτ᾽ αὐτοῖσι βέλος ἐχεπευκὲς ἐφιεὶς
βάλλ᾽· αἰεὶ δὲ πυραὶ νεκύων καίοντο θαμειαί.[a]

The poet is as far above the painter here as life itself is above the painting. Armed with bow and quiver, the enraged Apollo descends from the peaks of Olympus. I not only see him descending, I hear him also. At every step the arrows rattle upon the angry god's shoulders. He strides on, like the

[1] *Iliad* I. 44-53; [Caylus], *Tableaux tirés de l'Iliade*, p. 70.

night. Now he sits opposite the ships and lets the first arrow fly at the mules and dogs. Dreadful is the clang of the silver bow. Then, with more poisonous dart, he smites the men themselves; and everywhere the pyres of the dead burn incessantly. It is impossible to translate this musical picture which the words of the poet present into another language. And it is equally impossible to form an idea of it from the material painting, even though this is only the smallest advantage that the poetic description has over the painting. The principal superiority is that the poet leads us to the scene through a whole gallery of paintings, of which the material picture shows only one.

But perhaps the plague is not a profitable subject for painting. Here is another, which has a greater charm for the eye. The gods are deliberating at a banquet.[2] An open, golden palace, occasional groups of the most beautiful and dignified figures, each with cup in hand, ministered to by Hebe, the personification of eternal youth. What setting, what masses of light and shadow, what contrasts, what variety of expression! Where can I begin, and where cease, to feast my eyes? If the painter enchants me this way, how much more so will the poet! I open his work and I find myself deceived! I find four good, plain verses which could serve as the caption for a painting, but which, though they contain the subject matter for a painting, are in themselves no picture.

> Οἱ δὲ θεοὶ πὰρ Ζηνὶ καθήμενοι ἠγορόωντο
> χρυσέῳ ἐν δαπέδῳ, μετὰ δέ σφισι πότνια Ἥβη
> νέκταρ ἐῳνοχόει· τοὶ δὲ χρυσέοις δεπάεσσι
> δειδέχατ᾽ ἀλλήλους, Τρώων πόλιν εἰσορόωντες.[b]

An Apollonius, or an even more mediocre poet, would not have said this more poorly; and Homer here is as inferior to the painter as the painter was beneath him earlier.

Add to this the fact that in the entire fourth book of the *Iliad* Caylus cannot find a single picture except in these four lines. However much, he says, the fourth book is distinguished

2 *Ibid.*, IV. 1-4; [Caylus], p. 30.

by various speeches encouraging to attack, by the abundance of brilliant and striking characters, and by the art with which the poet depicts the multitude he is about to set in motion, it is still quite useless to painters. He might have added: however rich it is in what we call poetic pictures. For in truth, there occur in the fourth book as numerous and as perfect pictures as can be found in any of the other books. Where can we find a more elaborate or more vivid picture than that of Pandarus [3] breaking the truce at Minerva's instigation and firing his arrow at Menelaus? Or than that of the advance of the Greek army? Or than that of the mutual charge? Or than that of Ulysses' deed, by which he avenges the death of his friend Leucus?[4]

But what conclusion may we draw from all this? That not a few of Homer's most beautiful descriptions furnish no picture for the artist? That the artist can find material for pictures in Homer where he has none? That the pictures which Homer does present and which the artist can use would be but pitiable descriptions if they showed no more than the artist does? What other conclusions can we draw but the negative of the question I put at the beginning of this chapter? Thus, we must conclude that from material paintings for which Homer's poems supply the subjects, no matter how numerous or excellent they may be, we can come to no decision in regard to the pictorial talent of the poet.

3 [A famous Trojan archer. The breaking of the truce is described in the fourth book of the *Iliad*.]

4 [Leucus, one of the Greek heroes and a friend of Odysseus, was killed by Antiphos, son of Priam.]

CHAPTER FOURTEEN

But if it is true that one poem though not in itself pictorial can be very suggestive to the painter, while another poem may be highly pictorial and yet not fruitful for the painter, this puts an end to the notion of Count Caylus, who would make the test of a poem its usefulness to the painter and who would rank poets according to the number of paintings for which they furnish subjects to the artist.[a]

Far be it from us even by our silence to allow this notion to gain the appearance of a rule. Milton would be the first innocent victim of this, for it seems that the contemptuous judgment which Caylus passes on him was the result as much of national taste as of his would-be rule. The loss of sight, he says, may well be the strongest point of similarity between Milton and Homer. Milton cannot fill picture galleries, it is true. But if the range of my physical sight must be the measure of my inner vision, I should value the loss of the former in order to gain freedom from the limitations on the latter.

Paradise Lost is no less the finest epic after Homer because it furnishes few pictures, than the story of Christ's Passion *is* a poem because one can hardly touch it anywhere without hitting on a spot that has suggested subjects to a multitude of the greatest artists. The evangelists recount the story with the barest possible simplicity, and the artist makes use of its numerous parts without the former having demonstrated the slightest spark of poetically pictorial genius. There are paintable and unpaintable facts, and the historian can relate the most paintable ones just as unpicturesquely as the poet is able to present the most unpaintable ones in a picturesque way.

To see it differently would be permitting ourselves to be misled by the ambiguity of the word "picture." A poetic picture is not necessarily something that can be converted into a material painting; but every detail, every combination of de-

tails by which the poet makes his subject so palpable to us that we become more conscious of the subject than of his words, is picturesque, is a picture. This holds true because it brings us closer to that degree of illusion which the material painting is especially qualified to produce, and which for us can best and most easily be drawn from the material picture.[b]

CHAPTER FIFTEEN

As experience shows, the poet can raise to this degree of illu-
sion the representation of objects other than those that are
visible. Consequently, whole categories of pictures which the
poet claims as his own must necessarily be beyond the reach
of the artist. Dryden's *Song for St. Cecelia's Day* [1] is full of mu-
sical pictures which leave the painter's brush idle. But I do
not want to stray too far from my subject with such examples,
from which in the final analysis we learn little more than that
colors are not sounds and ears not eyes.[a]

I will confine myself rather to the consideration of pictures
of visible objects only, which are common to both poet and
painter. Why is it that a number of poetic pictures of this kind
are of no use to the painter and, conversely, many real pic-
tures lose most of their effect when treated by the poet? Ex-
ample may guide me here. I repeat: the picture of Pandarus
in the fourth book of the *Iliad* is one of the most elaborate and
graphic in all of Homer. From the seizing of the bow to the
flight of the arrow every moment is painted, and all these
moments follow in such close succession and yet are so distinct,
one from the other, that if we did not know how a bow should
be handled, we would be able to learn it from this description
alone.[b] Pandarus takes out his bow, strings it, opens the quiver,
chooses an unused, well-feathered arrow, adjusts the arrow's
notch to the string and draws both back; the string is brought
close to the breast, the metal point of the arrow comes close
to the bow, the great round bow springs open again with a
clang, the string vibrates, and the arrow has sped away, flying
eagerly toward its mark.

Caylus cannot have overlooked this splendid picture. What,
then, did he find there to make him consider it unable to

[1] [Also called *Alexander's Feast*, this ode was written in 1687 and set to
music by Handel in 1739.]

76

afford material to his artists? And why was it that the council of deliberating and drinking gods seemed to him better suited for his purpose? The subjects are visible in both cases, and what more than visible subjects does the painter need to fill his canvas?

The difficulty must be this: although both subjects, being visible, are equally suitable for actual painting, there is still this essential difference between them: in the one case the action is visible and progressive, its different parts occurring one after the other in a sequence of time, and in the other the action is visible and stationary, its different parts developing in co-existence in space. But if painting, by virtue of its symbols or means of imitation, which it can combine in space only, must renounce the element of time entirely, progressive actions, by the very fact that they are progressive, cannot be considered to belong among its subjects. Painting must be content with coexistent actions or with mere bodies which, by their position, permit us to conjecture an action. Poetry, on the other hand. . . .

CHAPTER SIXTEEN

But I shall attempt now to derive the matter from its first principles.

I reason thus: if it is true that in its imitations painting uses completely different means or signs than does poetry, namely figures and colors in space rather than articulated sounds in time, and if these signs must indisputably bear a suitable relation to the thing signified, then signs existing in space can express only objects whose wholes or parts coexist, while signs that follow one another can express only objects whose wholes or parts are consecutive.

Objects or parts of objects which exist in space are called bodies. Accordingly, bodies with their visible properties are the true subjects of painting.

Objects or parts of objects which follow one another are called actions. Accordingly, actions are the true subjects of poetry.

However, bodies do not exist in space only, but also in time. They persist in time, and in each moment of their duration they may assume a different appearance or stand in a different combination. Each of these momentary appearances and combinations is the result of a preceding one and can be the cause of a subsequent one, which means that it can be, as it were, the center of an action. Consequently, painting too can imitate actions, but only by suggestion through bodies.

On the other hand, actions cannot exist independently, but must be joined to certain beings or things. Insofar as these beings or things are bodies, or are treated as such, poetry also depicts bodies, but only by suggestion through actions.

Painting can use only a single moment of an action in its coexisting compositions and must therefore choose the one which is most suggestive and from which the preceding and succeeding actions are most easily comprehensible.

Similarly, poetry in its progressive imitations can use only one single property of a body. It must therefore choose that one which awakens the most vivid image of the body, looked at from the point of view under which poetry can best use it. From this comes the rule concerning the harmony of descriptive adjectives and economy in description of physical objects.

I should put little faith in this dry chain of reasoning did I not find it completely confirmed by the procedure of Homer, or rather if it had not been just this procedure that led me to my conclusions. Only on these principles can the grand style of the Greek be defined and explained, and only thus can the proper position be assigned to the opposite style of so many modern poets, who attempt to rival the painter at a point where they must necessarily be surpassed by him.

I find that Homer represents nothing but progressive actions. He depicts bodies and single objects only when they contribute toward these actions, and then only by a single trait. No wonder, then, that where Homer paints, the artist finds little or nothing to do himself; and no wonder that his harvest can be found only where the story assembles a number of beautiful bodies in beautiful positions and in a setting favorable to art, however sparingly the poet himself may paint these bodies, these positions, and this setting. If we go through the whole series of paintings as Caylus proposes them, one by one, we find that each is a proof of this remark.

At this point I shall leave the Count, who wants to make the artist's palette the touchstone of the poet,[a] in order to analyze the style of Homer more closely.

Homer, I say, generally gives only one single characteristic to each object. To him a ship is a black ship, or a hollow ship, or a fast ship, or at most a well-manned black ship. He goes no further than this in describing a ship. But the departure, the sailing away, the putting in to shore are the things which he combines in a detailed picture—one which the artist would have to break up into five or six individual pictures if he wanted to put the whole of it on canvas.

Even when Homer is forced by peculiar circumstances to fix

our attention longer on a single object, he still does not create a picture which the artist could imitate with his brush. On the contrary! By means of countless artistic devices he places this single object in a series of stages, in each of which it has a different appearance. In the last stage the artist must wait for the poet in order to show us complete what we have seen the poet making. For example, if Homer wants to show us Juno's chariot, he shows Hebe putting it together piece by piece before our eyes. We see the wheels and axle, the seat, the pole, the traces, and the straps, not as these parts are when fitted together, but as they are actually being assembled by Hebe. It is only to the wheels that Homer devotes more than a single epithet; he shows us the eight bronze spokes, the golden rims, the bronze tires, the silver hubs, one by one. We might almost say that since there was more than one wheel, exactly as much additional time had to be devoted to them in the description as would have been required to fasten them on separately in reality.[1]

Ἥβη δ' ἀμφ' ὀχέεσσι θοῶς βάλε καμπύλα κύκλα,
χάλκεα ὀκτάκνημα, σιδηρέῳ ἄξονι ἀμφίς.
τῶν ἤτοι χρυσέη ἴτυς ἄφθιτος, αὐτὰρ ὕπερθεν
χάλκε' ἐπίσσωτρα προσαρηρότα, θαῦμα ἰδέσθαι·
πλῆμναι δ' ἀργύρου εἰσὶ περίδρομοι ἀμφοτέρωθεν.
δίφρος δὲ χρυσέοισι καὶ ἀργυρέοισιν ἱμᾶσιν
ἐντέταται, δοιαὶ δὲ περίδρομοι ἄντυγές εἰσιν.
τοῦ δ' ἐξ ἀργύρεος ῥυμὸς πέλεν· αὐτὰρ ἐπ' ἄκρῳ
δῆσε χρύσειον καλὸν ζυγόν, ἐν δὲ λέπαδνα
κάλ' ἔβαλε, χρύσει'·[b]

And when Homer wants to show us how Agamemnon was dressed, he has the king put on his garments, one by one, before our eyes: the soft chiton, the great cloak, the beautiful sandals, the sword. Now he is ready and takes up his scepter. We see the garments while the poet is describing the act of dressing; another poet would have described the garments themselves down to the smallest fringe, and we should have seen nothing of the action itself.[2]

[1] *Iliad* V. 722-731. [2] *Ibid.*, II. 43-47.

μαλακὸν δ' ἔνδυνε χιτῶνα,
καλὸν νηγάτεον, περὶ δὲ μέγα βάλλετο φᾶρος·
ποσσὶ δ' ὑπὸ λιπαροῖσιν ἐδήσατο καλὰ πέδιλα,
ἀμφὶ δ' ἄρ ὤμοισιν βάλετο ξίφος ἀργυρόηλον.
εἵλετο δὲ σκῆπτρον πατρώϊον, ἄφθιτον αἰεί· [c]

Here the scepter is called merely paternal and imperishable, just as a similar one is elsewhere described [3] merely as the golden-studded scepter, χρυσέιοις ἥλοισι πεπάρμενον. But what does Homer do when we require a more complete and accurate picture of this important scepter? Does he describe the wood and the carved knob in addition to the golden studs? Of course he would do so if the description were intended for a handbook of heraldic art, so that at some later time an exact duplicate of it could be made. And I am quite certain that many a modern poet would have given us just such a heraldic description, in the naïve belief that he himself had painted a picture because the painter can follow his description with the brush. But what does Homer care how far he outstrips the painter? Instead of an illustration he gives us the story of the scepter. First it is being made by Vulcan; next it glitters in the hands of Jupiter; now it is a symbol of the dignity of Mercury; now it is the martial wand of the warlike Pelops; now it is the shepherd's staff of the peaceful Atreus, etc.

σκῆπτρον ἔχων· τὸ μὲν Ἥφαιστος κάμε τεύχων·
Ἥφαιστος μὲν δῶκε Διὶ Κρονίωνι ἄνακτι,
αὐτὰρ ἄρα Ζεὺς δῶκε διακτόρῳ Ἀργειφόντῃ·
Ἑρμείας δὲ ἄναξ δῶκεν Πέλοπι πληξίππῳ,
αὐτὰρ ὁ αὖτε Πέλοψ δῶκ' Ἀτρέϊ, ποιμένι λαῶν·
Ἀτρεὺς δὲ θνῄσκων ἔλιπεν πολύαρνι Θυέστῃ,
αὐτὰρ ὁ αὖτε Θυέστ' Ἀγαμέμνονι λεῖπε φορῆναι,
πολλῇσιν νήσοισι καὶ Ἄργεϊ παντὶ ἀνάσσειν· [4, d]

And so finally I know this scepter better than if a painter were to place it before my eyes or a second Vulcan in my very hands. I should not be surprised if I found that one of the ancient commentators on Homer had praised this passage as being the most perfect allegory of the origin, development, strengthen-

<hr />

3 [Ibid., I. 246.] 4 Ibid., II. 101-108.

ing, and ultimate hereditary succession of royal power among men. I should smile, to be sure, if I were to read that the forger of the scepter, Vulcan, as the personification of fire, of that which is most important to man's preservation, represented the alleviation of all those general wants which induced the first men to submit to a single ruler. Or if I were to read that the first king, a son of Time (Ζεὺς Κρονίων), was a venerable patriarch who was willing to share with or even relinquish his power entirely to an eloquent and able man, a Mercury (Διακτόρῳ 'Αργεϊφόντῃ). Or that the clever orator, at a time when the young nation was threatened by foreign enemies, handed over his authority to the bravest warrior (Πέλοπι πληξίππῳ). And that the brave warrior, after he had subdued the enemy and secured the realm, could manipulate this power into his son's hands; who in turn, and as a peace-loving regent and benevolent shepherd of his people (ποιμὴν λαῶν), brought them prosperity and superabundance, and at whose death the way was paved for the richest of his relatives (πολύαρνι Θυέστῃ) to appropriate by means of gifts and bribes, and afterwards to secure for his family as if it were a property he had purchased, that which only confidence had bestowed before and merit had considered a burden rather than an honor. I should smile at all this, but it would strengthen my regard for the poet to whom so much can be attributed. But this is not my present concern, and I am regarding the history of the scepter merely as an artistic device, by means of which the poet causes us to linger over a single object without entering into a tiring description of its parts.

Again, when Achilles swears by his scepter to avenge the contemptuous way in which Agamemnon treated him, Homer gives us the history of this scepter. We see it verdant on the hills; the iron divides it from the trunk, deprives it of its leaves and bark and renders it suitable to serve the judges of the people as a symbol of their godlike dignity.[5]

[5] *Ibid.*, IV[I]. 234-239.

ναὶ μὰ τόδε σκῆπτρον, τὸ μὲν οὔποτε φύλλα καὶ ὄζους
φύσει, ἐπειδὴ πρῶτα τομὴν ἐν ὄρεσσι λέλοιπεν,
οὐδ' ἀναθηλήσει· περὶ γάρ ῥά ἑ χαλκὸς ἔλεψε
φύλλα τε καὶ φλοιόν· νῦν αὐτέ μιν υἷες Ἀχαιῶν
ἐν παλάμῃς φορέουσι δικασπόλοι, οἵτε θέμιστας
πρὸς Διὸς εἰρύαται.ᵉ

Homer was not so much concerned with describing two staffs
of differing shape and material, as to give us a clear image of
the difference in power which the two staffs symbolized. The
one the work of Vulcan; the other, cut from the mountain-
side by some unknown hand. The one an ancient possession
of a noble house; the other destined to fit the hand of any
who might chance to grasp it. The one wielded by a monarch
over many islands and over all of Argos; the other held by one
from the midst of the Greeks, to whom, with others, the
guardianship of the laws had been entrusted. This was the
real difference between Agamemnon and Achilles; a difference
which Achilles himself, in spite of all his blind rage, could
not help but acknowledge.

But it is not only where Homer combines such further aims
with his descriptions that he disperses the image of his object
over a kind of history of it; he does this also where his sole
object is to show us the picture, in order that its parts which
in nature we find side by side may follow one another in his
description just as naturally, and keep pace, as it were, with
the progress of the narrative. For example, he wishes to show
us the bow of Pandarus: a bow of horn, of such and such a
length, well polished and tipped on both ends with gold.
What does he do? Does he dryly enumerate all these things,
one after the other? Far from it! That would be to show us
such a bow and to describe how it was to be made, but not to
paint it. He begins with the wild goat hunt, from whose horns
the bow was made. Pandarus had lain in wait for the goat in
the rocks and had killed it. The horns were of an extraordi-
nary size, and for that reason he ordered them to be made
into a bow. The work on the bow begins, the artisan joins

the horns together, polishes them and tips them with metal. And so, as I have said, we see in the poet's work the origin and formation of that which in the picture we can only behold as completed and formed.[6]

τόξον ἐύξοον ἰξάλου αἰγὸς
ἀγρίον, ὅν ῥά ποτ᾽ αὐτὸς ὑπὸ στέρνοιο τυχήσας
πέτρης ἐκβαίνοντα, δεδεγμένος ἐν προδοκῆσιν,
βεβλήκει πρὸς στῆθος· ὁ δ᾽ ὕπτιος ἔμπεσε πέτρῃ.
τοῦ κέρα ἐκ κεφαλῆς ἑκκαιδεκάδωρα πεφύκει·
καὶ τὰ μὲν ἀσκήσας κεραοξόος ἤραρε τέκτων,
πᾶν δ᾽ εὖ λειήνας, χρυσέην ἐπέθηκε κορώνην.[f]

If I were to set down all the examples of this sort, I should never finish the task. They will occur in great number to everyone who is familiar with his Homer.

6 *Ibid.*, IV. 105-111.

CHAPTER SEVENTEEN

But the objection will be raised that the symbols of poetry are not only successive but are also arbitrary; and, as arbitrary symbols, they are of course able to represent bodies as they exist in space. Examples of this might be taken from Homer himself. We need only to recall his shield of Achilles to have the most decisive instance of how discursively and yet at the same time poetically a single object may be described by presenting its coexistent parts.

I shall reply to this twofold objection. I call it twofold because a correct deduction must hold good even without examples; and, conversely, an example from Homer is of importance to me even when I am unable to justify it by means of deduction.

It is true that since the symbols of speech are arbitrary, the parts of a body may, through speech, be made to follow one another just as readily as they exist side by side in nature. But this is a peculiarity of speech and its signs in general and not as they serve the aims of poetry. The poet does not want merely to be intelligible, nor is he content—as is the prose writer—with simply presenting his image clearly and concisely. He wants rather to make the ideas he awakens in us so vivid that at that moment we believe that we feel the real impressions which the objects of these ideas would produce on us. In this moment of illusion we should cease to be conscious of the means which the poet uses for this purpose, that is, his words. This was the substance of the definition of a poetical painting given above. But the poet is always supposed to paint, and we shall now see how far bodies with their coexistent parts adapt themselves to this painting.

How do we arrive at a clear conception of an object in space? We first look at its parts singly, then the combination of parts, and finally the totality. Our senses perform these vari-

ous operations with such astonishing rapidity that they seem
to us to be but one single operation, and this rapidity is abso-
lutely necessary if we are to receive an impression of the whole,
which is nothing more than the result of the conceptions of
the parts and of their combination. Now let us assume that
the poet takes us from one part of the object to the other in
the best possible order; let us assume that he knows how to
make the combination of these parts ever so clear to us; how
much time would he use in doing this? That which the eye
takes in at a single glance he counts out to us with perceptible
slowness, and it often happens that when we arrive at the end
of his description we have already forgotten the first fea-
tures. And yet we are supposed to form a notion of the whole
from these features. To the eye, parts once seen remain con-
tinually present; it can run over them again and again. For
the ear, however, the parts once heard are lost unless they re-
main in the memory. And even if they do remain there, what
trouble and effort it costs to renew all their impressions in
the same order and with the same vividness; to review them
in the mind all at once with only moderate rapidity, to arrive
at an approximate idea of the whole!

Let us test this on an example, which may be called a mas-
terpiece of its kind:

Dort ragt das hohe Haupt vom edeln Enziane
Weit übern niedern Chor der Pöbelkräuter hin,
Ein ganzes Blumenvolk dient unter seiner Fahne,
Sein blauer Bruder selbst bückt sich und ehret ihn.
Der Blumen helles Gold, in Strahlen umgebogen,
Thürmt sich am Stengel auf, und krönt sein grau Gewand,
Der Blätter glattes Weiss, mit tiefem Grün durchzogen,
Strahlt von dem bunten Blitz von feuchtem Diamant.
Gerechtestes Gesetz! dass Kraft sich Zier vermähle,
In einem schönen Leib wohnt eine schönre Seele.

Hier kriecht ein niedrig Kraut, gleich einem grauen Nebel,
Dem die Natur sein Blatt im Kreuze hingelegt;
Die holde Blume zeigt die zwei vergöldten Schnäbel,
Die ein Amethyst gebildter Vogel trägt.
Dort wirft ein glänzend Blatt, in Finger ausgekerbet,

Auf einen hellen Bach den grünen Wiederschein;
Der Blumen zarten Schnee, den matten Purpur färbet,
Schliesst ein gestreifter Stern in weisse Strahlen ein.
Smaragd und Rosen blühn auch auf zertretner Heide,
Und Felsen decken sich mit einem Purpurkleide.[a]

These are herbs and flowers which the learned poet paints
with great art and fidelity to nature. Paints, I say, but without
producing a trace of illusion. I do not mean to say that anyone
who has never seen these herbs and flowers can form practi-
cally no notion at all of them from his painting. It may be
that all poetic painting demands a previous knowledge of its
subject. Nor will I deny that the poet might awaken a more
vivid idea of some of its details in one who has the advantage
of such knowledge. I ask him only: what about the conception
of the whole? If this is to be more vivid, too, then no single
part must be given prominence, but all parts must seem
equally illuminated. Our imagination must be able to survey
them all with the same rapidity in order to construct from
them in one moment that which can be seen in one moment
in nature. Is that the case here? And if it is not, how can it
have been said that "the most faithful drawing by a painter
would appear weak and dull in comparison with this poetic
description"?[1] It remains infinitely inferior to what lines
and colors can express on canvas, and the critic who praised
it in this exaggerated manner must have looked at it from a
completely false point of view. He must have paid greater
regard to the foreign ornaments which the poet has inter-
woven with it, to its elevation above vegetable life, to the
development of those inner perfections which external beauty
serves merely as a shell, than to this beauty itself and the de-
gree of vividness and fidelity of the picture which the painter
and the poet respectively can give us. For all that, it is only
the last which is of importance here, and whoever would say
that the mere lines—

Der Blumen helles Gold in Strahlen umgebogen,
Thürmt sich am Stengel auf, und krönt sein grau Gewand,

[1] Breitinger's *Kritische Dichtkunst*, II, 807.

Der Blätter glattes Weiss, mit tiefem Grün durchzogen,
Strahlt von dem bunten Blitz von feuchtem Diamant

—that these lines, in regard to the impression they make, can
compete with the imitation of a Huysum, must either never
have questioned his feelings or else have wanted deliberately
to belie them. It may be very nice to recite them, holding the
flower in one's hand; but by themselves they say little or
nothing. In every word I hear the poet at work, but I am a
long way from seeing the object itself.

Once more, then: I do not deny to language altogether the
power of depicting the corporeal whole according to its parts.
It can do so because its signs, although consecutive, are still
arbitrary. But I do deny it to language as the medium of
poetry, because the illusion, which is the principal object of
poetry, is wanting in such verbal description of bodies. And
this illusion, I say, must be wanting because the coexistent
nature of a body comes into conflict with the consecutive na-
ture of language, and although dissolving the former into the
latter makes the division of the whole into its parts easier for
us, the final reassembling of the parts into a whole is made
extremely difficult and often even impossible.

In every case, therefore, where illusion is not the object and
where the writer appeals only to the understanding of the
reader and aims only at conveying distinct and, insofar as
this is possible, complete ideas, these descriptions of bodies,
excluded from poetry, are quite in place; and not only the
prose writer, but also the didactic poet (for where he becomes
didactic he ceases to be a poet) can use them to great advan-
tage. For instance, in his *Georgics* Virgil describes a cow good
for breeding in this way:

> . . . Optima torvae
> Forma bovis, cui turpe caput, cui plurima cervix,
> Et crurum tenus a mento palearia pendent.
> Tum longo nullus lateri modus: omnia magna:
> Pes etiam, et camuris hirtae sub cornibus aures.
> Nec mihi displiceat maculis insignis et albo,
> Aut iuga detractans interdumque aspera cornu,

Et faciem tauro propior: quaeque ardua tota,
Et gradiens ima verrit vestigia cauda.^b

Or a beautiful colt:

. . . Illi ardua cervix
Argutumque caput, brevis alvus, obesaque terga;
Luxuriatque toris animosum pectus, etc.^{2, c}

Is it not obvious here that the poet was much more concerned with the description of the parts than with the whole? He wants to enumerate for us the characteristics of a beautiful colt, or a useful cow, in order to put us in a position to judge the worth of this or that specimen if we should encounter one or more of them. But whether or not all these characteristics can be put together readily into one vivid picture is a matter of utter indifference to him.

With the exception of this use, the detailed depictions of physical objects (without the above-mentioned Homeric device for transforming what is coexistent in them into what is really consecutive) have always been recognized by the best critics as being pieces of pedantic trifling, to which little or no genius can be attributed. When the poetaster, says Horace, can do nothing more, he begins to paint a grove, an altar, a brook meandering through pleasant meadows, a rushing stream, a rainbow:

. . . Lucus et ara Dianae,
Et properantis aquae per amoenos ambitus agros,
Aut flumen Rhenum, aut pluvius describitur arcus.³

The mature Pope ⁴ looked back on the descriptive attempts of the poetic works of his youth with great contempt. He demanded expressly that whoever would bear the name of poet with dignity must renounce the mania for description as early as possible, and he called a purely descriptive poem a banquet

2 *Georgics* III. 51-62, 79-80.

3 *Ars Poetica* 16. [Translated in the text above.]

4 [Alexander Pope (1688-1744). Doubtless *Windsor Forest*, published in 1713, but for the most part written in 1704, is especially referred to here (cf. Howard, p. 394).]

of nothing but sauces.[d] In regard to von Kleist I am able to assure you that he prided himself very little on his *Spring*. Had he lived longer, he would have given it a competely different form. He considered giving it a plan and searched for a means of having the host of images, which he seemed to have drawn at random from the infinite realm of rejuvenated nature, arise and follow one another in some natural order before his eyes. At the same time he would have done what Marmontel, no doubt prompted by his *Eclogues*, advised several German poets to do. He would have converted a series of images scantily interwoven with feelings into a succession of feelings sparingly interlaced with images.[e]

CHAPTER EIGHTEEN

And yet should Homer himself have lapsed into this lifeless description of material objects? I do hope that there are but few passages which one can find to support this; and I feel certain that these few passages are of such a nature as to confirm the rule to which they seem to be the exception.

It remains true that succession of time is the province of the poet just as space is that of the painter.

It is an intrusion of the painter into the domain of the poet, which good taste can never sanction, when the painter combines in one and the same picture two points necessarily separate in time, as does Fra Mazzuoli when he introduces the rape of the Sabine women [1] and the reconciliation effected by them between their husbands and relations, or as Titian does when he presents the entire history of the prodigal son, his dissolute life, his misery, and his repentance.

It is an intrusion of the poet into the domain of the painter and a squandering of much imagination to no purpose when, in order to give the reader an idea of the whole, the poet enumerates one by one several parts or things which I must necessarily survey at one glance in nature if they are to give the effect of a whole.

But as two equitable and friendly neighbors do not permit the one to take unbecoming liberties in the heart of the other's domain, yet on their extreme frontiers practice a mutual forbearance by which both sides make peaceful compensation for those slight aggressions which, in haste and from force of circumstance, the one finds himself compelled to make on the other's privilege: so also with painting and poetry.

To support this I will not cite the fact that in great historical paintings the single moment is always somewhat extended, and that perhaps there is not a single work comprising a

1 [Described in the *Aeneid* VIII. 635ff.]

wealth of figures in which each one of them is in exactly that
motion and position it should be in at the moment of the
main action; some are represented in the attitude of a some-
what earlier, others in that of a somewhat later moment. This
is a liberty which the master must justify by certain refine-
ments in the arrangement—in the way he uses his figures and
places them closer to or more distant from the main action—
which permits them to take a more or less momentary part in
what is going on. I shall merely make use of a remark made
by Mengs concerning Raphael's drapery. "In his paintings," he
says, "there is a reason for every fold, whether it be because of
its own weight or because of the movement of the limbs. Some-
times we can tell from them how they were before, and Ra-
phael even tried to attach significance to this. We can see from
the folds whether an arm or a leg was in a backward or for-
ward position prior to its movement; whether the limb had
moved or is moving from contraction to extension, or whether
it had been extended and is now contracted." [2] It is indispu-
table that in this case the artist is combining two different
moments into one. For since that part of the drapery which
lies on the foot immediately follows it in its forward motion—
unless the drapery be of very stiff material and hence entirely
unsuitable for painting—there is no moment in which the
garment can form any other fold whatsoever except that which
the actual position of the limb requires. However, if it is per-
mitted to form a different fold, then the drapery is represented
at the moment preceding and the limb at the following. Nev-
ertheless, who would be so particular with the artist who finds
it advantageous to show us these two moments at the same
time? Who would not praise him rather for having had the
understanding and the courage to commit such a minor error
for the sake of obtaining greater perfection of expression?

The poet deserves the same forbearance. His progressive
imitation actually allows him to allude to only one side, only
one characteristic of his material objects at one time. But when

2 *Gedanken über die Schönheit und über den Geschmack in der Malerei,*
p. 69.

the happy structure of his language permits him to do this in a single word, why should he not be allowed to add a second word now and then? And why not even a third, if it is worth the trouble? Or even a fourth? I have already said that for Homer a ship is only a black ship, or a hollow ship, or a swift ship, or at the most a well-manned black ship. This is to be understood of his style in general. Here and there we find a passage in which he adds a third descriptive epithet: Καμπύλα κύκλα, χάλκεα, ὀκτάκνημα,[3] round, bronze, eight-spoked wheels. And also a fourth: ἀσπίδα πάντοσ᾽ εἴσην, καλὴν, χαλκείην, ἐξήλατον,[4] a uniformly smooth, beautiful, embossed bronze shield. Who would censure him for this? Who would not rather thank him for this little extravagance when he feels what a good effect it can have in some few suitable passages?

But I shall not allow the particular justification of either poet or painter to be based on the above-mentioned analogy of the two friendly neighbors. A mere analogy neither proves nor justifies anything. The following consideration must be their real justification: just as in the painter's art two different moments border so closely on one another that we can, without hesitation, accept them as one, so in the poet's work do the several features representing the various parts and properties in space follow one another in such rapid succession that we believe we hear them all at once.

It is in this, I say, that the excellence of Homer's language aids him unusually well. It not only allows him the greatest possible freedom in the accumulation and combination of epithets, but it finds such a happy arrangement for these accumulated adjectives that the awkard suspension of their noun disappears. Modern languages are lacking entirely in one or more of these advantages. For example, the French must paraphrase the καμπυλα κυκλα, φάλκεα, ὀκτάκνημα with "the round wheels, which were of bronze and had eight spokes." They give the meaning but destroy the picture. Yet the picture is everything here and the meaning nothing; and without the

3 *Iliad* V. 722.
4 *Ibid.*, XII. 294.

former the latter turns the liveliest of poets into a tiresome bore, a fate which has often befallen our good Homer under the pen of the conscientious Madame Dacier. The German language, on the other hand, can usually translate Homer's epithets with equally short equivalent adjectives, although it is unable to imitate the advantageous arrangement of Greek. We can say, to be sure, *die runden, ehernen, achtspeichigten* . . . [the round, brazen, eight-spoked], but *Räder* [wheels] drags behind. Who does not feel that three different predicates, before we learn the subject, can produce only an indistinct and confused picture? The Greek combines the subject and the first predicate, and leaves the others to follow. He says, "round wheels, brazen, eight-spoked." And so we know immediately what he is speaking of. In conformity with the natural order of thought, we first become acquainted with the thing itself and then with its accidents. Our [German] language does not enjoy this advantage. Or should I say, it does enjoy it but can seldom make use of it without ambiguity? Both amount to the same thing. For if we place the adjectives after the subject, they must stand *in statu absoluto*, i.e., in uninflected form. Hence, we must say *runde Räder, ehern und achtspeichigt* (round wheels, brazen and eight-spoked). However, in this *statu* the German adjectives are identical with the German adverbs, and if we take them as such with the next verb that is predicated of the subject, they not infrequently produce a completely false, and in any case a very uncertain meaning.

But I am lingering over trifles and it may appear as if I were going to forget the shield, the shield of Achilles, that is—the famous picture which more than anything else caused Homer to be considered by the ancients a master of painting.[5] A shield, it will be said, is a single material object which the poet cannot present by describing its coexistent parts. And yet Homer, in more than a hundred splendid verses, has de-

5 Dionysius Halicarnassus, *Vita Homeri*, in Thomas Gale, *Opuscula mythologica*, [*ethica et physica*, 1671,] p. 401. [Lessing is not citing Dionysius but is taking his information from Gale.]

scribed this shield, its material, its form, all the figures which filled its enormous surface, so exactly and in such detail that it was not difficult for modern artists to produce a drawing of it exact in every part.

My answer to this particular objection is that I have already answered it. Homer does not paint the shield as finished and complete, but as a shield that is being made. Thus, here too he has made use of that admirable artistic device: transforming what is coexistent in his subject into what is consecutive, and thereby making the living picture of an action out of the tedious painting of an object. We do not see the shield, but the divine master as he is making it. He steps up to the anvil with hammer and tongs, and after he has forged the plates out of the rough, the pictures which he destines for the shield's ornamentation rise before our eyes out of the bronze, one after the other, beneath the finer blows of his hammer. We do not lose sight of him until all is finished. Now the shield is complete, and we marvel at the work. But it is the believing wonder of the eyewitness who has seen it forged.

The same cannot be said of the shield of Aeneas in Virgil. The Roman poet either did not feel the fineness of his model or else the things which he wanted to put on the shield seemed to him to be of such a nature as not to permit their execution before our eyes. They were prophecies, which it would certainly have been improper for the god to utter in our presence as clearly as the poet afterwards explains them. Prophecies as such demand an obscure language in which the actual names of persons of the future, to whom these prophecies refer, do not belong. And yet to all appearances these actual names were of great importance to the poet and courtier.[a] However, if this justifies him, it does not take away the bad effect which his deviation from Homer's style produces here. Readers of refined taste will grant that I am right. The preparations which Vulcan makes for his work are approximately the same in Virgil as in Homer. But while we see not only the preparations but the work itself in Homer, Virgil, after he has shown us the busy god with his Cyclops,

Ingentem clypeum informant . . .
 . . . Alii ventosis follibus auras
Accipiunt, redduntque: alii stridentia tingunt
Aera lacu. Gemit impositis incudibus antrum.
Illi inter sese multa vi brachia tollunt
In numerum, versantque tenaci forcipe massam,[6, b]

suddenly lets the curtain fall and transports us to an entirely
different scene, whence he gradually takes us to the valley in
which Venus comes to Aeneas with the now completed weap-
ons. She leans them against the trunk of an oak, and after the
hero has gaped and stared in wonder at them, and felt and
tried them enough, the description, or painting, of the shield
begins. By its eternal "here is" and "there is," "close by stands"
and "not far off we see," the description becomes so cold and
tedious that all the poetic beauty which a Virgil could give it
was required to keep it from becoming intolerable. Since this
picture which begins now is not delineated by Aeneas, who is
delighted at the mere figures and knows nothing of their
meaning—

 . . . rerumque ignarus imagine gaudet [7]—

nor by Venus (although presumably she must have known as
much about the future destinies of her dear grandchildren as
did the good-natured husband [8]), but comes from the mouth
of the poet himself, it is obvious that the action comes to a
standstill during this time. Not a single one of the char-
acters takes part in the description; it does not exercise the
slightest influence on what follows, regardless of whether this
or something else is represented on the shield; the clever cour-
tier who decks out his material with every sort of flattering
allusion is everywhere in evidence, but not the great genius
who relies entirely on the intrinsic strength of his work and
scorns all external means of awakening interest. Consequently,
the shield of Aeneas is an insertion, intended solely to flatter

6 *Aeneid* VIII. 447-54.
7 [*Aeneid* VIII. 730: "ignorant of the deeds to come, he delights in the
picture."]
8 [Vulcan.]

the national pride of the Romans; an alien stream turned by the poet into his own river in order to stir it up. The shield of Achilles, on the other hand, is the natural growth of its own fertile soil; for a shield had to be made, and since the necessary never comes from the hand of divinity without grace, the shield had to be embellished. But the art lay in treating these embellishments merely as such, in weaving them into the subject and making it show them to us only when there was occasion to do so; and this could be accomplished only in the style of Homer. Homer has Vulcan produce skillful ornaments because he has to produce and does produce a shield worthy of him. Virgil, on the other hand, appears to have him produce the shield for the sake of its decorations, since he considers them important enough to be specially described long after the shield is finished.

CHAPTER NINETEEN

The objections raised by the elder Scaliger, Perrault, Terrasson, and others against Homer's shield are well known, as are the replies of Dacier, Boivin, and Pope. But it seems to me that these latter sometimes go too far, and out of faith in the justness of their cause make claims that are incorrect and contribute little to the justification of the poet. To meet the main objection that Homer filled his shield with a host of figures which could not possibly have found space within its circumference, Boivin undertook to have the shield drawn, being careful to observe the required measurements. His idea of dividing the space into various concentric circles is quite ingenious, though the poet's words do not give him the slightest cause for doing so. There is, furthermore, no evidence that the ancients divided their shields in this way. Since Homer himself calls it σάκος πάντοσε δεδαιδαλμένον (a shield artistically worked on all sides), I myself should prefer to gain the needed space by making use of the concave side of the shield. For it is well known that the ancient artists did not leave this side empty, as Phidias' shield of Minerva clearly proves.[a] Not only did Boivin fail to make use of this advantage, he also needlessly increased the number of designs themselves, for which he had to find space in an area that he reduced by one-half by breaking up into two or three pictures what the poet obviously intended to be only one. I know very well what induced him to do this, but he ought not to have been so induced. Instead of attempting to satisfy the demands of his opponents, he should have shown them that their demands were unjust.

An example will explain more clearly what I mean. When Homer says of a city:

λαοὶ δ' εἰν ἀγορῇ ἔσαν ἀθρόοι· ἔνθα δὲ νεῖκος
ὠρώρει, δύο δ' ἄνδρες ἐνείκεον εἵνεκα ποινῆς

ἀνδρὸς ἀποφθιμένου· ὁ μὲν εὔχετο πάντ᾽ ἀποδοῦναι,
δήμῳ πιφαύσκων, ὁ δ᾽ ἀναίνετο μηδὲν ἑλέσθαι·
ἄμφω δ᾽ ἱέσθην ἐπὶ ἵστορι πεῖραρ ἑλέσθαι.
λαοὶ δ᾽ ἀμφοτέροσιν ἐπήπυον, ἀμφὶς ἀρωγοί.
κήρυκες δ᾽ ἄρα λαὸν ἐρήτυον· οἱ δὲ γέροντες
εἵατ᾽ ἐπὶ ξεστοῖσι λίθοις ἱερῷ ἐνὶ κύκλῳ,
σκῆπτρα δὲ κηρύκων ἐν χέρσ᾽ ἔχον ἠεροφώνων·
τοῖσιν ἔπειτ᾽ ἤϊσσον, ἀμοιβηδὶς δὲ δίκαζον.
κεῖτο δ᾽ ἄρ᾽ ἐν μέσσοισι δύω χρυσοῖο τάλαντα,[1,b]

I do not believe that he wanted to draw more than one picture, namely that of a public lawsuit about the contested payment of a heavy fine for a murder that had been committed. The artist who executes this subject cannot make use of more than one single moment at one time: either the moment of accusation, or the examination of witnesses, or the passing of judgment, or any other moment before, after, or between these points which he deems most suitable. He makes this single moment as suggestive as possible and describes it with all the illusion which makes art superior to poetry in the portrayal of visible objects. Being infinitely surpassed in this respect, what remains for the poet who wants to paint the same subject in words with any degree of success, but to avail himself likewise of his own peculiar advantages? And what are these advantages? The liberty to extend his description over that which preceded and that which followed the single moment represented in the work of art; and the power of showing not only what the artist shows, but also that which the artist must leave to the imagination. Only by means of this liberty and this power can the poet again raise himself to equality with the artist. Their works will appear most alike when their effect is equally vivid; but this is not so when the one does not impart to the soul through the ear more or less what the other can present to the eye. Boivin ought to have judged the passage from Homer according to this principle, for had he done so, he would not have made as many separate pictures as he thought he distinguished different points of time in the shield. Obviously, not everything Homer says can be combined into a

[1] *Iliad* XVIII. 497-508.

single picture; the accusation and denial, the presentation of witnesses and the shouts of the divided crowd, the attempts of the heralds to still the tumult, and the decision of the judges are events which follow one another and cannot exist side by side at the same time. However, to use the language of scholastic philosophy, what is not contained in the picture *actu* is there *virtute;* and the only true way to express an actual picture in words is to combine *virtute,* i.e., what is implied in the picture, with what is actually visible, and not to confine oneself to the limits of the art, within which the poet can reckon the data for a painting, to be sure, but can never create a painting.

Similarly, Boivin divides the picture of the besieged town [2] into three separate pictures. He might just as well have made a dozen out of it as three, for once he had failed to grasp the spirit of the poet and demanded that he submit to the unities of material painting he might have found so many violations of these unities that it would almost have been necessary to allot to each separate passage of the poem a particular area of the shield. In my opinion, however, Homer does not have more than ten different pictures on the entire shield, each of which he begins with ἐν μὲν ἔτευξε, or ἐν δὲ ποίησε, or ἐν δ' ἐτίθει, or ἐν δὲ ποίκιλλε 'Αμφιγυήεις.[c] Where these introductory words are lacking there is no basis for assuming a separate picture, and conversely, everything the phrase unites must be treated as one unit, lacking only the arbitrary concentration into a single point of time, which the poet was by no means bound to observe. On the contrary, if he had chosen this limitation and then rigidly conformed to it, if he had not introduced the slightest detail which in a material representation could not have been combined with it—in short, if he had done as his critics demanded he would not have exposed himself to blame, but neither would any man of good taste have found anything to admire.

Pope not only approved Boivin's arrangement and diagram,

2 *Ibid.,* 509-540.

but thought he was performing a special service when he went on to show that each one of the pictures broken up in this way was in accordance with the strictest rules of present day painting. In them he found contrast, perspective, and the three unities all strictly observed. Of course, he knew very well from good and trustworthy sources that at the time of the Trojan War painting was still in its infancy. And so Homer, by virtue of his divine genius, must have, I won't say adhered to what painting could then or in his time achieve, but rather must have anticipated by a guess what it is able to perform at all times; or else those sources would be less reliable than the apparent information from the artificial shield, which then would deserve preference. Whoever prefers, may choose the former hypothesis; of the latter, at least, no one will be persuaded who knows something more of the history of art than the mere data of historians. For we do not believe that in Homer's time painting was still in its infancy merely because Pliny or some other writer says so, but chiefly because we are able to see from the art works enumerated by the ancients that many centuries later art had still not progressed much further, and that the paintings of a Polygnotus, for example, are far from standing the test which, in Pope's opinion, the pictures on Homer's shield are able to pass successfully. The two major works of this master in Delphi, of which Pausanias has left us so detailed a description,[3] were evidently devoid of all perspective. This branch of art was completely unknown to the ancients, and what Pope cites as proof that Homer already had some notion of it proves only that he had a very incomplete notion of it himself.[d] "Homer," he says, "cannot have been unfamiliar with perspective because he expressly states the distance from one object to another. He tells us, for instance, that the spies lay a little farther off than the other figures, and that the oak, under which the reapers' meal was spread, stood apart. What he says of the valley dotted with herds, huts and stalls is clearly the description of a wide area

3 *Phocis* XXV-XXXI.

in perspective. A general argument in favor of this may in fact be drawn from the large number of figures on the shield, which could not all be depicted in full size. This is itself a sort of evidence that the art of reducing the size of figures according to perspective was already known at that time." The mere observation of the optical experience that a thing appears smaller at a distance than close up does not by any manner of means make a picture contain perspective. Perspective requires a single vantage point, a definite, natural field of vision, and it was this that ancient paintings did not have. In the paintings of Polygnotus the ground was not horizontal but raised so much toward the back that the figures which were supposed to be standing in the background seemed to be raised above those in front. And if this position of the various figures and groups of figures was a generally accepted one, as may be assumed from the ancient bas-reliefs (in which the hindmost figures are always higher than the foremost and look over their heads), then it is only natural to assume such practice also in Homer's description, and not to separate without necessity those of Homer's pictures which can, in accordance with such practice, be united into one. Accordingly, the double scene of the peaceful town, through whose streets the gay wedding procession moves, while at the same time an important trial is being held in the market place, does not require two pictures. Certainly Homer might have thought of this double scene as one single picture, since he chose such a high vantage point that he could see the market place and the street at the same time.

I am of the opinion that real perspective in painting was accidentally hit upon by the scenery painters. And even when stage painting had reached perfection, it still must have been anything but easy to apply its principles to pictures painted on a single surface, since in the later paintings found among the antiquities of the Herculaneum there are so many and such varied offenses against perspective which today would be hardly excusable in a novice.[4]

4 *Betracht. über die Malerei*, p. 185.

But I shall spare myself the trouble of collecting my scattered observations on a point which I hope to find fully treated in the art history which Herr Winckelmann has promised us.[5]

5 Written in the year 1763.

CHAPTER TWENTY

I shall return now to my old path, if indeed a man who takes a stroll can be said to have one.

What I have said about material objects generally is doubly true of beautiful material objects. The beauty of an object arises from the harmonious effect of its various parts, which the eye is able to take in at one glance. It demands, therefore, that these parts lie in juxtaposition; and since things whose parts are in juxtaposition are the proper subject of painting, it follows that painting and painting alone can imitate material beauty.

Because the poet is able to show the elements of beauty in succession only, he abstains entirely from the depiction of physical beauty as such. He feels that these elements, when placed in succession, are unable to achieve the effect that they produce in close union; that the concentrating glance which we try to cast back on the parts after they have been enumerated fails to produce the effect of a harmonious image; that it lies beyond the power of human imagination to picture to oneself what the composite effect of this mouth, this nose, and these eyes will be unless we can recall a similar composition of such parts from nature or art.

In this respect, also, Homer is the best model of all. He says that Nireus was beautiful,[1] Achilles still more beautiful, and that Helen possessed a godlike beauty. But nowhere does he enter into a detailed description of these beauties. And yet the entire poem is based on the beauty of Helen. How a modern poet would have reveled in a description of it!

Even Constantinus Manasses once attempted to adorn his dry chronicle with a description of Helen. I am obliged to thank him for his attempt, for I really do not know where else

[1] [In the *Iliad* II. 673, Homer describes Nireus as "the most beautiful man that came up before Troy."]

I could have found an example from which it would have been so manifestly obvious how foolish it is to attempt something which Homer himself so wisely left untried. When I read—

ἦν ἡ γυνὴ περικαλλὴς, εὔοφρυς, εὐχρουστάτη,
εὐπάρειος, εὐπρόσωπος, βοῶπις, χιονόχρους,
ἑλικοβλέφαρος, ἁβρὰ, χαρίτων γέμον ἄλσος,
λευκοβραχίων, τρυφερὰ, κάλλος ἀντικρὺς ἔμπνουν,
τὸ πρόσωπον καταλευκὸν, ἡ παρειὰ ῥοδόχρους,
τὸ πρόσωπον ἐπίχαρι, τὸ βλέφαρον ὡραῖον,
κάλλος ἀνεπιτήδευτον, ἀβάπτιστον, αὐτόχρουν,
ἔβαπτε τὴν λευκότητα ῥοδοχρία πυρινή.
ὡς εἴ τις τὸν ἐλέφαντα βάψει λαμπρᾷ πορφύρᾳ.
δειρὴ μακρὰ, καταλευκὸς, ὅθεν ἐμυθουργήθη
κυκνογενῆ τὴν εὔοπτον Ἑλένην χρηματίζειν,[a]

—it is like seeing stones rolled up a mountain for the building of a splendid edifice on the summit, but they all roll down the other side of their own weight. What kind of image does this torrent of words leave in us? What did Helen look like? If a thousand people read this description, will not every one of them have his own image of her?

However, a monk's political verses are admittedly not poetry. Let us hear how Ariosto describes his bewitching Alcina:

Di persona era tanto ben formata,
Quanto mai finger san Pittori industri:
Con bionda chioma, lunga e annodata,
Oro non è, che piu risplenda, e lustri,
Spargeasi per la guancia delicata
Misto color di rose e di ligustri.
Di terso avorio era la fronte lieta,
Che lo spazio finia con giusta meta.

Sotto due negri, e sottilissimi archi
Son due negri occhi, anzi due chiari soli,
Pietosi à riguardar, à mover parchi,
Intorno à cui par ch' Amor scherzi, e voli,
E ch' indi tutta la faretra scharchi,
E visibilmente i cori involi.
Quindi il naso per mezo il viso schende
Che non trova l'invidia ove l'emende.

Sotto quel sta, quasi fra due vallette,
La bocca sparsa di natio cinabro,
Quivi due filze son di perle elette,
Che chiude, ed apre un bello e dolce labro;
Quindi escon le cortesi parolette,
Da render molle ogni cor rozo e scabro;
Quivi si forma quel soave riso,
Ch' apre a sua posta in terra il paradiso.

Bianca neve è il bel collo, e'l petto latte,
Il collo è tondo, il petto colmo e largo;
Due pome acerbe, e pur d'avorio fatte,
Vengono e van, come onda al primo margo,
Quando piacevole aura il mar combatte.
Non potria l'altre parti veder Argo,
Ben si può giudicar, che corrisponde,
A quel ch' appar di fuor, quel che s'asconde.

Mostran le braccia sua misura giusta,
Et la candida man spesso si vede,
Lunghetta alquanto, e di larghezza angusta
Dove nè nodo appar, nè vena eccede.
Si vede al fin de la persona augusta
Il breve, asciutto e ritondetto piede.
Gli angelici sembianti nati in cielo
Non si ponno celar sotto alcun velo.[b]

Milton, when speaking of the Pandemonium,[2] says: ". . .
the work some praise, and some the architect." Praise of one,
then, does not always mean praise of the other. A work of art
may deserve all possible esteem without bringing the artist
any special renown. On the other hand, an artist may justly
claim our admiration even when his work does not entirely
satisfy us. We should never forget this fact, for it will enable
us to reconcile completely conflicting judgments. Such is the
case here. In his dialogue on painting Dolce has Aretino make
much ado about the above-quoted verses of Ariosto,[c] while
I have chosen them as an example of a painting with no pic-
ture. We are both right. Dolce admires the knowledge of phys-
ical beauty which the poet displays in them, while I am con-

2 [The name which Milton, in his *Paradise Lost*, gives to Satan's palace.]

cerned only with the effect which this knowledge, when expressed in words, has on my imagination. Dolce concludes from this knowledge that good poets are no less good painters; and I in turn judge from this effect that what is best expressed by the painter in lines and colors is least expressible in words. Dolce recommends Ariosto's description to all painters as a perfect model of a beautiful woman; and I recommend it to all poets as the most instructive warning not to try, with less hope of success, where an Ariosto had to fail. It may be that when Ariosto says

Di persona era tanto ben formata,
Quanto mai finger san Pittori industri,[3]

he thereby proves that he has fully understood the laws of proportion as they have always been studied by the most zealous artist from nature and from the works of the ancients.[d] We may even grant that in the mere words

Spargeasi per la guancia delicata
Misto color di rose e di ligustri

he shows himself to be the most perfect master of color, a veritable Titian.[e] His comparing of Alcina's hair with gold instead of actually calling it golden indicates clearly that he disapproves of the use of real gold in coloring.[f] We may even discover in the descending nose,

Quindi il naso per mezo il viso scende,

the profile of those ancient Greek noses which was given to Roman portraits by Greek artists.[g] But of what use is all this learning and knowledge to us readers, who want only to believe that we see a beautiful woman and, in believing, to feel something of those gentle pulsations of the blood which accompany the actual sight of beauty? Because the poet knows by what proportions a beautiful form is produced, does that mean that we know it too? And even if we do know, does he

3 [This and the following five quotations from *Orlando Furioso* are translated in Appendix Note b, p. 221.]

show us these proportions here? Or does he ease in the least
the difficulty of remembering these proportions vividly and
plastically? "A forehead enclosed within fitting bounds,"

> . . . la fronte
> Che lo spazio finia con giusta meta;

"a nose where Envy herself finds nothing to improve,"

> Che non trova l'invidia, ove l'emende;

"a hand, somewhat long and slender,"

> Lunghetta alquanto, e di larghezza augusta . . .

—what kind of picture do these vague formulae suggest? In
the mouth of a drawing master who wanted to call the atten-
tion of his pupils to the beauties of the academic model they
might possibly mean something; one look at this model and
they see the fitting bounds of the gay brow, they see the finely
chiseled nose, the slenderness of her dainty hand. But in the
poem I see nothing and I am annoyed by the futility of my
best efforts to see something.

On this point, in which one can imitate Homer by doing
precisely nothing, Virgil has been relatively fortunate. His
Dido, too, is never anything more to him than *Pulcherrima
Dido.*[4] When he wants to say something more circumstantial
about her, he describes her rich jewelry and her splendid
attire:

> Tandem progreditur . . .
> Sidoniam picto chlamydem circumdata limbo:
> Cui pharetra ex auro, crines nodantur in aurum,
> Aurea purpuream, subnectit fibula vestem.[5,h]

If on this account we wanted to apply to him what that an-
cient artist[6] said to a pupil who had painted a richly decked-
out Helen—"Since you could not paint her beautiful, you have

[4] ["Most beautiful Dido."]

[5] *Aeneid* IV. 136-39.

[6] [According to Clemens Alexandrinus (*Paedog.* II. 125), Apelles is sup-
posed to have said this to a pupil who had painted Helen of Troy covered
with gold ornaments (cf. Blümner, p. 638).]

painted her rich"—Virgil would reply, "It is not my fault that I could not paint her beautiful; the blame lies in the limits of my art. Let it be to my credit that I have stayed within these limits."

I must not forget here the two songs of Anacreon in which he analyzes the beauty of his mistress and his Bathyllus.[7] The device which he adopts justifies itself completely. He imagines that he has a painter before him who is working under his direct supervision. Paint me the hair this way, he says, and the forehead this way, and the eyes, and the mouth, the neck and bosom, the thighs and hands this way! What the painter could only put together part by part, the poet could likewise only describe for him part by part. He does not intend us to see and feel the whole beauty of the beloved objects in these oral instructions to the painter; he himself senses the inadequacy of verbal expression, and for that reason calls to his aid the expressive capacity of art, whose power of illusion he so highly extols that the whole poem seems more a hymn of praise to art than to his mistress. He sees not her picture but herself and believes that she is about to open her mouth to speak:

ἀπέχει· βλέπω γὰρ αὐτήν.
τάχα, κηρέ, καὶ λαλήσεις.[i]

In his presentation of Bathyllus, too, the praise of the beautiful boy is so interwoven with praise of art and the artist that it becomes doubtful in whose honor Anacreon really composed the song. He combines the most beautiful parts of various pictures, in which the outstanding beauty of these parts is the characteristic feature; he takes the neck of an Adonis, the breast and hands of a Mercury, the thighs of a Pollux, the abdomen of a Bacchus—until finally he sees the whole Bathyllus in a completed Apollo of the artist:

μετὰ δὲ πρόσωπον ἔστω,
τὸν Ἀδώνιδος παρελθών,

7 *Odes* XXVIII. 33ff.; XXIX. 27ff. and 43ff. [Bathyllus was one of Anacreon's youthful favorites.]

ἐλεφάντινος τράχηλος·
μεταμάζιον δὲ ποίει
διδύμας τε χεῖρας Ἑρμοῦ,
Πολυδεύκεος δὲ μηρούς,
Διονυσίην δὲ νηδύν.

. . .

τὸν Ἀπόλλωνα δὲ τοῦτον
καθελών, ποίει Βάθυλλον.ʲ

Lucian, too, knew of no other way to convey the beauty of Panthea than to refer to the loveliest female statues of ancient artists.[8] Yet what is this but an admission that language in itself is powerless here; that poetry falters and eloquence grows mute unless art serves as an interpreter in some degree?

[8] Εἰκόνες, § 3, Vol. II, p. 461 (ed. Reitz).

CHAPTER TWENTY-ONE

We might ask whether poetry does not lose too much when we take from her all depictions of physical beauty? But who would do this? If we dissuade her from taking one particular way to attain such pictures, and from following confusedly the footsteps of a sister art without ever reaching the same goal, do we thereby exclude her from every other path where art in turn must see poetry take the lead?

The same Homer, who so assiduously refrains from detailed descriptions of physical beauties, and from whom we scarcely learn in passing that Helen had white arms [1] and beautiful hair,[2] nevertheless knows how to convey to us an idea of her beauty which far surpasses anything art is able to accomplish toward that end. Let us recall the passage where Helen steps before an assembly of Trojan elders. The venerable old men see her, and one says to the other:

> Οὐ νέμεσις Τρῶας και ἐϋκνήμιδας Ἀχαιοὺς
> τοιῆδ' ἀμφὶ γυναικὶ πολὺν χρόνον ἄλγεα πάσχειν·
> αἰνῶς ἀθανάτῃσι θεῇς εἰς ὦπα ἔοικεν.[3, a]

What can convey a more vivid idea of beauty than to let cold old age acknowledge that she is indeed worth the war which had cost so much blood and so many tears?

What Homer could not describe in all its various parts he makes us recognize by its effect. Paint for us, you poets, the pleasure, the affection, the love and delight which beauty brings, and you have painted beauty itself. Who can picture to himself as ugly the beloved object of Sappho,[4] at whose sight she confesses losing all sense and thought? And who does

[1] *Iliad* III. 121.
[2] *Ibid.*, III. 329.
[3] *Ibid.*, III. 156-8.
[4] [Said to have thrown herself into the sea because of her unrequited love for the youth Phaon. Lessing is referring to a fragment of Sappho which may be found in Bergk's *Poetae lyrici*, no. 2.]

111

not believe he is seeing the most beautiful and perfect form
as soon as he recognizes the feelings which only such a form
can awaken? It is not because Ovid shows us the beautiful
body of his Lesbia part by part [5]—

> Quos humeros, quales vidi tetigique lacertos!
> Forma papillarum quam fuit apta premi!
> Quam castigato planus sub pectore venter!
> Quantum et quale latus! quam iuvenile femur! [6]

—that we believe we are enjoying the sight that he enjoyed, but
because he does it with that intense sensuousness which so
easily stirs our passions.

Another way in which poetry can draw even with art in the
description of physical beauty is by changing beauty into
charm. Charm is beauty in motion and for that reason less
suitable to the painter than to the poet. The painter can only
suggest motion, because in reality his figures are motionless.
As a result, charm with him becomes a grimace. But in poetry
it remains what it is, a transitory beauty that we desire to see
again and again. It comes and goes; and since we can gen-
erally recall a movement more readily and more vividly than
mere forms or colors, charm will in the same proportion be
more impressive than beauty. All that is pleasing and moving
to us in the description of Alcina is charm. Her eyes make an
impression on us, not because they are black and fiery, but
because

> Pietosi à riguardar, à mover parchi,[7]

"they look gracefully about her and move slowly," and because
Cupid hovers about them and empties his whole quiver from
them. Her mouth delights us, not because two rows of choice
pearls are enclosed by the natural vermilion of her lips, but

[5] [Lessing has confused Lesbia, Catullus' mistress, with Corinna, who is
described in Ovid's poem.]

[6] [*Amores* I. 5, 19ff.: "What arms and shoulders did I now see and
touch! And how her bosom offered itself, heaving, to be squeezed! Below
the slender breast the body tapered in perfect moderation. Oh, how youth-
fully slender hips and thighs arched!"]

[7] [From *Orlando Furioso*, translated in Appendix Note b, p. 221.]

because that lovely smile is formed here which in itself already opens a paradise on earth; because from it come the friendly words that soften every callous heart. Her bosom enchants us, not so much because its whiteness and delicate shape call to mind milk and ivory apples as because we see it gently rise and fall, like the waves on the farthest edge of the shore when a playful zephyr contends with the sea:

> Due pome acerbe, e pur d'avorio fatte,
> Vengono e van, come onda al primo margo,
> Quando piacevole aura il mar combatte.[8]

I am convinced that such expressions of sheer charm, compressed into one or two stanzas, would have a far greater effect than all the five stanzas over which Ariosto has scattered them, interspersed with chilling descriptions of beautiful form far too learned to affect our feelings.

Even Anacreon preferred to commit the apparent impropriety of demanding an impossibility of the painter rather than forego having the form of his mistress enlivened by charm.

> τρυφεροῦ δ' ἔσω γενείου
> περὶ λυγδίνῳ τραχήλῳ
> Χάριτες πέτοιντο πᾶσαι.[9]

He bids the artist make all the graces hover around her soft chin, her marble neck! But how? Literally? That is impossible to do in painting. The painter could give to the chin the most beautiful rounding, the loveliest dimple, *Amores digitulo impressum* [10] (for I believe the ἔσω alludes to a dimple). He could give the neck the most beautiful flesh tone. But that is all he could do. The turning of this lovely neck, the play of muscles by which the dimple becomes now more, now less apparent, the actual charm lay beyond his powers. The poet said all that his heart was capable of saying in order to make

[8] [Translated in Appendix Note b, p. 221.]
[9] [*Odyssey* XXVIII. 26: "Let all the graces flutter about her delicate, sensual chin and about her marble-white throat."]
[10] ["pressed in by the finger of Amor."]

beauty perceptible to us and also in order that the painter might likewise seek to achieve the highest expression in his art. It is a further example of the observation I made above,[11] that the poet, even when he speaks of works of art, is not compelled to confine his description within the limits of art.

[11] [Lessing is alluding to his observations on Homer's description of Achilles' shield, pp. 94-95.]

CHAPTER TWENTY-TWO

Zeuxis painted a Helen and had the courage to write at the bottom of his picture those famous lines of Homer in which the delighted elders confess their feelings. Never were painting and poetry engaged in a more even contest. The victory remained undecided, and both deserved a crown.

The wise poet showed us beauty, which he felt he could depict not according to its parts but only in its effect. In the same way, the no less wise painter showed us that same beauty by showing us its constituent parts only, and deemed it improper for his art to have recourse to any other means. His painting contained nothing but the standing nude figure of Helen. For it is probably the Helen that he painted for the people of Croton.[1]

We might, for the sake of curiosity, compare this with the painting which Caylus sketches out for the modern artist from those lines of Homer: "Helen, covered with a white veil, appears in the midst of several old men, among them Priam, who is recognizable by the emblems of his royal dignity. The artist must take special pains to make us feel the triumph of beauty in the eager glance and the expressions of astonished admiration on the faces of these frigid old men. The scene is over one of the gates of the town. The background of the painting may be lost or deepened either in the open sky or against the higher buildings of the town. The first would produce a bolder effect, but one is as suitable as the other."

Let us imagine for a moment that this painting had been executed by the greatest master of our time, and let us compare it with the work of Zeuxis. Which of the two will show the real triumph of beauty? The latter, in which I feel this beauty myself, or the former, in which I am supposed to

1 Valerius Maximus, III. 7. Dionysius Halicarnassus, *Ars Rhetorica* 12: περὶ λύγων ἐξεγάσεως. [Croton was a famous town in Magna Graecia.]

gather it from the grimaces of deeply moved graybeards? *Turpe senilis amor*,[2] a covetous expression makes the most venerable face look ridiculous, and an old man with the desires of youth is a revolting object. Homer's old men cannot be reproached for this, for the emotion that they feel is a momentary spark which wisdom immediately stifles. It is intended only to do honor to Helen, not to cast shame on themselves. They confess their feelings, and immediately add:

> ἀλλὰ καὶ ὣς, τοίη περ ἐοῦσ', ἐν νηυσὶ νεέσθω,
> μηδ' ἡμῖν τεκέεσσί τ' ὀπίσσω πῆμα λίποιτο.[a]

Without such a decision they would have been silly old fops; they would be what they are made to appear in Caylus' picture. And on what, then, do they fix their greedy glances? On a masked, veiled figure. Is that Helen? It is incomprehensible to me how Caylus could have left her a veil. It is true that Homer expressly gives her one,

> αὐτίκα δ' ἀργεννῇσι καλυψαμένη ὀθόνῃσιν
> ὡρμᾶτ' ἐκ θαλάμοιο,[b]

but only to wear in the streets. And even if the elders do express their admiration before she has removed or thrown back the veil, it was not the first time they had seen her. Hence their confession did not necessarily arise from the present, momentary sight of her, for they might often have felt what they acknowledge for the first time on this occasion. In the painting nothing of the sort takes place. When I see enraptured old men here, I immediately want to know what it is that has enraptured them. And I am extremely surprised if, as I said before, I perceive nothing but a masked, veiled figure at which they gape lasciviously. How much of Helen is there in this creature? Her white veil and something of her well-proportioned outline, as far as an outline can be discernible beneath the robes. But perhaps the count did not mean that her face should be covered, and he merely mentions the veil as part of her dress. If this is the case (although his words,

[2] ["Love in old men is hideous" (Ovid, *Amores* I. 9. 4).]

Hélène couverte d'un voile blanc,[3] hardly permit such an interpretation), I find another reason for astonishment: he very carefully recommends the artist to show the expression on the old men's faces and yet does not say a single word about the beauty of Helen's face. This virtuous beauty, timidly approaching with a repentant tear glittering in her eye—is such supreme beauty so familiar to our artists that they do not need to be reminded of it? Or is expression more than beauty? And are we in the habit of letting the ugliest actress pass for a charming princess in painting as well as on the stage, if only her prince expresses his love passionately to her?

Truly, Caylus' painting would be to that of Zeuxis as pantomine to sublime poetry.

In ancient times Homer was unquestionably studied more diligently than now, and yet we do not find too many pictures mentioned which the ancient artists have drawn from his works.[4] They seem only to have made diligent use of hints given by the poet concerning physical beauties. These they painted, for they felt that only in them could they really rival the poet. Besides Helen, Zeuxis also painted Penelope; and the Diana of Apelles was the Diana of Homer attended by her nymphs. On this occasion I shall also mention that the passage in Pliny where this latter is discussed needs emendation.[e] To paint scenes from Homer simply because they offered a rich composition, excellent contrasts, and artistic effects of light was not to the liking of the ancient artists. Nor could it be as long as art remained within the narrower orbit of its highest ideals. And so to make up for this they drew sustenance from the spirit of the poet; they filled their imagination with his noblest features; the fire of his enthusiasm kindled their own; they saw and felt as he did; and so their works became reproductions of Homer's, not as a portrait is of its original, but as a son is a reproduction of his father—similar, but different. This similarity often lies in only a single trait; the other parts

3 ["Helen, covered by a white veil."]

4 *Fabricii Bibliotheca Graeca* II. 6, p. 345. [Published in Hamburg (1705-1718), in fourteen volumes, by Johann Fabricius (1668-1736).]

have nothing in common with each other except that in the one, as well as in the other, they harmonize with the one common trait.

Besides, since Homer's masterpieces of poetry were older than any one masterpiece of art, and since Homer looked at nature with the eye of a painter before Phidias or Apelles, it is not surprising that the artists found various and particularly useful observations already made by Homer before they found time to gain them from nature herself. These they eagerly seized upon in order to imitate nature through Homer's eyes. Phidias confessed that the lines

<div style="text-align:center">

Ἦ καὶ κυανέῃσιν ἐπ' ὀφρύσι νεῦσε Κρονίων·
ἀμβρόσιαι δ' ἄρα χαῖται ἐπερρώσαντο ἄνακτος
κρατὸς ἀπ' ἀθανάτοιο· μέγαν δ' ἐλέλιξεν Ὄλυμπον,[5, d]

</div>

served him as a model for his Olympian Jupiter,[6] and that it was only through Homer's help that he succeeded in producing a divine countenance, *propemodum ex ipso coelo petitum.*[7] Whoever is of the opinion that this means only that the artist's imagination was kindled by the poet's exalted picture, and thus made capable of producing equally exalted conceptions, overlooks the essential thing, in my opinion, and contents himself with a very general conclusion where he could actually find a particular one that would be far more satisfactory. As I see it, Phidias confessed here that he first noticed in this passage how much expression lies in the eyebrows, *quanta pars animi,*[8] reveals itself in them. It may be that this also induced him to pay more attention to the hair, in order to express to a degree what Homer calls ambrosial locks. For it is certain that ancient artists before Phidias understood little of the language of meaning of the features and that they especially neglected the hair. Pliny says that even Myron was reprehensi-

[5] *Iliad* I. 528-30. Valerius Maximus, III. 7.

[6] [The famous statue in the temple of Zeus at Olympia, one of the seven wonders of the ancient world (cf. Murray, *Greek Sculpture*, II, 98ff.).]

[7] ["almost brought down from heaven itself."]

[8] Pliny, X [XI]. 51, p. 616 (ed. Hard.). ["how much expression of the soul."]

ble on these two points,[e] and that it was Pythagoras Leontinus who first distinguished himself by his careful treatment of the hair.[9] What Phidias had learned from Homer, the other artists learned from the works of Phidias.

I shall cite another example of this kind which I always enjoyed particularly. Remember what Hogarth said about the Apollo Belvedere. "This Apollo," he said, "and the Antinous [10] may both be seen in the same palace in Rome. While Antinous fills the beholder with admiration, Apollo calls forth surprise which, as travelers express it, is created by an appearance of something more than human and which none of them is able to describe. And this effect, they say, is all the more amazing because upon examination its disproportion is evident even to an untrained eye. One of the best sculptors we have in England, who recently went there to see the statue, confirmed to me what has just now been said, particularly in regard to the feet and thighs being too long and wide for the upper parts. And Andrea Sacchi, one of the greatest Italian painters, seems to have been of the same opinion, or he would hardly have given his Apollo, shown crowning the composer Pasquilini [11] (in a famous painting, now in England), the exact proportions of the Antinous, since in other respects it appears to be an actual copy of the Apollo. Although we can often see in great works that a less important feature has been neglected, this cannot be the case here, for in a beautiful statue correct proportion is one of its essential beauties. We may therefore conclude that these limbs must have been made longer intention-

9 *Ibid.,* [XI.] 59: "Hic primus nervos et venas expressit, capillumque diligentius." ["He first portrayed the muscles and veins, and bestowed more attention on the hair."]

10 [When Antinous, a youth of great beauty, and a favorite of the emperor Hadrian, was drowned in the Nile, Hadrian had a number of statues of him erected in his honor. The statue mentioned here, however, is not of Antinous, as was originally believed, but of Hermes (cf. Blümner, p. 651).]

11 [Presumably a eunuch in the Pope's private choir during Sacchi's time. No composer by that name has been discovered (cf. Blümner, p. 652).]

ally, since this could easily have been avoided. If we examine carefully the beauties of this figure, we may reasonably conclude that what has up to now been considered so unaccountably excellent in its general appearance is in fact due to what has appeared to be a blemish in one of its parts." [12]

All this is quite clear; and already Homer, I might add, felt and indicated that there is an exalted appearance which arises merely from this increase in size in the proportions of feet and thighs. When Antenor wants to compare the figure of Ulysses with that of Menelaus, Homer has him say

στάντων μὲν Μενέλαος ὑπείρεχεν εὐρέας ὤμους,
ἄμφω δ' ἑζομένω, γεραρώτερος ἦεν 'Οδυσσεύς. [13]

("When both stood, Menelaus towered high above the other with his broad shoulders; but when both sat, Ulysses was the more impressive.") Since Ulysses, therefore, gained in sitting what Menelaus lost in that position, it is easy to determine the proportion of the two men's upper parts to their feet and thighs. In Ulysses the former were somewhat larger in proportion, in Menelaus the latter.

[12] *Zergliederung der Schönheit*, Berlin edn. [chap. 11], p. 47. [The original, *Analysis of Beauty*, was published in 1753.]
[13] *Iliad* III. 210-11.

CHAPTER TWENTY-THREE

The harmonious interaction of many parts which produces beauty can be destroyed by a single unfitting part, without, however, making the object ugly. Ugliness demands also a number of unsuitable parts, which we must be able to take in at one glance if we are to feel the opposite effect of that which beauty produces.

According to this, then, ugliness by its very nature could not be a subject of poetry; and yet Homer has depicted Thersites as being extremely ugly, and this ugliness is described according to its contiguous parts. Why was he able to do with ugliness what he so wisely abstained from attempting to do with beauty? Is not the effect of ugliness destroyed by the successive enumeration of its elements just as much as the effect of beauty is destroyed through a similar enumeration?

Of course it is; but in this very fact lies Homer's justification. The poet's use of ugliness becomes possible for the very reason that in his description it is reduced to a less offensive manifestation of physical imperfection and ceases, as it were, to be ugly in its effect. Hence, what the poet cannot use by itself, he uses as an ingredient to produce and heighten certain mixed feelings with which he must entertain us in the absence of purely agreeable ones. .

These mixed feelings are those of the ridiculous and the terrible.

Homer makes Thersites ugly in order to make him ridiculous; but it is not merely through his ugliness that he becomes so, for ugliness is an imperfection, and to create the ridiculous we need a contrast of perfections and imperfections.[1] This is the explanation given by my friend, to which I should like to add that such contrasts should not be too glaring or sharp, and that, to continue in the language of the artist, they should

[1] *Philosophische Schriften des Herrn Moses Mendelssohn*, II, 23.

be of a kind that can be blended into one another. The wise and virtuous Aesop does not become ridiculous because Thersites' ugliness has been attributed to him.[2] It was some monk's silly whim to try to transfer the Γελοῖον, or comical element, in his moralizing fables to his own person by representing him as misshapen. For a deformed body and a pure soul are like oil and vinegar: no matter how much we shake them together, they remain separate to the taste. They do not produce a third quality. The body produces annoyance, the soul pleasure, and each has its own effect. It is only when the deformed body is at the same time frail and sickly, when it affects the soul and is the source of prejudicial judgments against it, that annoyance and pleasure blend together. However, the new product is not ridicule, but compassion, and its object becomes interesting to us, whereas before we should only have respected it. The sickly, misshapen Pope must have been far more interesting to his friends than the handsome and healthy Wycherley to his. Thersites is no more made ridiculous merely by his ugliness than he would be without it. His ugliness, the consistency in this ugliness and his character, the incongruity which both form with his feeling of self-importance, the harmless effect of his malicious chatter, debasing to himself only: all these things unite to produce this result. The last circumstance is the Οὐ φθαρτικόν, the harmless, which Aristotle [3] demands as an indispensable part of the ridiculous. My friend,[4] too, makes it a necessary condition that the contrast of perfection with imperfection should not be of much importance nor interest us very much. For if we were to assume that Thersites paid dearly for his malicious disparagement of Agamemnon, that he paid for it with his life rather than with a few bloody weals, we should cease to

[2] [Aesopus, the famous Greek writer of fables, is said to have been extremely deformed. A fourteenth-century monk, Maximus Planudes, describes him that way, and he is represented as a cripple in the statue of him at Rome in the Villa Albani.]

[3] *De Poetica*, chap. 5.

[4] [Moses Mendelssohn.]

laugh at him.[5] This monster of a man is, after all, still a man whose destruction must always seem to us a greater evil than all his failings and vices. To experience this ourselves we need only read the account of his end in Quintus Calaber.[6] Achilles regrets that he has killed Penthesilea; this beauty, bathed in her own bravely shed blood, demands the respect and compassion of the hero—and respect and compassion turn into love. But the slanderous Thersites imputes this love to him as a crime. Passionately he declaims against the lust which can drive even the best men to commit folly,

$$\mathring{\eta}\tau' \ \mathring{a}\phi\rho ova \ \phi\tilde{\omega}\tau a \ \tau i\theta\eta\sigma\iota$$
$$\kappa a\grave{\iota} \ \pi\iota\nu\upsilon\tau \acute{o}\nu \ \pi\epsilon\rho \ \acute{\epsilon}\acute{o}\nu\tau a.^7$$

Achilles becomes angry and, without saying a word, strikes him so ungently between cheek and ear that his teeth, his blood, and his life fly out of his mouth in one. This is too brutal. The irascible and murderous Achilles becomes more hateful to me than the malicious, snarling Thersites; and I am offended by the cheers of the Greeks at this deed. My sympathies are with Diomedes, who draws his sword to avenge the murder of his kinsman, for I feel that Thersites as a human being is my kinsman, too.

But let us suppose that the instigations of Thersites had resulted in mutiny and that the rebellious people had really taken to their ships and treacherously left their leaders behind; let us suppose that these leaders had fallen into the hands of a vengeful enemy and that, once at sea, a divine decree of punishment had doomed fleet and people to utter destruction. How would Thersites' ugliness appear to us then? Harmless ugliness can be ridiculous, but when it becomes

5 [Thersites has reviled Agamemnon and attempted to stir up a revolt among the Greeks with the intention of persuading them to abandon the struggle and return home. Odysseus promptly rebukes him and beats him so violently that his back becomes bloody and swollen. Homer tells us (*Iliad* II. 265ff.) that the other Greeks are overcome with laughter at the sight of Thersites weeping.]

6 *Paralipom.* I. 722-81.

7 ["That deprives a man of his reason, / be he ever so wise."]

harmful it is always terrible. I know of no better way to illus-
trate this than by citing two excellent passages from Shake-
speare. Edmund, bastard son of the Earl of Gloucester (in
King Lear), is no less a scoundrel than Richard, Duke of
Gloucester, who opened his way to the throne by committing
the most abominable crimes, and who ascended the throne
as Richard the Third. How is it, then, that the former arouses
far less dread and loathing in us than the latter? When I hear
the bastard son say:

> Thou, Nature, art my goddess; to thy law
> My services are bound. Wherefore should I
> Stand in the plague of custom, and permit
> The curiosity of nations to deprive me,
> For that I am some twelve or fourteen moonshines
> Lag of a brother? Why bastard? wherefore base?
> When my dimensions are as well compact,
> My mind as generous, and my shape as true
> As honest madam's issue? Why brand they us
> With base? with baseness? bastardy? base, base?
> Who, in the lusty stealth of nature, take
> More composition and fierce quality
> Than doth, within a dull, stale tired bed,
> Go to the creating a whole tribe of fops,
> Got 'tween asleep and awake? [8]

I am listening to a devil, but I see him in the form of an angel
of light. However, when I hear the Duke of Gloucester say:

> But I, that am not shap'd for sportive tricks,
> Nor made to court an am'rous looking glass,
> I, that am rudely stampt, and want love's majesty;
> To strut before a wanton ambling nymph;
> I, that am curtailed by this fair proportion,
> Cheated of feature by dissembling nature,
> Deformed, unfinished, sent before my time
> Into this breathing world, scarce half made up,
> And that so lamely and unfashionable,
> That dogs bark at me as I halt by them;
> Why I, in this weak piping time of peace,
> Have no delight to pass away the time,
> Unless to spy my shadow in the sun

[8] *King Lear*, Act I, scene 2.

And descant on mine own deformity;
And therefore, since I cannot prove a lover,
To entertain these fair, well-spoken days,
I am determined to prove a villain! [9]

I hear a devil and I see a devil—and in a form which the devil alone ought to have.

[9] *The Life and Death of Richard III,* Act I, scene 1.

CHAPTER TWENTY-FOUR

Such is the manner in which the poet makes use of physical ugliness. What use can the painter make of it?

Painting, as an imitative skill, can express ugliness; painting as a fine art refuses to do so. As a skill, it may take all visible objects as its subjects; as an art, it restricts itself only to those visible objects which awaken our pleasure.

But do not even unpleasant feelings become pleasing in imitation? No, not all. A perceptive critic [1] has already noted this fact about disgust. "Representations of fear," he says, "of melancholy, terror, compassion, etc., can arouse our dislike only insofar as we believe the evil to be real. Hence, these feelings can be transformed into pleasant ones by recalling that it is an artificial illusion. But whether or not we believe the object to be real, the disagreeable sensation of disgust results, by virtue of the law of our imagination, from the mere mental image. Is the fact that the artistic imitation is ever so recognizable sufficient to reconcile the offended sensibilities? Our dislike did not arise from the supposition that the evil was real, but from the mere mental image of it, which is indeed real. Feelings of disgust are therefore always real and never imitations." [2]

This also applies to the ugliness of forms. Ugliness offends our eyes, contradicts the taste we have for order and harmony, and awakens aversion irrespective of the actual existence of the object in which we perceive it. We do not care to see Thersites either in reality or in a picture; and if the picture is less displeasing, it is not because his physical ugliness ceases being ugly in imitation, but because we are able to disregard this ugliness and derive all our pleasure from the painter's art.

[1] [Moses Mendelssohn.]
[2] *Briefe, die neueste Litteratur betreffend,* V, 102.

But even this pleasure is constantly interrupted by the thought that art has been put to such a bad use, and this consideration will seldom fail to bring about a feeling of contempt for the artist.

Aristotle has found another reason why things which we see with displeasure in nature afford us pleasure when they are most faithfully represented.[3] He calls it the general thirst for knowledge in men. We are pleased when we can learn from the imitation, τί ἕκαστον, what a thing is, or when we can deduce from it, ὅτι οὗτος ἐκεῖνος, that it is this or that thing. But we are unable to infer anything from this in favor of the representation of ugliness. The pleasure which arises from the stilling of our thirst for knowledge is a momentary one, and merely incidental to the object through which it is satisfied. Displeasure, on the other hand, which accompanies our contemplation of ugliness, is permanent, and inherent in the object that awakens it. How is it possible, then, for the former to counterbalance this latter? Still less can the slightly pleasing interest that we feel on noticing the similarity overcome the unpleasant effect of ugliness. The more closely I compare the ugly imitation with its ugly original, the more I expose myself to this effect, so that the pleasure of comparing soon vanishes, leaving behind nothing but the disagreeable impression of a twofold ugliness. To judge from the examples which Aristotle gives, it would seem that he had no intention of including bodily ugliness in those displeasing objects which can afford pleasure in imitation. These examples are ferocious beasts and corpses. Ferocious beasts incite terror, even though they may not be ugly, and it is this terror rather than their ugliness which is transformed into a feeling of pleasure in their imitations. So it is, too, with corpses: it is the keener feeling of pity, the terrifying thought of our own destruction, that makes a real corpse repulsive to us; but in imitation this pity loses its keenness through our awareness that it is a deceit, and the addition of soothing circumstances can either di-

3 *De Poetica,* chap. 4.

vert our thoughts from this fatal recollection or, by uniting itself inseparably with it, cause us to believe that we can see in it something more desirable than terrible.

Physical ugliness cannot in itself be a subject for painting as a fine art, because the feeling that it arouses is not only displeasing, but does not even belong to that class of unpleasant sensations which in imitation are turned into pleasant ones. Now it remains to be seen whether it cannot be useful to painting as an ingredient for strengthening other sensations, just as it is useful to poetry.

May painting make use of ugly forms to attain the ridiculous and the terrible?

I will not venture to answer with an unequivocal "no." It is undeniable that harmless ugliness can become ridiculous in painting too; particularly when an affectation of charm and dignity is combined with it. It is just as incontestable that harmful ugliness excites horror in a painting just as in nature, and that the ridiculous and the terrible, which are in themselves mixed sensations, attain in imitation a new degree of attractiveness and pleasure.

I must point out, however, that in spite of this, painting and poetry are not in exactly the same position. In poetry, as I have already noted, ugliness of form loses its repulsive effect almost entirely by the change from coexistence to the consecutive. From this point of view it ceases to be ugliness, as it were, and can therefore combine even more intimately with other qualities to produce a new and special effect. In painting, on the other hand, ugliness exerts all its force at one time and hence has an effect almost as strong as in nature itself. Harmless ugliness consequently cannot remain ridiculous for long; the unpleasant sensation gains the upper hand, and what was at first comical becomes in course of time merely disgusting. It is the same with harmful ugliness; the element of terror is gradually lost and the deformity is left behind alone and unchanged.

In the light of these considerations Count Caylus was quite right in omitting the Thersites episode from his series of

Homeric paintings. But are we for that reason justified in wishing that they had been left out of Homer's poem itself? I regret to say that a scholar of otherwise correct and refined taste is of this opinion.[4] I shall reserve for another occasion [5] a fuller explanation of my views on this subject.

4 *Klotzii Epistolae Homericae*, pp. 33ff. [Christian Adolf Klotz, 1738-71.]

5 [See the *Briefe antiquarischen Inhalts*, particularly the fifty-first letter.]

CHAPTER TWENTY-FIVE

The second distinction which the critic I have just quoted [1] draws between disgust and other unpleasant sensations may be found in the repugnance which ugliness of form awakens in us.

"Other unpleasant passions," he says, "may, even in nature, and setting aside imitation, frequently please our senses by never exciting pure dislike but always mixing their bitterness with pleasure. Our fear is seldom devoid of all hope. Terror rouses all our powers to escape danger, wrath is linked with the desire for revenge, sorrow with the pleasing recollection of past happiness, and compassion is inseparably bound up with the tender feelings of love and devotion. The soul has the liberty of dwelling now on the pleasing, now on the disagreeable part of a passion, and of creating for itself a mixture of pleasure and displeasure which is more enticing than the purest enjoyment. It requires but little self-observation to find this true numberless times. How else could we explain that to the angry man his anger, to the grieving man his grief, are dearer than all the cheerful ways by which we try to soothe him? But it is a very different matter with disgust and its related sensations. The soul does not recognize any perceptible admixture of pleasure in them. Displeasure gains the upper hand and there is hence no situation, either in nature or in imitation, in which the mind would not recoil in disgust from representations of them." [2]

Quite right. But since the critic himself grants that there are other sensations related to disgust which likewise can produce nothing but dislike, what can be more closely related to disgust than the perception of physical ugliness? This latter

1 [Klotz.]
2 *Klotzii Epistolae Homericae*, p. 103.

too is found in nature without the slightest admixture of pleasure; and since it is equally incapable of admitting any pleasure through imitation, it is likewise impossible to conceive of any condition in which the mind would not recoil from it in disgust.

Indeed, this repugnance, if I have examined my own feelings with sufficient care, is completely of the same nature as disgust. The feeling with which we react to physical ugliness is disgust, only in a lower degree. To be sure, this is at variance with another remark of the critic that only the dullest of our senses, taste, smell, and touch, are exposed to disgust. "The first two," he says, "through an excessive sweetness and the last through the oversoftness of bodies that do not offer sufficient resistance to the nerves that touch them. Such objects then become unbearable to the sense of sight also, but only through the association of ideas in that we recall the repugnance which they cause to our sense of taste or smell or touch. For, strictly speaking, there are no objects of disgust to our sense of sight." It seems to me, however, that there are some such objects. A mole on the face, a harelip, a flat nose with prominent nostrils, a complete lack of eyebrows are cases of ugliness repugnant to neither our sense of smell nor taste nor touch. Still, it is certain that we feel something much more closely akin to disgust than that which other bodily deformities, such as a clubfoot or a high shoulder, awaken in us. The more delicate our temperaments, the more we will feel in our bodies those sensations which precede nausea. The only difference between actual nausea and these sensations is that the latter soon subside and are only rarely followed by actual nausea. The reason for this lies in the fact that, because they are objects of sight, our sense of sight perceives in them and with them a number of realities whose pleasant images weaken and obscure the unpleasant ones to the point where they can have no noticeable influence on the body. On the other hand taste, smell, and touch, our lower senses, cannot perceive such realities while they are being affected by something repugnant; hence repugnance is left to work alone and in its full strength,

and cannot but be accompanied by a far more violent physical reaction.

Furthermore, the disgusting bears exactly the same relation to imitative art as does the ugly. In fact, since its unpleasant effect is more violent, it is even less capable than the ugly of becoming in and of itself a subject for either painting or poetry. Only because its effect is likewise softened by verbal expression should I be bold enough to maintain that the poet can employ at least some disgusting features as an ingredient in producing the mixed sensations of the ridiculous and the terrible which he so successfully heightens by the addition of the ugly.

The disgusting can heighten the ridiculous; or representations of dignity and propriety may be made ridiculous by contrasting them with the disgusting. We can find numerous examples of this in Aristophanes. One that comes to my mind is the weasel that interrupted the good Socrates in his astronomical observations.

> ΜΑΘ. πρώην δέ γε γνώμην μεγάλην ἀφηρέθη
> ὑπ᾿ ἀσκαλαβώτου. ΣΤΡ. τίνα τρόπον; κάτειπέ μοι.
> ΜΑΘ. ζητοῦντος αὐτοῦ τῆς σελήνης τὰς ὁδοὺς
> καὶ τὰς περιφοράς, εἶτ᾿ ἄνω κεχηνότος
> ἀπὸ τῆς ὀροφῆς νύκτωρ γαλεώτης κατέχεσεν.
> ΣΤΡ. ἤσθην γαλεώτῃ καταχέσαντι Σωκράτους.[3,a]

If we suppose that what fell into his open mouth was not disgusting, the ridiculous vanishes altogether. The drollest features of this sort are contained in the Hottentot tale "Tquassouw and Knonmquaiha" in the *Connoisseur*,[4] an English weekly magazine, full of humor, which is ascribed to Lord Chesterfield.[b] We know how dirty the Hottentots[5] are and

3 *Nubes* [*Clouds*] 169-74.

4 [This English weekly, which ran for 140 numbers, was written almost entirely by Colman and Thornton. It was published in four volumes in 1761.]

5 [The African aborigines in the area around the Cape of Good Hope were called Hottentots, or stutterers, by the Dutch.]

how many things that awaken disgust and loathing in us are beautiful, comely, and sacred to them. A piece of flattened cartilage for a nose, flabby breasts which hang down to the navel, the whole body covered with a layer of goat's fat and soot and tanned by the sun, the hair dripping with grease, feet and arms entwined with fresh entrails—think of all this in the object of a fiery, worshiping, tender love; hear this expressed in the noble language of sincerity and admiration, and try to keep from laughing.

The disgusting seems capable of an even greater degree of amalgamation with the terrible. That which we call horrible is nothing more than the terrible which has been made disgusting. Longinus [6] does not like the τῆς εκ μὲν ῥινῶν μύξαι ῥεόν [7] in Hesiod's picture of Sadness; [8] not so much, it seems to me, because it is a disgusting trait, but because it is one that contributes in no way to the terrible. For he appears to have no objection to the long nails protruding beyond the fingers (μακροὶ δ' ὄνυχες χείρεσσιν ὑπῆσαν), although long nails are scarcely less disgusting than a running nose. But long nails are also terrible, for they tear the flesh from the cheeks so that the blood streams to the ground:

. . . ἐκ δὲ παρειῶν
αἷμ' ἀπελείβετ' ἔραζε . . . [9]

A running nose, on the other hand, is nothing but a running nose, and I can only advise Sadness to keep her mouth shut. Or let us read Sophocles' description of the wretched cave of the unfortunate Philoctetes. There is no trace of food nor of life's comforts to be seen except for a trampled litter of dry leaves, a misshapen wooden bowl, a piece of flint. This is the whole wealth of the sick and deserted man! How does the poet complete this sad and fearful picture? By adding an ele-

[6] Περὶ Ὕψους, τμῆμα δ' ["On the Sublime"], p. 15 (ed. T. Fabri.).
[7] ["from their noses a discharge flowed."]
[8] Scutum Hercules 266. ['Ασπὶς 'Ηρακλέους, "the shield of Hercules."]
[9] ["from the cheeks blood ran to the earth."]

ment of disgust. "Ha!" Neoptolemus suddenly starts back in shock. "There is a heap of torn rags full of blood and pus drying here!"

NE. ὁρῶ κενὴν οἴκησιν ἀνθρώπων δίχα.
ΟΔ. οὐδ' ἔνδον οἰκοποιός ἐστί τις τροφή;
NE. στείπτή γε φυλλὰς ὡς ἐναυλίζοντί τῳ.
ΟΔ. τὰ δ' ἄλλ' ἔρημα, κοὐδέν ἐσθ' ὑπόστεγον;
NE. αὐτόξυλόν γ' ἔκπωμα φαυλουργοῦ τινὸς τεχνήματ' ἀνδρός, καὶ πυρεῖ' ὁμοῦ τάδε.
ΟΔ. κείνου τὸ θησαύρισμα σημαίνεις τόδε.
NE. ἰού, ἰού· καὶ ταῦτά γ' ἄλλα θάλπεται ῥάκη, βαρείας του νοσηλείας πλέα.[10,c]

Homer's Hector too, when he has been dragged over the ground, becomes disgusting; his face is disfigured by blood and dust, and his hair is matted,

Squalentem barbam et concretos sanguine crines,[11]

as Virgil puts it; [12] a disgusting object, but he is for that very reason all the more terrible and moving. Who can picture to himself the punishment of Marsyas,[13] in Ovid, without a feeling of disgust?

Clamanti cutis est summos direpta per artus:
Nec quidquam, nisi vulnus erat: cruor undique manat:
Detectique patent nervi: trepidaeque sine ulla
Pelle micant venae: salientia viscera possis,
Et perlucentes numerare in pectore fibras.[14,d]

But who does not feel, at the same time, that the disgusting is in its proper place here? It makes the terrible horrible; and the horrible is not altogether displeasing even in nature, so

[10] *Philoctetes* 31-39.
[11] ["Beard befouled and hair filled with clotted blood."]
[12] *Aeneid* II. 277.
[13] [According to Greek legend, Marsyas found the flute which Athena had thrown away and challenged Apollo to a contest in music. Just as the Muses, who were the judges of the contest, were about to award the prize to Marsyas, the god Apollo picked up his lyre and began to sing. They then decided in favor of Apollo, and he, in his anger at the presumption of Marsyas, flayed him alive. Cf. Meyers, *Konversationlexikon* (6th ed.), XIII, 361.]
[14] *Metamorph.* VI. 387ff.

long as our compassion is engaged. And how much less so in imitation! I do not wish to overburden the reader with examples, and yet I must make one further observation: there is a type of the terrible to which the poet has access almost solely through the element of disgust. It is the awful aspect of hunger. Even in ordinary life we can express an extreme degree of hunger only by enumerating all the unnutritious, unwholesome, and particularly disgusting things with which the stomach must needs be satisfied. Since imitation cannot excite in us the actual feeling of hunger, it resorts to arousing another unpleasant feeling which, in the case of starvation, we recognize as the lesser evil. It seeks to arouse this feeling in us so that from our dislike of it we may infer just how strong the other discomfort must be, under whose influence we would readily forget the present one.

Ovid says of the Oread, whom Ceres has sent out to meet Famine:

Hanc (Famem) procul ut vidit . . .
. . . refert mandata deae; paulumque morata,
Quanquam aberat longe, quanquam modo venerat illuc,
Visa tamen sensisse famem . . . [15,e]

An unnatural exaggeration! The sight of a hungry person, even though it be Famine herself, does not have this contagious power. Pity, horror, and disgust it might awaken in one, but not hunger. Ovid has not spared us this horror in his description of *Fames,* and in his depiction of the starvation of Eresichthon, as well as in that by Callimachus,[16] the disgusting features are the strongest. After Eresichthon has consumed everything, not even sparing the sacrificial cow which his mother had raised for Vesta, Callimachus has him fall upon horses and cats, and beg in the streets for the crumbs and filthy leftovers from other people's tables:

Καὶ τὰν βῶν ἔφαγεν, τὰν Ἑστίᾳ ἔτρεφε μάτηρ,
Καὶ τὸν ἀεθλόφορον καὶ τὸν πολεμήιον ἵππον,

[15] *Ibid.,* VIII. 809.
[16] *Hymnus in Cererem* 111[109]-16 [*Hymn to Demeter* VI].

Καὶ τὰν αἴλουρον, τὰν ἔτρεμε θήρια μικκά—
Καὶ τόθ' ὁ τῶ βασιλῆος ἔνι τριόδοισι καθῆστο
αἰτίζων ἀκόλως τε καὶ ἔκβολα λύματα δαιτός.[17]

And Ovid has him finally set his teeth into his own limbs in order to nourish his body with his own flesh:

Vis tamen illa mali postquam consumserat omnem
Materiam . . .
Ipse suos artus lacero divellere morsu
Coepit; et infelix minuendo corpus alebat.[18]

The hideous Harpies were thought of as being stinking and filthy so that the hunger caused by their snatching away the food would appear all the more terrible. Let us listen to the lament of Phineus in Apollonius' account:

τυτθὸν δ' ἦν ἄρα δή ποτ' ἐδητύος ἄμμι λίπωσι,
πνεῖ τόδε μυδαλέον τε καὶ οὐ τλητὸν μένος ὀδμῆς.
οὔ κέ τις οὐδὲ μίνυνθα βρότων ἄνσχοιτο πελάσσας,
οὐδ' εἰ οἱ ἀδάμαντος ἐληλαμένον κέαρ εἴη.
ἀλλά με πικρὴ δῆτά κε δαῖτος ἐπίσχει ἀνάγκη
μίμνειν, καὶ μίμνοντα κακῇ ἐν γαστέρι θέσθαι.[19, f]

I should like to justify from this point of view the introduction of the revolting Harpies in Virgil; [g] but the hunger described there is not a real and present one that the Harpies bring about, but an impending one that they prophesy. And, as a matter of fact, the whole prophecy ends up in a play on words. Dante, too, not only prepares us for the account of Ugolino's starvation by putting him and his former persecutor in the most disgusting, most horrible position in Hell, but the starvation itself is not without certain disgusting features which affect us most strongly when the sons offer themselves to

17 ["And he devoured the cow which his mother had reared for Vesta, and his victorious warhorse, and the cat, at whose sight small animals tremble; and he, the son of the king, sat in the streets begging for scraps of bread and for the thrown-away remnants of the feast" (Hamann, p. 286).]

18 ["But when the violence of the evil had consumed all possible food . . . he began to lacerate his own limbs with his teeth; and the wretch sustained his body by consuming it" (Hamann, p. 286).]

19 *Argonautica* II. 228-33.

their father as food.[h] In the footnote I quote a passage from a play by Beaumont and Fletcher which might have served in place of all my other examples were it not for the fact that I must acknowledge that it is a bit too exaggerated.[i]

I come now to disgusting objects in painting. Even if it were an indisputable fact that there is, properly speaking, no such thing as an object disgusting to the sight—which painting as a fine art would naturally renounce—disgusting objects would still have to be avoided because the association of ideas renders them disgusting to the sight also. In a painting of the burial of Christ, Pordenone pictures one of the bystanders holding his nose. Richardson objects to this on the ground that Christ has not been dead long enough for his body to have begun to putrefy.[20] But in the case of the resurrection of Lazarus he believes that the painter might be allowed to depict some of the bystanders in such an attitude, because the story expressly states that his body had already begun to smell. To my mind this representation would be unthinkable here, too, for not only does actual stench, but even the very idea of it, awaken a feeling of disgust. We avoid places that stink, even when we have a cold. But painting, it may be objected, does not want the disgusting for its own sake; just as is true of poetry, it needs it to intensify the ridiculous and the terrible. At its own peril! But what I have said about the ugly in this respect applies all the more to the disgusting. It loses incomparably less of its effect in an imitation which is meant for the eye than in one which is meant for the ear. Consequently, it will blend less closely with elements of the ridiculous and the terrible in the former than in the latter instance, for as soon as our surprise is over and our first eager look satisfied, the disgusting becomes a separate thing again and appears before us in its own crude form.

20 Richardson, *de la Peinture*, I, 74.

CHAPTER TWENTY-SIX

Herr Winckelmann's *History of Ancient Art* [a] has appeared, and I shall not venture another step until I have read it. To speculate subtly on art merely on the basis of general ideas might lead us to fanciful conclusions, which sooner or later and to our shame we should find refuted in the works of art. The ancients, too, knew the bonds connecting painting and poetry, and they have not, I believe, drawn them more tightly than was advantageous for both. What their artists did will teach me what artists in general should do; and where such a man as Winckelmann carries the torch of history before him, speculation may boldly follow.

We usually leaf through an important work before beginning to read it seriously. In my case, I was above all curious to learn the author's opinion of the Laocoön, not with regard to the artistic aspect of the work which he has already discussed elsewhere, but as to its date. Whose side does he take in this matter? The side of those who believe Virgil to have had the statue before his eyes, or those who believe that the artists worked from the poem?

I am very much pleased to find that he says absolutely nothing of an imitation on the part of the one or the other. Where is the absolute necessity for it? It is by no means impossible that the points of similarity between the poetic description and the work of art, which I have considered above, are incidental rather than intentional, and that, far from one serving as a model for the other, both need not even have had a common model. Nevertheless, if he too had been dazzled by the semblance of such imitation, he would have been obliged to declare himself in favor of those who believe that the poet had the statue before his eyes. For he assumes that the Laocoön dates from the time when art had reached its highest peak of

perfection under the Greeks, that is, from the age of Alexander the Great.

"The kindly fate," he says, "that watched over art even during its destruction, has to the amazement of the whole world preserved a work from this period of art, proving the truth of history in ascribing a high degree of excellence to so many destroyed masterworks. The statue of Laocoön and his two sons, done by Agesander, Apollodorus,[1] and Athenodorus of Rhodes, is most probably from this period, although this cannot be definitely proved nor the Olympiad given in which these artists flourished, as some have tried to do." [2]

In a note, he adds: "Pliny does not say a word about the time when Agesander and his assistants lived, but Maffei, in his commentary on ancient statues, seems to think it certain that these artists flourished in the 88th Olympiad. Relying on his word, Richardson and others have adopted the theory. Maffei has, I believe, mistaken an Athenodorus among the pupils of Polycletus for one of our artists, and since Polycletus flourished in the 87th Olympiad, he has placed his supposed pupil one Olympiad later. Maffei can have no other grounds."

It is quite certain that he could not have any other. But why is Herr Winckelmann content with merely stating this supposed reason of Maffei? Does it refute itself? Not quite, for although there is no further evidence to support it, it constitutes of itself a slight probability, unless it can be shown that Athenodorus, Polycletus' pupil, and Athenodorus, associate of Agesander and Polydorus, cannot possibly have been one and

[1] Not Apollodorus, but Polydorus. Pliny is the only one who mentions these artists, and I do not think that the manuscripts differ in regard to this name. If they do, Hardouin would surely have noticed it. The older editions have Polydorus, too, so Winckelmann must have made this minor error in transcription here. [Lessing is entirely right in making this emendation. In later editions of Winckelmann's works, which were emended in various places after a thorough examination of unpublished papers which came to light after Winckelmann's death, the passage quoted by Lessing was corrected to read "Polydorus." Lessing is hence undoubtedly correct in assuming that the error was one of transcription.]

[2] *Geschichte der Kunst*, II, 347.

the same person. Fortunately, however, this can be shown by the fact that they were from different places. According to the express testimony of Pausanias,[3] the first Athenodorus came from Clitor in Arcadia, whereas the second, according to Pliny, was a native of Rhodes.

Herr Winckelmann cannot have acted intentionally in declining to refute Maffei's assertion by producing this evidence. Rather it must be that the reasons which he derives, with his unquestionable knowledge, from the art revealed in the execution of the work appeared so important to him that he did not trouble to ask himself whether or not Maffei's opinion still retains some probability. Undoubtedly he recognizes in the Laocoön too many of those *argutiae* [4] characteristic of Lysippus to assume it to be of an earlier date than Lysippus, who was the first to enrich art with such *argutiae*.

But even if it is a proven fact that Laocoön cannot be earlier than Lysippus, does this necessarily mean that it must be roughly contemporaneous, or that it could not possibly belong to a far later time? Passing over the time prior to the beginnings of the Roman monarchy, when Greek art now raised and now dropped its head, why could not the Laocoön have been the happy result of a competition which the extravagant splendor of the first emperors must have kindled among the artists? Why could not Agesander and his associates have been contemporaries of a Strongylion, an Arcesilaus, a Pasiteles, a Posidonius, or a Diogenes? For were not some of the works of these masters also considered to rank among the best that art ever produced? If pieces, unquestionably from their hands, were still extant but the time of their creators unknown and inferable only from their style, would it not take an almost divine inspiration to prevent the critic from believing that he ought to attribute them to the only age which

[3] Ἀθηνόδωρος δὲ καὶ Δαμίας—οὗτοι δὲ Ἀρκαδές εἰσινἐκ Κλείτορος (*Phocis* IX. 5-9, p. 819, ed. Kuhn.). ["Athenodorus and Damias—these are Arcadians from Clitor."]

[4] Pliny, XXXIV. 19, p. 653 (ed. Hard.). ["Keenness of details." Lessing writes *argutiis* to make the Latin word conform with the German case.]

Herr Winckelmann thinks capable of having produced the Laocoön?

It is true that Pliny does not expressly mention the time at which the artists of the Laocoön lived. Yet if I had to judge from the context of the entire passage whether he meant them to be considered among the early rather than among the later artists, then I must confess that I hold the latter to be more probable. But let each one judge for himself.

After discussing the oldest and greatest masters of sculpture, Phidias, Praxiteles, and Scopas, at some length and then naming the others, without any chronological order, and particularly those whose works were represented in Rome, Pliny continues in the following way:

> Nec multo pluriam fama est, quorundam claritati in operibus eximiis obstante numero artificum, quoniam nec unus occupat gloriam, nec plures pariter nuncupari possunt, sicut in Laocoonte, qui est in Titi imperatoris domo, opus omnibus et picturae et statuariae artis praeponendum. Ex uno lapide eum et liberos draconumque mirabiles nexus de consilii sententia fecere summi artifices, Agesander et Polydorus et Athenodorus Rhodii. Similiter Palatinas domus Caesarum replevere probatissimis signis Craterus cum Pythodorus, Polydectes cum Hermolao, Pythodorus alius cum Artemone, et singularis Aphrodisius Trallianus. Agrippae Pantheum decoravit Diogenes Atheniensis, et Caryatides in columnis templi eius probantur inter pauca operum: sicut in fastigio posita signa, sed propter altitudinem loci minus celebrata.[5, b]

Of all the artists mentioned in this passage, Diogenes of Athens is the only one whose era is incontestably determined. He decorated the Pantheon of Agrippa, which means that he lived in the time of Augustus. And yet if we examine Pliny's words more carefully, I believe that we may determine just as unquestionably the era of Craterus and Pythodorus, of Polydectes and Hermolaus, of the second Pythodorus and Artemon and of Aphrodisius of Tralles. He says of them: "Palatinas domus Caesarum replevere probatissimis signis." Can this, may I ask, mean only that the palaces of the em-

[5] XXXVI. 4, p. 730.

perors were filled with their excellent works, in the sense that the Caesars had them collected from everywhere and brought to their palaces in Rome? Certainly not. The artists must have created their works expressly for these imperial palaces, hence they must have lived during the time of these emperors. That they were artists of a late period, who worked only in Italy, may be inferred from the fact that they are not mentioned anywhere else. If they had been active in Greece at an earlier period, Pausanias would have seen one or another of their works and preserved their memory for us. He makes mention of a certain Pythodorus, to be sure,[6] but Hardouin is incorrect in identifying him with the Pythodorus of Pliny's passage. For Pausanias calls one of the formers's works, a statue of Juno which he saw at Coronea in Boeotia, ἄγαλμα ἀρχαῖον,[7] a designation which he applies only to the works of those masters who lived in the earliest, most primitive age of art, long before a Phidias or a Praxiteles. And the emperors surely would not have filled their palaces with such works as theirs. Still less attention is to be given to Hardouin's conjecture that Artemon was perhaps the same Artemon mentioned by Pliny in another passage. Similarity of names affords only a very low probability, and surely does not entitle us to distort the natural interpretation of an uncorrupted passage.

If there is, then, no doubt that Craterus and Pythodorus, Polydectes and Hermolaus and the others lived at the time of the emperors whose palaces they filled with their excellent works, it seems to me that we can assign no other date also to these artists, from whom Pliny passes on to his discussion of the others by means of a *similiter*.[8] These are the sculptors of the Laocoön. Let us consider for a moment: if Agesander, Polydorus, and Athenodorus were such old masters as Herr Winckelmann takes them to be, how unnatural it would seem for an author, to whom precision of expression is no small matter, when he is forced to jump suddenly from them to the

6 *Boeotia* XXXIV. [6], p. 778 (ed. Kuhn.).

7 ["the work of an early master."]

8 ["in the same way."]

very latest artists, to take his leap with the words "in the same way"!

But, it will be objected, this *similiter* does not refer to a connection in point of time but to another circumstance which these sculptors, so different as to period, had in common. Pliny, it will be said, was speaking of those artists who worked together and because of this collaboration remained less known than they deserved to be. For since the individual artist could not claim the sole honor of a work done in common, and since it would have been too tedious to name all those that shared in the work (*quoniam nec unus occupat gloriam, nec plures pariter nuncupari possunt*), their names were simply neglected. This, says Pliny, happened to the sculptors of the Laocoön and to quite a number of other artists whom the emperors commissioned to decorate their palaces.

I grant all this, but even so it is highly probable that Pliny was referring only to later artists who worked in collaboration; for if he were referring also to the earlier ones, why is it that he mentioned only the sculptors of the Laocoön? Why not others, too? For instance Onatas or Calliteles; Timocles or Timarchides; or the sons of Timarchides, whose statue of Jupiter, a joint work, was in Rome? [9] Herr Winckelmann himself says that a long list could be made of such older works which had more than one father.[10] And are we to believe that Pliny would have been able to remember only Agesander, Polydorus, and Athenodorus if he had not expressly restricted himself to most recent times?

Besides, if the probability of a conjecture increases in proportion to the number and importance of the problems which can be explained by it, then the supposition that the creators of the Laocoön flourished during the time of the first Caesars takes on a high degree of probability. For if they had been active in Greece at the time that Herr Winckelmann claims, and if the Laocoön itself had formerly been in Greece, the

9 Pliny, XXXVI. 4, p. 730.
10 *Geschichte der Kunst*, Pt. II, p. 331.

deep silence observed by the Greeks about such a work (*opere omnibus et picturae et statuariae artis praeponendo*) would be remarkable. It would be surprising if such great artists had created nothing more, or if Pausanias should have failed to see any of their other works all over Greece just as he had failed to see the Laocoön. In Rome, on the other hand, the greatest masterwork might have remained in obscurity for a long time, and even if the Laocoön had been done at the time of Augustus, there would be nothing strange in Pliny's being the first and only one to mention it. For we need only remember what he says of a Venus by Scopas, which stood in a temple of Mars in Rome:

. . . quemcunque alium locum nobiliatura. Romae quidem magnitudo operum eam obliterat, ac magni officiorum negotiorumque acervi omnes a contemplatione talium abducunt: quoniam otiosorum et in magno loci silentio apta admiratio talis est.[11]

Those who prefer to see in the Laocoön group an imitation of Virgil's Laocoön will accept what I have said up to now with a great deal of satisfcation. Another conjecture might occur to me which they would likewise gladly accept. Perhaps, they might think, it was Asinius Pollio who commissioned Greek artists to do a Laocoön from Virgil's description. Pollio was a particular friend of the poet, outlived him, and seems even to have written a work on the *Aeneid* himself. For where else but in a work of his own upon this poem could the scattered remarks that Servius quotes from him have found a place so easily? [12] At the same time, Pollio was a lover and connoisseur of art, possessed a rich collection of fine old art works, and commissioned the artists of his day to execute new ones.

11 Pliny [XXXVI. 4], p. 727. ["She would lend luster to every place. In Rome, it is true, the number of great works obscures her, and the pressure of business and of obligations of all kinds draws every one away from the contemplation of such works, to the full appreciation of which leisure and quiet are indispensable" (Hamann, p. 291).]

12 From the *Aeneid* II. 7, and particularly from XI. 183. One might therefore justifiably add such a work to the list of this author's lost writings.

So bold a piece as the Laocoön was in perfect accordance with the taste which he displayed in his selection: "ut fuit acris vehementiae sic quoque spectari monumenta sua voluit." [13] However, since Pollio's art collection seems to have been kept intact in one particular place at the time of Pliny, when the Laocoön stood in the palace of Titus, this supposition might, on the other hand, lose some of its probability. And after all, why couldn't Titus himself have done what we are attempting to ascribe to Pollio?

[13] Pliny, XXXVI. 4, p. 729. ["Being in general violent in his desires, he wished to make his buildings too the objects of public admiration" (Hamann, p. 291).]

CHAPTER TWENTY-SEVEN

My opinion that the sculptors of the Laocoön worked under the first Caesars, or that at least the group cannot be as early as Herr Winckelmann supposes, is strengthened by a bit of information which he himself is the first to publish. It is this:

At Nettuno,[1] formerly called Antium, Cardinal Alexander Albani discovered in the year 1717 in a large vault, sunk beneath the sea, the base of a statue. It is of greyish black marble, now called *bigio,* into which the group was fitted; upon it was the following inscription:

ΑΘΑΝΟΔΩΡΟΣ ΑΓΗΣΑΝΔΡΟΥ
ΡΟΔΙΟΣ ΕΠΟΙΗΣΕ

("Athanodorus, son of Agesander, of Rhodes, made it.") We learn from this inscription that father and son worked on the Laocoön, and presumably Apollodorus (Polydorus), son of Agesander also; for this Athanodorus can be no other than the one mentioned by Pliny. The inscription also proves that there were more than only three works, as Pliny has it, on which artists inscribed the word "made" in the past definite time (aorist), namely ἐποίησε, *fecit.* All the other artists, he reports, expressed it, out of modesty, in the imperfect, ἐποίει, *faciebat.*[2]

Herr Winckelmann will find little opposition to his assertion that the Athanodorus of this inscription can be no other than the Athenodorus whom Pliny mentions as one of the sculptors of the Laocoön. Athanodorus and Athenodorus are most certainly the same name, for the Rhodians spoke the Doric dialect. But I must make a few comments on the other conclusions that Herr Winckelmann draws from this inscription.

[1] [A town of Latium, about fifteen miles south of Rome, on the coast. Among a number of statues found there were the Apollo Belvedere and the Borghese gladiator.]

[2] ["was making."] *Geschichte der Kunst,* II, 347.

The first conclusion, that Athenodorus was a son of Agesander, may pass. It is very probable, though not incontestable, for it is known that there were ancient artists who, instead of using their father's name, preferred to adopt that of their teacher. What Pliny says about the brothers Apollonius and Tauriscus will scarcely admit of any other interpretation.[3]

But what does this mean? Is this inscription supposed to refute Pliny's assertion that no more than three works of art were to be found on which their creators acknowledged their productions in the aorist (by ἐποίησε instead of ἐποίει)? This inscription? Why should we first learn from this inscription what we could have learned long ago from countless others? Hadn't the words Κλεομένης ἐποίησε already been found on the statue of Germanicus?[4] And 'Αρχέλαος ἐποίησε[5] on the so-called "Apotheosis of Homer"? And Σαλπίων ἐποίησε on the famous vase at Gaeta?[6] And so on.

Herr Winckelmann can say: "Who knows this better than I? But," he will add, "so much the worse for Pliny. The more often his assertion is contradicted, the more definite the refutation is."

Not yet, I say. For what if Herr Winckelmann makes Pliny say more than he really means? What if the examples I have cited do not refute Pliny's assertion, but only the additional elements which Winckelmann has introduced into it? And this is actually the case. I must quote the whole passage. In

3 XXXVI. 4, p. 730.

4 ["Cleomenes made it." Actually, there were two well-known Greek sculptors of that name, father and son. They lived at Athens during the second half of the first century B.C. The supposed statue of Germanicus is attributed to the son, and the Medicean Venus to the father. The statue to which Lessing refers is now thought to represent a Roman orator and not Germanicus.]

5 ["Archelaus made it." This is the bas-relief, thought to be a Roman work of the first century B.C., now in the British Museum.]

6 See the list of inscriptions on ancient works of art in Marquard Gudius (ad Phaedri fabulas, V, Bk. I) and also Gronov's correction of this passage (Praefatio to Vol. IX, Thesaurus Antiquitatum Graecarum).

his dedication to Titus, Pliny wishes to refer to his work with
the modesty of a man who himself best knows how far from
perfect it is. He finds a strange example of such modesty in
the Greeks, whose boastful and ambitious title pages (*inscrip-
tiones, propter quas vadimonium deseri possit* ["titles for the
sake of which one could miss a deadline"]) he criticizes at some
length, and goes on to say:

> Et ne in totum videar Graecos insectari, ex illis nos velim
> intelligi pingendi fingendique conditoribus, quos in libellis
> his invenies, absoluta opera, et illa quoque quae mirando
> non satiamur, pendenti titulo inscripsisse: ut APELLES
> FACIEBAT, aut POLYCLETUS: tanquam inchoata semper
> arte et imperfecta: ut contra iudiciorum varietates super-
> esset artifici regressus ad veniam, velut emendaturo quidquid
> desideraretur, si non esset interceptus. Quare plenum vere-
> cundiae illud est, quod omnia opera tanquam novissima
> inscripsere, et tamquam singulis fato adempti. Tria non
> amplius, ut opinor, absolute traduntur inscripta, ILLE
> FECIT, quae suis locis reddam: quo apparuit, summam
> artis securitatem auctori placuisse, et ob id magna invidia
> fuere omnia ea.[7, a]

I call attention to Pliny's words: *pingendi fingendique con-
ditoribus* ["masters of painting and sculpture"]. Pliny does not
say that the practice of declaring oneself the author of a work
in the imperfect tense was a general one, observed by all artists
of all times; he expressly states that only the first of the old
masters, those initiators of the fine arts, *pingendi fingendique
conditores,* an Apelles, a Polycletus, and their contemporaries
showed this wise modesty. And since he mentions only these
names, he silently but unmistakably intimates that their suc-
cessors, particularly in later times, expressed greater confidence
in themselves.

But if we accept this interpretation, as everyone surely
must, then the inscription of one of the three artists of the
Laocoön that has been discovered may be perfectly correct
without changing the truth of Pliny's assertion that there
were only three extant works in whose inscriptions their

[7] Bk. I, p. 5 (ed. Hard.).

authors used the aorist, that is, among the works of earlier artists from the periods of Apelles, Polycletus, Nicias, and Lysippus. But if this is true, then it cannot be correct that Athenodorus and his associates were contemporaries of Apelles and Lysippus, as Herr Winckelmann would have it. We must rather reason thus: if it is true that among the works of the earlier artists, of Apelles, Polycletus, and the others of this class, there are only about three to be found in whose inscriptions the aorist is used; if it is true that Pliny himself mentioned these three works by name,[b] then Athenodorus, who did none of these works and who nevertheless uses a perfect tense in the inscriptions on his works, cannot belong to these ancient artists. He cannot be a contemporary of Apelles or Lysippus but must be placed at a later date.

In short, I believe that we may accept as a reliable criterion the fact that all artists who have used the ἐποίησε flourished long after the time of Alexander the Great, shortly before or during the time of the Caesars. This is indisputably true of Cleomenes, highly probable of Archelaus, and of Salpion the contrary at least cannot in any way be proved. The same may be said of the rest, including Athenodorus.[8]

Herr Winckelmann may judge all this for himself! I for my part protest in advance against the converse proposition. If all the artists who used ἐποίησε belong to the later period, it does not necessarily follow that all those who used ἐποίει belong to the earlier one. Even among the later artists there may have been some who actually possessed this modesty so becoming to a great man, and there may have been others who pretended to possess it.

8 [Lessing's theory that the use of the imperfect or the aorist in inscriptions on ancient statues can assist us in determining their time of origin is no longer accepted. One of the principal reasons for this is the simple fact that the aorist is found on statues of every possible date (cf. Blümner, pp. 676-77).]

CHAPTER TWENTY-EIGHT

Next to his comments on Laocoön I was most curious to see what Herr Winckelmann might say about the so-called Borghese gladiator. I believe that I have made a discovery about this statue, of which I am as proud as one can be of such discoveries.

I was afraid that Herr Winckelmann might have anticipated me, but I find nothing in his work to justify this fear; and if anything could make me suspicious of the validity of my discovery, it would be the fact that my apprehensions were not realized.

Some (says Herr Winckelmann) take this to be a statue of a discobolus, that is, of a man throwing a disc or a plate of metal, and this was the opinion that the famous Herr von Stosch expressed in a letter to me. However, it was formed without a sufficiently careful examination of the posture in which such a figure would be represented. For anyone about to hurl something leans backward so that at the moment of throwing, the weight of the body rests on the right leg while the left remains idle. Here, however, it is just the reverse. The whole figure is bent forward, resting on the left leg, and the right leg is stretched back as far as possible. The right arm is a later addition, and a piece of a lance has been placed in his hand. On the left arm there is the strap of the shield which he carried. If one observes that the head and eyes are directed upward and that the figure appears to be defending itself against something that threatens it from above, one could justifiably take this statue to be that of a warrior who has especially distinguished himself in a dangerous situation. Gladiators at public shows were presumably never honored with a statue by the Greeks, and besides, this work appears to be earlier than the introduction of gladiators into Greece.[1]

No criticism could be more just. This statue is no more that of a gladiator than of a discus thrower; it is in reality the

[1] *Geschichte der Kunst*, II, 394.

representation of a warrior who, in the position in which he is depicted, had distinguished himself in a time of danger. But since Herr Winckelmann has made such a happy conjecture here, how does it happen that he stopped at this point? Why didn't he think of the warrior, who in this very same position averted the total defeat of an army and to whom his grateful nation had a statue erected in exactly the same position? In a word, the statue represents Chabrias.

The following passage from Nepos' biography of this General furnishes proof for this.

> Hic quoque in summis habitus est ducibus: resque multas memoria dignas gessit. Sed ex his elucet maxime inventum eius in proelio, quod apud Thebas fecit quum Boeotiis subsidio venisset. Namque in eo victoriae fidente summo duce Agesilao, fugatis iam ab eo conductitiis catervis, reliquam phalangem loco vetuit cedere, obnixoque genu, scuto, proiectaque hasta impetum excipere hostium docuit. Id novum Agesilaus contuens, progredi non est ausus, suosque iam incurrentes tuba revocavit. Hoc usque eo tota Graecia fama celebratum est, ut illo statu Chabrias sibi statuam fieri voluerit, quae publice ei ab Atheniensibus in foro constituta est. Ex quo factum est, ut postea athletae, ceterique artifices his statibus in statuis ponendis uterentur, in quibus victoriam essent adepti.[2, a]

I know that the reader will hesitate a moment before agreeing with me—but I hope it will really be for a moment only. The posture of Chabrias does not seem to be exactly the same as that of the Borghese statue. The extended lance, *proiecta hasta,* is the same in both, but the commentators explain the *obnixo genu scuto* by *obnixo in scutum, obfirmato genu ad scutum:* Chabrias showed his soldiers how they should press their shields against their knees and wait behind them for the enemy; the statue, however, holds the shield aloft. But suppose the commentators were wrong? Is it not possible that the words *obnixo genu scuto* do not belong together, but that *obnixo genu* and *scuto* should be taken separately, or the last connected to the words *proiectaque hasta* which follow? By

2 Chap. 2.

inserting a single comma the correspondence becomes absolutely perfect. The statue is that of a soldier, *qui obnixo genu*,[3] *scuto proiectaque hasta impetum hostis excipit;* it represents what Chabrias did and is the statue of Chabrias. That a comma is really lacking is shown by the *que* added to the *proiecta,* which would be superfluous if *obnixo genu scuto* belonged together. Some editions have actually omitted the comma on that account.

Accordingly, the statue would be very old, and with this age the form of the letters in the inscription is in perfect agreement;[4] Herr Winckelmann himself has inferred from this that it is the most ancient of the statues now in Rome on which the sculptors recorded their names. I shall leave it to his perceptive eye to determine whether he observes anything in its style that would conflict with my opinion. Should he approve of my suggestion, I should flatter myself that I had offered a better example of how successfully classical authors may be explained by ancient works of art and in turn how these may be explained by them, than can be found in the whole of Spence's folio.

[3] Statius uses *obnixa pectora* (*Thebaid* VI. 866): . . . *rumpunt obnixa furentes Pectora**—which the old commentator on Barth explains by *summa vi contra nitentia.* Ovid (*Halieutica* 12) uses *obnixa fronte* when describing the *scarus* trying to force its way through the fish-trap with its tail rather than its head: *Non audet radiis obnixa occurrere fronte.*†

* ["In great rage they crush the breast braced against it."]
† ["Not with its head first does does it run against the trap."]
[4] ["This is not the case; on the contrary, the shape of the letters indicates that the statue was not made before the time of Sulla" (Blümner, p. 669).]

CHAPTER TWENTY-NINE

Herr Winckelmann, who brought both boundless reading and a most extensive and perceptive knowledge of art to his *History*, has gone about his task with the same noble self-assurance that we see in the ancient artists, who devoted all their energies to the main subject and either treated secondary things with, as it were, conventional carelessness or assigned them to the next best artist who happened to come along.

It is no small merit for a man to have committed only such errors as anyone might have avoided. They strike one at a first, cursory reading, and if I make note of them at all, it is only to remind certain people who think they alone have eyes that these errors are not worth noting in the first place.

In his writings on the imitation of Greek works of art Herr Winckelmann had previously let himself be misled several times by Junius. Junius is a very deceptive author; his entire work is a *cento*,[1] and because he always attempts to use the language of the ancients, he not infrequently applies to painting passages from them which refer in their original context to anything but painting. For example, when Herr Winckelmann wants to tell us that the ideal cannot be achieved, either in art or in poetry, through a mere imitation of nature, and that both poet and painter should prefer the impossible which is plausible to the mere possible, he adds: "the possibility and truth which Longinus demands of a painter, as opposed to the incredible in poetry, is quite consistent with this." But this addition had best been left out, for it shows the two

1 [*Cento* originally meant a piece of patchwork, i.e., cloth made of all sorts of scraps and rags. Hence, in the figurative sense, a *cento* is a poem pieced together out of verses or words and phrases taken from other poets. This is what Lessing calls Junius' *De pictura veterum*.]

greatest art critics [2] in a contradiction that is entirely without foundation. It is untrue that Longinus ever said anything like that. He says something similar of rhetoric and poetry, but certainly not of poetry and painting.

Ὡς δ' ἕτερόν τι ἡ ῥητορικὴ φαντασία βούλεται, καὶ ἕτερον ἡ παρὰ ποιηταῖς, οὐκ ἂν λάθοι σε, οὐδ' ὅτι τῆς μὲν ἐν ποιήσει τέλος ἐστὶν ἔκπληξις, τῆς δ' ἐν λόγοις ἐνάργεια,[3]

he writes to his friend Terentianus; and again,

Οὐ μὴν ἀλλὰ τὰ μὲν παρὰ τοῖς ποιηταῖς μυθικωτέραν ἔχει τὴν ὑπερέκπτωσιν, καὶ πάντη τὸ πιστὸν ὑπεραίρουσαν· τῆς δὲ ῥητορικῆς φαντασίας, κάλλιστον ἀεὶ ἔμπρακτον καὶ ἐναληθές.[a]

It is Junius who substitutes painting for rhetoric; and it was in his writings and not in Longinus' that Herr Winckelmann read: "Praesertim cum Poeticae phantasiae finis sit ἔκπληξις, Pictoriae vero, ἐνάργεια. Καὶ τά μὲν παρὰ τοῖς ποιηταῖς ut loquitur idem Longinus," etc.[4] Those are Longinus' words, true, but not his meaning!

The same thing doubtless happened to him when he made the following observation: "All actions," he says, "and positions of Greek figures who were not characterized by wisdom, but were much too passionate and wild, were regarded as a fault which the ancient artists called *parenthyrsus*." [5] The ancient artists? That could only be proved from Junius, because *parenthyrsus* was a technical term in rhetoric and perhaps, as the passage from Longinus seems to indicate, peculiar to Theodorus alone:

Τούτῳ παράκειται τρίτον τι κακίας εἶδος ἐν τοῖς παθητικοῖς, ὅπερ ὁ

2 [Aristotle and Longinus. In chapter 25 of the *Poetics*, Aristotle recommends to the poets the πιθανὸν ἀδύνατον, the impossible that is plausible.]

3 Περὶ Ὕψους, τμῆμα δ' (ed. T. Fabri.), pp. 36, 39. [For a translation, see Appendix Note a, chap. 29, p. 239.]

4 *De pictura veterum* I. 4, p. 33. ["Especially when the end of the poetical imagination is to astonish, but that of painting is to make vivid. And among the poets, as the same Longinus says," etc. (Hamann, p. 295).]

5 ["false pathos in speech."] *Von der Nachahmung der griech. Werke*, etc., p. 23.

Θεόδωρος παρένθυρσον ἐκάλει· ἔστι δὲ πάθος ἄκαιρον καὶ κενόν, ἔνθα μὴ δεῖ πάθους· ἢ ἄμετρον, ἔνθα μετρίου δεῖ.[6]

Indeed, I even doubt whether this word can be applied to painting at all. For in rhetoric and poetry there is a pathos that may be carried to its extreme without becoming *parenthyrsus;* and only the deepest pathos out of place is *parenthyrsus.* But in painting the deepest pathos would invariably be *parenthyrsus,* even if it can be justified by the circumstances of the person expressing it.

To all appearances, then, various inaccuracies in the *History of Art* have arisen simply because in his haste Herr Winckelmann consulted Junius rather than the primary sources. For instance, when he wishes to illustrate by example that the Greeks placed special value on excellence in all the arts and in labor, and that the best worker in even the smallest things might succeed in immortalizing his name, he quotes this among other things: "We know the name of a maker of very accurate balances or scales; it is Parthenius."[7] Herr Winckelmann must have read Juvenal's words to which he refers here, *Lances Parthenio factas,* in the list that Junius gives, for had he looked them up in Juvenal himself, he would not have been misled by the ambiguity of the word *lanx,* but have recognized at once from the context that the poet did not mean balances or scales, but plates and dishes. Juvenal is here praising Catullus for having thrown his most valuable possessions overboard during a violent storm in order to save his ship and his life, just as the beaver would rather mutilate his body and remove a part of it than lose his life. He describes these valuables and says, among other things:

> Ille nec argentum dubitabat mittere, lances
> Parthenio factas, urnae cratera capacem

[6] Τμῆμα β′. [Section β′· "Next to this is a third sort of deformity in pathetic writing, which Theodorus calls *parenthyrsus*. It is an unseasonable and empty grief where none is needed, or an uncontrolled one where one under control is required" (Hamann, p. 295).]

[7] *Geschichte der Kunst,* I, 136.

Et dignum sitiente Pholo, vel coniuge Fusci.
Adde et bascaudas et mille escaria, multum
Caelati, biberet quo callidus emtor Olynthi.ᵇ

What else could *lances* mean but plates and dishes, standing
as it does among goblets and kettles? And what would Juvenal
be saying here but that Catullus threw overboard his whole
service of silver plates among which were some embossed by
Parthenius? *Parthenius caelatoris nomen,*[8] says an old scholiast.
But when Grangaeus in his commentary adds to this name
sculptor, de quo Plinius, he must have done so at random, for
Pliny does not mention any artist of that name.

Herr Winckelmann continues: "Even the name of the
saddler, as we should call him, who made the leather shield
for Ajax has been preserved." But he cannot have taken this
information from the authority to whom he refers the reader,
Herodotus' *Life of Homer.* To be sure, the lines of the *Iliad*
where the poet applies the name Tychius to this leatherworker
are quoted there, but it is also expressly stated that such was
the name of a saddler of Homer's acquaintance. Homer wanted
to express friendship and gratitude by mentioning his name:

’Απέδωκε δὲ χάριν καὶ Τυχίῳ τῷ σκύτει, ὃς ἐδέξατο αὐτὸν
ἐν τῷ Νέῳ τείχει, προσελθόντα πρὸς τὸ σκύτειον, ἐν τοῖς
ἔπεσι καταζεύξας ἐν τῇ Ἰλιάδι τοῖσδε:

’Αίας δ’ ἐγγύθεν ἦλθε, φέρων σάκος ἠύτε πύργον,
χάλκεον, ἑπταβόειον· ὅ οἱ Τύχιος κάμε τεύχων
σκυτοτόμων ὄχ’ ἄριστος, Ὕλῃ ἔνι οἰκία ναίων·[9,c]

This is the exact opposite of what Herr Winckelmann is try-
ing to persuade us to believe; the name of the saddler who
made Ajax's shield had already been forgotten so completely
in Homer's time that the poet was free to substitute quite a
different name.

Various other minor errors are simply slips of memory, or
else concern things mentioned only cursorily by way of illus-
tration.

8 ["Parthenius, the name of the chaser."]
9 Herodotus, *de vita Homeri,* p. 756 (ed. Wessel).

For example, it was Hercules and not Bacchus of whom Parrhasius boasted that he appeared to him in the same form in which he painted him.[10]

Tauriscus was not a native of Rhodes, but of Tralles in Lydia.[11]

Antigone is not the first tragedy of Sophocles.[d]

But I shall refrain from accumulating more such trifles. It could scarcely be taken as censoriousness, but anyone who knows my high regard for Herr Winckelmann might consider it *krokylegmus*.[12]

[10] *Geschichte der Kunst,* I, 167. Pliny, XXXV. 36. *Athenaeus,* XII, 543.

[11] *Ibid.,* II, 353. Pliny, XXXVI. 4, p. 729.

[12] ["Pedantry," perhaps best rendered here by "pedantic quibbling" or "a carping display of pedantry." The word is a compound of κροκύς, a flock of wool, and λέγω, to gather. Originally it meant a person who nervously twitched or plucked bits of wool from his clothing or blankets. The equivalent word in German is *Kleinkrämerei,* literally, "dealing in trifles."]

APPENDIX NOTES

NOTES, CHAPTER ONE

NOTE a, p. 7

["Philoctetes, the leader of seven ships of archers against Troy (*Iliad* II. 716), is bitten by a snake on the island of Chrysa, near Lemnos, and, by the advice of Odysseus, left behind at Lemnos because the stench of his wound and his cries are intolerable. He is, however, in possession of the bows and arrows of Heracles, without which, as has been foretold, Troy cannot be captured. Accordingly, Odysseus undertakes to bring Philoctetes to Troy. But since Odysseus knows that he cannot by fair means prevail upon Philoctetes to come, he induces Neoptolemus, son of Achilles, to try a subterfuge. The play of Sophocles opens with Odysseus and Neoptolemus at Lemnos, looking for Philoctetes. Neoptolemus is fated to take Troy, but only with the bow and arrows of Heracles, and with the help of Philoctetes. Although a noble-minded youth, he allows himself to be persuaded by Odysseus, on the ground that the end justifies the means. Odysseus withdrawing, Neoptolemus represents to Philoctetes that he has deserted the Greek host before Troy, because the arms of his father have been taken from him and given to Odysseus. He thus wins the confidence of Philoctetes, and the sufferer beseeches Neoptolemus to take him home in his ship. The youth promises to do this; but he is so deeply touched by the misery which Philoctetes endures when his wound festers and a paroxysm comes over him, that, although the bow is now in his hands and Philoctetes is completely in his power, he cannot proceed with the intended stratagem. Thereupon Odysseus steps forth; but he can accomplish nothing with Philoctetes. Not until Heracles speaks as a god from the heavens, and declares it to be the will of fate that Philoctetes shall aid in the destruction of Troy, does he consent to accompany Neoptolemus and Odysseus thither" (Howard, *Lessing's Laokoon*, pp. 343-44).]

NOTES, CHAPTER TWO

NOTE a, p. 13

For this reason Aristotle refused to let Pauson's pictures be shown to young people, so that their imagination might be kept as free as possible from all representations of the ugly (*Politics* VIII. 5, p. 526, ed. Conring). Boden suggests reading Pausanias instead of Pauson in this passage, because the former is known to have painted licentious pictures (*de Umbra poetica*, comment. I, p. xiii). As though one had to learn first from a philosophical lawgiver that such licentious temptations ought to be kept away from young people! Had he taken the trouble to refer to the famous passage in the *Poetics* (chap. 2), he would never have expounded his theory. There are commentators (e.g., Kühn on Aelian, *Variae Historiae* IV. 3) who maintain that the distinction Aristotle draws there between Polygnotus, Dionysius, and Pauson actually lies in the fact that Polygnotus painted gods and heroes; Dionysius, people; and Pauson, animals. But all of them painted human figures; and the fact that Pauson once painted a horse is no proof that he was exclusively an animal painter, which Boden takes him to have been. Their rank was determined by the degree of beauty they were able to impart to their human figures, and the reason that Dionysius could paint only people, and was therefore called the anthropographus (man-painter), was because he copied nature too slavishly and could not raise himself to that ideal beneath which it would have been sacrilege to paint gods and heroes.

NOTE b, p. 15

If we were to go through all the works of art which Pliny, Pausanias, and others mention, or search through all the an-

cient statues, bas-reliefs, and paintings still extant, we should not find a Fury anywhere. I except figures that belong more to the language of symbols than to art, such as are to be found chiefly on coins. Yet Spence, since he was determined to find Furies, would have done better to borrow them from the coins (*Seguini Numis.*, p. 178; *Spanhem. de Praest. Numism. Dissert.*, XIII, 639; Spanheim, *Les Césars de Julien*, p. 48) than to introduce them ingeniously into a work in which they definitely do not exist. He says in his *Polymetis* (Dial. XVI, p. 272): "Although Furies are quite rare in the works of ancient artists, there is one story in which they have generally introduced them. I am referring to the death of Meleager. In bas-reliefs on this subject they often encourage or urge Althaea to burn the fatal brand on which the life of her only son depended. For even a woman would not have gone so far in her revenge without a little prodding from the devil. In one of these bas-reliefs, published by Bellori (in the *Admirandis*), we see two women, to all appearances Furies, standing beside Althaea at the altar. For who else but Furies would have wanted to attend such a sacrifice? That they do not seem horrible enough for this role is doubtless the fault of the copy. The most remarkable thing about this work, however, is the round disk to be seen near the lower center, which evidently displays the head of a Fury. Perhaps it was the one to whom Althaea, whenever she had resolved on any evil action, addressed her prayers, and especially now on this occasion had every reason to . . . ," etc. One can prove anything by the use of such tricky logic. Who else, asks Spence, would have attended such a ceremony? My answer is, the maidservants of Althaea, who had to light the fire and keep it burning. Ovid says (*Metamorphoses* VIII. 460, 461): "Protulit hunc (stipitem) genitrix, taedasque in fragmina poni Imperat, et positis inimicos admovet ignes." * Both figures actually have in their hands such *taedas,* long pieces of resinous fir, which the ancients used for torches, and one of them has just broken one of the pieces, as her attitude shows. And, in my opinion, that is no Fury on the disk near the center of the work. It is a face which has on it an expression of violent

pain and is doubtless meant to be the head of Meleager himself. (*Metamorph.* VIII. 515):

> Inscius atque absens flamma Meleagros in illa
> Uritur: et caecis torreri viscera sentit
> Ignibus: et magnos superat virtute dolores.†

The artist needed this as a transition, as it were, to the subsequent scene of the same story, which shows Meleager dying. The figures that Spence calls Furies Montfaucon takes to be Parcae (*Antiquité expliquée*, I, 162), with the exception of the head on the disk, which he too calls a Fury. Bellori himself (*Admiranda*, tab. 77) leaves undecided whether or not they are Parcae or Furies—an "or" which is enough to show that they are actually neither the one nor the other. The remainder of Montfaucon's explanation also lacks accuracy. The female figure leaning on her elbows against the bed should have been called Cassandra and not Atalanta, who is sitting in an attitude of mourning with her back to the bed. The artist has shown a great deal of perception in having Atalanta sit apart from the family, since she is only the mistress and not the wife of Meleager, and since her grief at a misfortune she herself inadvertently brought about could only have embittered his relatives.

* ["And now the mother bore it away and had sticks of resinous fir (*taedas*) collected in a heap, and into this she sent the power of destroying fire."]

† ["Unknowing and far off, Meleager is made fiery by the flame, and he feels a mysterious flame burning his insides. But he forcefully restrains the mighty pains."]

NOTE c, p. 18

"Eundem" (that is to say, Myro), we read in Pliny (XXXIV. 19), "vicit et Pythagoras Leontinus, qui fecit stadiodromon Astylon, qui Olympiae ostenditur: et Libyn puerum tenentem tabulam, eodem loco, et mala ferentem nudum. Syracusis au-

tem claudicantem: cuius hulceris dolorem sentire etiam spectantes videntur." ‡ Let us examine these last words more closely. Is it not obvious that they refer to a person known everywhere because of a painful ulcer? *Cuius hulceris.* And is this *cuius* to refer to the mere *claudicantem,* and the *claudicantem* perhaps to the *puerem,* which is back in the preceding clause? No one has the right to be more celebrated on account of such an ulcer than Philoctetes. Hence I read *Philoctetem* instead of *claudicantem,* or at least maintain that the former of the two words was pushed out of the MS. by the latter, and that the correct reading would be *Philoctetem claudicantem.* Sophocles speaks of his στίβον κατ' ἀνάγκην ἕρπειν,§ and he must have had a limp, since he could not step firmly with the affected foot.

‡ ["And the same one overcame Pythagoras also, who made (a statue of) Astylos, who is shown in Olympia, as well as a Libyan youth holding a tablet. This he did in the same place and also a naked body holding apples. However, in Syracuse (he made) a lame figure, in whom even the beholders appear to feel the pain of the sores."]
§ ["crawling along the road under constraint."]

NOTES, CHAPTER FOUR

NOTE a, p. 26

When the chorus sees the misery of Philoctetes under this accumulation of miseries it seems to be deeply moved by his helpless isolation. In its every word we can hear the sociable Greek. I have some doubts about one of these passages, however. It is the following (ll. 701-705):

> Ἵν' αὐτὸς ἦν πρόσουρος οὐκ ἔχων βάσιν,
> οὐδέ τιν' ἐγχώρων,
> κακογείτονα παρ' ᾧ στόνον ἀντίτυπον
> βαρυβρῶτ' ἀποκλαύ-
> σειεν αἱματηρόν.*

The plain translation by Winshem renders it this way:

> Ventis expositus et pedibus captus
> Nullum cohabitatorem
> Nec vicinum ullum saltem malum habens, apud quem
> gemitum mutuum
> Gravemque ac cruentum
> Ederet.

Th. Johnson's interpolated translation differs from this only in the wording:

> Ubi ipse ventis erat expositus, firmum gradum
> non habens,
> Nec quenquam indigenarum,
> Nec malum vicinum, apud quem ploraret
> Vehementer edacem
> Sanguineum morbum, mutuo gemitu.

One might think that he had borrowed this version from the metrical translation of Thomas Naogeorgus, for this latter (whose work is quite scarce; Fabricius himself knew it only from Operin's book catalogue) renders the passage thus:

> . . . ubi expositus fuit
> Ventis ipse, gradum firmum haud habens,
> Nec quenquam indigenam, nec vel malum
> Vicinum, ploraret apud quem
> Vehementer edacem atque cruentum
> Morbum mutuo.

If these translations are correct, then the chorus is bestowing the highest praise possible on human society: the wretched man has no companion near, no friendly neighbor; his happiness would have been great if he had had even a single bad one! Perhaps Thomson had this passage in mind when he made Melisander, who had been abandoned by scoundrels on a desert island, say:

> Cast on the wildest of the Cyclad isles
> Where never human foot had marked the shore,
> These ruffians left me—yet believe me, Arcas,
> Such is the rooted love we bear mankind,

All ruffians as they were, I never heard
A sound so dismal as their parting oars.

To him too the company of scoundrels would have been better
than none at all. A splendid and logical meaning! If it were
only certain that this was what Sophocles meant to say! But I
must reluctantly confess that I for my part can find nothing
of this in Sophocles, unless I should prefer to see with the
eyes of an old commentator rather than with my own. He
paraphrases the poet's words in the following way: Οὐ μόνον
ὅπου καλὸν οὐκ εἶχέ τινα τῶν ἐγχωρίων γείτονα, ἀλλὰ οὐδὲ κακόν, παρ'
οὗ ἀμοιβαῖον λόγον στενάζων ἀκούσειε. Brumoy, as well as our most
recent German translator, has followed this interpretation, as
did those whom I have already mentioned. The former says:
sans société, même importune, and the German translator:
Jeder Gesellschaft, auch der beschwerlichsten beraubet ["de-
prived of all society, even the most troublesome"]. My reasons
for differing from all of them are these: First, it is evident that
if κακογείτονα is separated from τιν' ἐγχώρον and is meant to con-
stitute a separate clause, the particle οὐδέ must necessarily be
repeated before it. But since this is not the case, it is just as
evident that κακογείτονα, belongs to τίνα, and that the comma
after ἐγχώρων must be omitted. This comma has crept in
because of the translation, for I find that some purely
Greek editions (e.g., the Wittenberg translation of 1585
in ottavo, which was unknown to Fabricius) do not have a
comma there, but place one after κακογείτονα, where it belongs.
Secondly, is it really a bad neighbor, from whom we can ex-
pect the στόνον ἀντίτυπον, ἀμοιβαῖον, as the commentator explains
it? To share our sighs with us is the mark of a friend, not an
enemy. In short, then, the word κακογείτονα has been misunder-
stood; it has been assumed that it is a compound made from
the adjective κακός, whereas it is actually compounded from
the substantive τὸ κακόν. Thus it has been translated "a bad
neighbor," where it should be "a neighbor or companion of
ill-fortune." In the same manner, κακόμαντις is not a bad, that
is false, untrue prophet, but a prophet of evil, and κακότεχνος

is not a bad or unskilled artist, but one who uses evil arts. By "companion of evil" the poet either means one who has been afflicted with the same misfortune as ourselves, or one who shares them with us for the sake of friendship. The entire sentence, οὐδ' ἔχων τιν' ἐγχώρων κακογείτονα, should therefore be translated as "neque quenquam indigenarum mali socium habens." Thomas Franklin, the latest English translator of Sophocles, is obviously of my opinion, because he does not translate κακογείτονα as "bad neighbor," but merely as "fellow mourner":

> Expos'd to the inclement skies,
> Deserted and forlorn he lyes,
> No friend nor fellow-mourner there,
> To sooth his sorrow, and divide his care.

* ["Where he was his own neighbor, without the power of walking and without anyone living nearby—no neighbor for his suffering, from whom his groan could receive a response as he lamented the bloody sore that devoured him." The passages quoted below by Lessing are all versions of the lines here translated.]

NOTE b, p. 30

[Among commentators on Lessing, there has been some disagreement as to who is meant in this passage. Both Cosack and Buschmann believed that the little-known Greek sculptor Ctesias was meant, but Blümner objects to this on the grounds that Lessing would scarcely have chosen such an obscure artist for his example. Blümner convincingly suggests that the "Ctesias" of the manuscript is an orthographical error, and that the correct reading should be "Ctesilaus," or "Cresilas." This latter sculptor is mentioned by Pliny (XXXIV. 77), and one of his statues does in fact represent a dying warrior (cf. Blümner, *Lessings Laokoon* [Berlin, 1880], pp. 521f.).]

NOTE c, p. 31

[The oracle of Dodona prophesied to Heracles that he would be freed from his struggles and his toil. Long before this, however, his father Zeus had prophesied that he would meet death at the hand of a deceased person, someone from Hades. As Heracles (called Hercules by the Romans) is dying, he realizes that the oracle is being fulfilled.]

NOTES, CHAPTER FIVE

NOTE a, p. 33

Saturnal V. 2: "Quae Virgilius traxit a Graecis, [not in the original text, which has (§ 2) 'non parva sunt alia, quae traxit a Graecis'] dicturumne me putatis quae vulgo nota sunt? quod Theocritum sibi fecerit pastoralis operis autorem, ruralis Hesiodum? et quod in ipsis Georgicis, tempestatis serenitatisque signa de Arati Phaenomenis traxerit? vel quod eversionem Trojae, cum Sinone suo, et equo ligneo, caeterisque omnibus, quae librum secundum faciunt, a Pisandro pene ad verbum [ad verbum paena] transcripserit? qui inter Graecos poetas eminet opere, quod a nuptiis Jovis et Junonis incipiens universas historias, quae mediis omnibus saeculis usque ad aetatem ipsius Pisandri contigerunt, in unam seriem coactas redegerit, et unum ex diversis hiatibus temporum corpus effecerit? in quo opere inter historias caeteras interitus quoque Trojae in hunc modum relatus est. Quae fideliter Maro [Mano fideliter] interpretando, fabricatus est sibi Iliacae urbis ruinam. Sed et haec et talis ut pueris [talia pueris] decantata praetereo." ["Do you think that I am going to tell of the things that, as everyone knows, Virgil got from the Greeks? That in the pastoral he plagiarized Theocritus and in the rustic poems

Hesiod? And that in the *Georgics* he borrowed the signs of a storm and of fair weather from Aratus' *Phenomena?* Or that he took almost verbatim from Pisander the account of the sack of Troy, as well as Sinon, the wooden horse, and everything else in the second book? Pisander is eminent among the Greeks for a work which, beginning with the marriage of Jupiter and Juno, gives a connected account of all the events that occurred in the centuries up to his own time and thus unites in one work events that happened at wide intervals. In this work the sack of Troy is also related, among other things. Maro (Virgil) translated this account and made his own fall of Troy from it. But I pass over these and similar things, known to every schoolboy."]

<div align="center">NOTE b, p. 35</div>

[Lessing is in error on this point. Virgil was not the first and only poet to represent Laocoön and both sons as being killed. Sophocles did the same before him. One Lessing commentator says of the passage: "In Lessing's syllogism, the major premise is erroneous, the minor premise doubtful; the conclusion proves nothing and is on other grounds probably erroneous. Lessing uses the conclusion, however, only as a working hypothesis, and its historical inaccuracy does not invalidate his aesthetic argumentation on the difference between sculpture and poetry" (Howard, p. 364).]

<div align="center">NOTE c, p. 35</div>

I do not forget that the picture which Eumolpus describes in Petronius might be cited against this. It depicted the destruction of Troy and particularly the story of Laocoön exactly as Virgil describes them; and since it hung in the same gallery at Naples with other ancient pictures by Zeuxis, Protogenes, and Apelles, it might be supposed that it too was an ancient

Greek painting. But permit me to point out that a novelist is not a historian. To all appearances, this gallery, this picture, and this Eumolpus never existed anywhere except in Petronius' imagination. Nothing betrays their complete fiction more clearly than the obvious traces of an almost schoolboyish imitation of Virgil's description. It is profitable to make the comparison. This is Virgil's account (*Aeneid* II. 199-224):

> Hic aliud maius miseris multoque tremendum
> Obiicitur magis, atque improvida pectora turbat.
> Laocoon, ductus Neptuno sorte sacerdos,
> Sollemnis taurem ingentem mactabat ad aras.
> Ecce autem gemini a Tenedo tranquilla per alta
> (Horresco referens) immensis orbibus angues
> Incumbunt pelago, pariterque ad litora tendunt:
> Pectora quorum inter fluctus arrecta, iubaeque
> Sanguineae exsuperant undas: pars cetera pontum
> Pone legit, sinuatque immensa volumine terga.
> Fit sonitus, spumante salo: iamque arva tenebant,
> Ardentesque oculos suffecti sanguine et igni
> Sibila lambebant linguis vibrantibus ora.
> Diffugimus visu exsangues. Illi agmine certo
> Laocoonta petunt, et primum parva duorum
> Corpora natorum serpens amplexus uterque
> Implicat, et miseros morsu depascitur artus.
> Post ipsum, auxilio subeuntem ac tela ferentem,
> Corripiunt, spirisque ligant ingentibus: et iam
> Bis medium amplexi, bis collo squamea circum
> Terga dati, superant capite et cervicibus altis.
> Ille simul manibus tendit divellere nodos,
> Perfusus sanie vittas atroque veneno:
> Clamores simul horrendos ad sidera tollit.
> Quales mugitus, fugit cum saucius aram
> Taurus et incertam excussit cervice securim.*

So also Eumolpus, about whom we may say, as of all *improvisatori,* that memory has had as large a part in these lines as imagination:

> Ecce alia monstra. Celsa qua Tenedos mare
> Dorso repellit, tumida consurgunt freta,
> Undaque resultat scissa tranquillo minor.
> Qualis silenti nocte remorum sonus
> Longe refertur, cum premunt classes mare,

Pulsumque marmor abiete imposita gemit.
Respicimus, angues orbibus geminis ferunt
Ad saxa fluctus: tumida quorum pectora
Rates ut altae, lateribus spumas agunt:
Dat cauda sonitum; liberae ponto iubae
Coruscant [consentiunt] luminibus, fulmineum iubar
Incendit aequor, sibilisque undae tremunt:
Stupuere mentes. Infulis stabant sacri
Phrygioque cultu gemina nati pignora
Laocoonte, quos repente tergoribus ligant
Angues corusci: parvulas illi manus
Ad ora referunt: neuter auxilio sibi,
Uterque fratri transtulit pias vices [fratri: transtulit
 pietas vices],
Morsque ipsa miseros mutuo perdit metu.
Accumulat ecce liberûm funus Parens,
Infirmus auxiliator; invadunt virum
Iam morte pasti, membraque ad terram trahunt.
Iacet sacerdos inter aras victima.†

The main features are the same in both passages, and some
things are expressed in the same words. But these are inci-
dentals which strike our eye at once. There are other indica-
tions of imitation which, though less striking, are no less cer-
tain. If the imitator is a man who has any confidence in
himself, he seldom imitates without attempting to improve;
and if, in his opinion, this improvement is successful, he is
enough of a fox to brush over with his tail the footsteps which
might betray the path by which he came. But this vain desire
to improve and this careful attempt to appear original betray
him. For his "improvement" is nothing but exaggeration and
unnatural refinement. Virgil says *sanguineae iubae;* and
Petronius, *liberae iubae luminibus coruscant.* Virgil, *ardentes
oculos suffecti sanguine et igni;* Petronius, *fulmineum iubar
incendit aequor.* Virgil, *fit sonitus spumante salo;* Petronius,
sibilis undae tremunt. Thus the imitator always goes from the
great to the stupendous, from the wonderful to the impossible.
In Virgil the description of the boys encircled by the serpents'
coils is a *parergon,* drawn with a few expressive strokes which

reveal only their helplessness and their anguish. Petronius turns this sketch into a finished picture, and the boys into two heroic souls:

> Neuter auxilio sibi
> Uterque fratri transtulit pias, vices
> Morsque ipsa miseros mutuo perdit metu.

But who can expect such self-denial from human beings, from children? The Greek understood human nature much better (Quintus Calaber, XII. 459-61) when he made even the mothers forget their children at the appearance of the dreadful serpents, so completely was each person concerned with his own preservation:

> . . . ἔνθα γυναῖκες
> Οἴμωζον, καί πού τις ἑῶν ἐπελήσατο τέκνων
> Αὐτὴ ἀλευομένη στυγερὸν μόρον . . .

["The women screamed, and some of them forgot their own children, in order to save themselves from a fearful death."] The imitator generally attempts to hide his actions by changing the arrangement of light and shade over his objects. He changes the shadows of the original into lights in the copy, thus throwing the lights into the background. Virgil takes pains to render the size of the serpents palpable, because the probability of the succeeding scene depends on their size; the noise they make is only a subordinate idea, intended to convey a more vivid picture of size. Petronius, on the other hand, turns this subordinate idea into the main one, describes the noise with the greatest possible wealth of detail, and forgets the size so completely that we are almost forced to infer it from the noise. It is hard to believe that he could have fallen into this impropriety if he had drawn only from his own imagination and had had no model from which he borrowed his design yet tried not to betray this fact. Indeed, we may safely assume that every poetic description which is overloaded in minor details and deficient in the important ones is an un-

successful imitation, regardless of the fact that the latter may itself possess many secondary beauties and that the original may or may not be determinable.

* ["Hereon another, weightier, and by far
More dread occurrence meets us in our woe,
And spreads dismay in unexpectant breasts.
Laocoön, to Neptune priest by lot,
Was at the wonted altars offering
A mighty bull, when lo! from Tenedos—
I shudder as I tell—over tranquil depths,
Two snakes with monstrous coils speed over the main,
And side by side are making for the shore;
Their breasts amid the billows stand aloft,
Their blood-red crests uprising over the waves;
The other part tracks through the sea behind,
And their huge backs glide serpentine along.
We hear the splash of foam, and now they reach
Our fields, and with their glowing eyes suffused
With blood and fire, lick round with quivering tongues
Their hissing mouths. Half-dead before the sight
We flee all ways; they with unswerving course
Make for Laocoön, and first each snake
Gripping the tender forms of his two sons
Entwines them round, and gnawing crops the flesh
From their poor limbs; and after, as he went
To bear them aid, his weapons in his hand,
Him too they seize, and bind with mighty folds—
And now they twice have bridled round his waist
Twice coiled their scaly backs around his throat—
Their heads and lofty neck tower over him.
He struggles with his hands the while to rend
Their knots apart, his fillets dyed with gore
And with their poison foul, and all the time
Lifts to the stars his horrifying shrieks;
Such bellowing as when a wounded bull
Has fled the altar, and has dashed aside
From off its neck the axe that missed the blow."

(*Aeneid* II. 199-224, tr. Delabère-May)]

† [And other portents too;
for where the sheer ridge of Tenedos usurps the sea,
the water writhed and rose, and the long swell, reverberant,
shattered the calm, as sometimes in the dead of night,
the beat of stroking oars shatters the hush upon the sea,
and the ships race on, and the marbled water, sundered
by the cleaving prow, turns froth and furrows white
beneath the slicing keel.
We turned to stare, and saw
twin serpents, a twine of writhing coils, drive on
and the water thrown against the rocks as by two ships
the waves are battered back. Their tails drummed the water;
blazing like their eyes their great crests crowded the sea;
lightnings ruddied the waves, and beneath their breath of flame,
the waters, seething, hissed.

Our hearts stopped dead.
The priest's two boys, two little pledges of a father's love,
stood, their hair with sacred fillets bound, upon the shore,
when suddenly the snakes enclosed them both in twisting loops
like flame. Each flung his hand in terror overhead;
each for the other; each moved to shield his brother,
both boys altered by their love, and when death came,
even then, each brother trembled only for the other.
Helpless, before our eyes, their father ran to help—
and piled his life on theirs. For gorged with double death,
they fell upon the priest and bore him to the ground. There
between the altars, thrashing the earth in death, he lay,
the priest, a victim to the gods.

(*Satyricon* 89.22-51, tr. Arrowsmith)]

NOTE d, p. 35

Suppl. aux Antiq. Expl., I, 243: "Il y a quelque petite dif-
férence entre ce que dit Virgile, et ce que le marbre représente.
Il semble, selon ce que dit le poéte, que les serpens quittèrent
les deux enfans pour venir entortiller le père, au lieu que dans
ce marbre ils lient même tems les enfans et leur père."
["There is some slight difference between what Virgil says
and what the marble represents. It seems, according to what
the poet says, that the serpents left the children in order to
entangle the father, whereas in the marble they bind the chil-
dren and the father at the same time."]

NOTE e, p. 36

["... they with unswerving course
Make for Laocoon, and first each snake
Gripping the tender forms of his two sons
Entwines them round, and gnawing crops the flesh
From their poor limbs; and after, as he went
To bear them aid, his weapons in his hand,
Him too they seize, and bind with mighty folds ..."

(*Aeneid* II.212-17, tr. Delabère-May)]

Note f, p. 36

Donatus [*Interpretationes Vergilianae*] on *Aeneid* II. 227: "Mirandum non est, clypeo et simulachri vestigiis tegi potuisse, quos supra et longos et validos dixit, et multiplici ambitu circumdedisse Laocoontis corpus ac liberorum, et fuisse superfluam partem." ‡ It seems to me that in this passage the word *non* must be omitted from the phrase *mirandum non est,* unless there is a whole dependent clause missing at the end. For, since the serpents were so extraordinarily large, it would certainly be surprising if they could conceal themselves beneath the shield of the goddess. Unless, of course, this shield were very large and belonged to a figure of colossal size. The missing clause must confirm this, or else the *non* has no meaning.

‡ ["It is not surprising that they could be covered by the shield and the garment of the statue, although, above, he called them long and strong, and said that they were coiled many times about the body of Laocoön and the children, and that there was still a part left over."]

Note g, p. 37

In the splendid edition of Dryden's English Virgil (published in large folio at London, 1697).§ And even in this picture the serpents are coiled only once about the body and hardly at all about the neck.# If such a mediocre artist deserves any excuse, all that could be said in his favor is that prints are meant to serve only as illustrations and are not intended to be judged as independent works of art.

§ [Reference is to Dryden's translation of the *Aeneid,* included in the 1697 edition.]

[Lessing's language offers a certain difficulty here. His explanation, "only once about the body and hardly at all about the neck" (*um den Leib nur einfach, und um den Hals fast gar nicht*), seems self-contradictory. What is meant is that the engraver depicts a single coil about the body and only the suggestion or the beginning of a coil about the neck.]

Note h, p. 38

This is the judgment of De Piles himself in his notes to Du Fresnoy, vs. 210: "Remarquez s'il vous plaît, que les draperies tendres et légères n'étant données qu'au sexe féminin, les anciens Sculpteurs ont évité autant qu'ils ont pû, d'habiller les figures d'hommes; parce qu'ils ont pensé, comme nous l'avons déjà dit, qu'en Sculpture on ne pouvoit imiter les étoffes et que les gros plis faisoient un mauvais effet. Il y a presque autant d'exemples de cette vérité, qu'il y a parmi les antiques de figures d'hommes nuds. Je rapporterai seulement celui du Laocoon, lequel selon la vrai semblance devroit être vêtu. En effet, quelle apparence y a-t-il qu'un fils de Roi, qu'un Prêtre d'Apollon se trouvât tout nud dans la cérémonie actuelle d'un sacrifice; car les serpens passèrent de l'Isle de Ténédos au rivage de Troye, et surprirent Laocoon et ses fils dans le tems même qu'il sacrifioit à Neptune sur le bord de la mer, comme le marque Virgile dans le second livre de son Enéide. Cependant les Artistes, qui sont les Auteurs de ce bel ouvrage, ont bien vû, qu'ils ne poúvoient pas leur donner de vêtemens convenables à leur qualité, sans faire comme un amas de pierres, dont la masse ressembleroit à un rocher, au lieu des trois admirables figures, qui ont été et qui sont toujours l'admiration des siècles. C'est pour cela que de deux inconvéniens ils ont jugé celui des Draperies beaucoup plus fâcheux, que celui d'aller contre la vérité même." ["Please note that since delicate and light garments were given only to females, the sculptors of antiquity avoided clothing their male figures as much as they could. As we have said, they were of the opinion that sculpture cannot imitate fabrics and that thick folds produce a bad effect. There are almost as many examples of this truth as there are nude male figures by ancient artists. I shall cite only the example of Laocoön, who in all probability ought to be clothed. Indeed, how probable is it that a king's son, a priest of Apollo would have been naked at a sacrificial ceremony? For the serpents came from the island

of Tenedos to the shores of Troy and attacked Laocoön and
his sons just as he was offering a sacrifice to Neptune beside
the sea, as Virgil relates it in the second book of the *Aeneid*.
However, the artists who created this beautiful work realized
that they could not give the figures clothing befiitting their
dignity without producing a heap of stones whose mass would
resemble a boulder instead of the three marvelous figures
which have and shall always have the admiration of the cen-
turies. For this reason they felt clothing to be a far greater
evil than the violation of truth itself."]

NOTES, CHAPTER SIX

NOTE a, p. 40

Maffei, Richardson, and more recently Herr von Hagedorn.
(*Betrachtungen über die Malerei*, p. 37; Richardson, *Traité
de la Peinture*, III, 513) De Fontaines hardly deserves to be
mentioned along with them. In the notes to his translation of
Virgil he likewise maintains, to be sure, that the poet had the
group in mind, but he is so ignorant as to call it a work of
Phidias.

NOTE b, p. 41

I cannot refer to anything more decisive for my argument than
this poem of Sadolet. It is worthy of an ancient poet, and since
it can well serve in place of an engraving, I venture to insert
it here in its entirety:

DE LAOCOONTIS STATUA IACOBI
SADOLETI CARMEN

Ecce alto terrae e cumulo, ingentisque ruinae
Visceribus, iterum reducem longinqua reduxit
Laocoonta dies; aulis regalibus olim

Qui stetit, atque tuos ornabat, Tite, penates.
Divinae simulacrum artis, nec docta vetustas
Nobilius spectabat opus, nunc celsa revisit
Exemptum tenebris redivivae moenia Romae.
Quid primum summumve loquar? miserumne parentem
Et prolem geminam? an sinuatos flexibus angues
Terribili aspectu? caudasque irasque draconum
Vulneraque et veros, saxo moriente, dolores?
Horret ad haec animus, mutaque ab imagine pulsat
Pectora, non parvo pietas commixta tremori.
Prolixum bini spiris glomerantur in orbem
Ardentes colubri, et sinuosis orbibus errant,
Ternaque multiplici constringunt corpora nexu.
Vix oculi sufferre valent, crudele tuendo
Exitium, casusque feros: micat alter, et ipsum
Laocoonta petit, totumque infraque supraque
Implicat et rabido tandem ferit ilia morsu.
Connexum refugit corpus, torquentia sese
Membra, latusque retro sinuatum a vulnere cernas.
Ille dolore acri, et laniatu impulsus acerbo,
Dat gemitum ingentem, crudosque evellere dentes
Connixus, laevam impatiens ad terga Chelydri
Obiicit: intendunt nervi, collectaque ab omni
Corpore vis frustra summis conatibus instat.
Ferre nequit rabiem, et de vulnere murmur anhelum est.
At serpens lapsu crebro redeunte subintrat
Lubricus, intortoque ligat genua infima nodo.
Absistunt surae, spirisque prementibus arctum
Crus tumet, obsepto turgent vitalia pulsu,
Liventesque atro distendunt sanguine venas.
Nec minus in natos eadem vis effera saevit
Implexuque angit rapido, miserandaque membra
Dilacerat: iamque alterius depasta cruentum
Pectus, suprema genitorem voce cientis,
Circumiectu orbis, validoque volumine fulcit.
Alter adhuc nullo violatus corpora morsu.
Dum parat adducta caudam divellere planta,
Horret ad adspectum miseri patris, haeret in illo,
Et iam iam ingentes fletus, lachrymasque cadentes
Anceps in dubio retinet timor. Ergo perenni
Qui tantum statuistis opus iam laude nitentes,
Artifices magni (quanquam et melioribus actis
Quaeritur aeternum nomen, multoque licebat
Clarius ingenium venturae tradere famae)

Attamen ad laudem quaecunque oblata facultas
Egregium hanc rapere, et summa ad fastigia niti.
Vos rigidum lapidem vivis animare figuris
Eximii, et vivos spiranti in marmore sensus
Inserere, aspicimus motumque iramque doloremque,
Et pene audimus gemitus: vos extulit olim
Clara Rhodos, vestrae iacuerunt artis honores
Tempore ab immenso, quos rursum in luce secunda
Roma videt, celebratque frequens: operisque vetusti
Gratia parta recens. Quanto praestantius ergo est
Ingenio, aut quovis extendere fata labore,
Quam fastus et opes et inanem extendere luxum.*

(*Leodegarii a Quercu Farrago Poematum*, II, 64)

Gruter also has incorporated this poem, along with others by
Sadolet, into his well known collection (*Delic. Poet. Italorum
Parte alt.*, p. 582). His version is, however, most inaccurate.
For *bini* (vs. 14) he reads *vivi;* for *errant* (vs. 15), *oram,* etc.

* [THE POEM OF JACOB SADOLETUS
ON THE STATUE OF LAOCOÖN

From mighty heaped-up mound of earth and from the heart
Of mighty ruins, lo! long time once more
Has brought Laocoon home, who stood of old
In princely palaces and graced thy halls
Imperial Titus. Wrought by skill divine
(E'en learned ancients saw no nobler work),
The statue now from darkness saved returns
To see the stronghold of Rome's second life.
What shall begin and what shall end my lay?
The hapless father and his children twain?
The snakes of aspect dire in winding coils?
The serpents' ire, their knotted tails, their bites,
The anguish, real, though but marble, dies?
The mind recoils and pity's self appalled,
Gazing on voiceless statues beats her breast.
Two serpents flushed with rage gather in coils
To one loose ring, and glide in winding orbs,
And wrap three bodies in their twisted chain.
Scarce can the eyes endure to look upon
The dreadful death, the cruel tragedy.
One serpent darting at Laocoon's self,
Enwraps him all, above, below; then strikes
With poisonous bite his side; the body shrinks
From such embrace. Behold the writhing limbs,
The side that starts recoiling from the wound.
By keen pain goaded and the serpent's bite
Laocoon groans, and struggling from his side
To pluck the cruel teeth, in agony
His left hand grapples with the serpent's neck.

The sinews tighten, and the gathered strength
Of all his body strains his arm in vain;
Poison o'ercomes him; wounded sore he groans.
The other serpent now with sudden glide
Returned, darts under him its shiny length,
Entwines his knees below and binds them fast.
The knees press outward, and the leg compressed
By tightening windings swells; the blood confined
Chokes up the vitals and swells black the veins.
His sons no less the same wild strength attacks,
And strangles them with swift embrace and tears
Their little limbs; e'en now the gory breast
Of one whose dying voice his father calls
Has been its pasture; round him wrap its coils
And crush him in the mighty winding folds.
The other boy, unhurt, unbitten yet,
Uplifts his foot to unloose the serpent's tail;
His father's anguish seen he stands aghast,
Transfixed with horror—his loud wailings stay,
His falling teardrops stay—in double dread.

Then, ye, the makers of so great a work,
Great workmen, still in lasting fame renowned
(Although by better deeds a deathless name
Is sought, although to some 'twas given to leave
A higher talent far to coming glory).
'Tis noble still to seize what chance is given
For praise, and strive the highest peak to gain.
'Tis yours with living shapes to quicken stone,
To give hard marble feeling till it breathes.
We gaze upon the passion, anger, pain,
We all but hear the groans, so great your skill,
You famous Rhodes of old extolled. Long time
The graces of your art lay low; again
Rome sees them in a new day's kindly light,
She honours them with many a looker on,
And on the ancient work new charms are shed.
Then better far by talent or by toil
To increase the span of fate, than still increase
Or pride or wealth or empty luxury.

<div align="right">(Tr. H. S. Wilkinson)]</div>

NOTE c, p. 42

De la Peinture, III, 516: "C'est l'horreur que les Troïens ont
conçue contre Laocoon, qui étoit nécessaire à Virgile pour la
conduite de son Poëme; et cela la mène à cette Description
pathétique de la destruction de la patrie de son Héros. Aussi
Virgile n'avoit garde de diviser l'attention sur la dernière
nuit, pour une grande ville entière, par la peinture d'un petit

malheur d'un Particulier." ["It is the horror conceived by the Trojans against Laocoön, which was necessary to Virgil for the development of his poem; and this leads him to that pathetic description of the destruction of his heroes' country. Also, Virgil did not wish to divert our attention from the last night of an entire city by depicting one unhappy detail."]

NOTES, CHAPTER SEVEN

NOTE a, p. 47

I say "possible." But I should wager ten to one that they did not do so. Juvenal is speaking of the earliest days of the Republic, a time when the people were still unacquainted with splendor and luxury, and the soldier used the gold and silver that he had plundered only to decorate his horse trappings and weapons (*Satyricon* XV [XI]. 100-107):

> Tunc rudis et Graias mirari nescius artes
> Uribus eversis praedarum de [in] parte reperta
> Magnorum artificum frangebat pocula miles,
> Ut phaleris gauderet equus, caelataque cassis
> Romuleae simulacra ferae mansuescere iussae
> Imperii fato, geminos sub rupe Quirinos,
> Ac nudam effigiem clypeo fulgentis [venientis] et hasta,
> Pendentisque Dei perituro ostenderet hosti.*

The soldier broke up the costliest goblets, masterpieces of great artists, in order to have a she-wolf and a little Romulus and Remus made from them, which he then used to adorn his helmet. Everything is intelligible up to the last two lines, where the poet continues his description of just such a chased figure on the helmets of the old soldiers. We can see that this figure is supposed to represent Mars; but what is the meaning of the adjective *pendentis* which he applies to him? Rigaltius discovered an old gloss which explained it by *quase ad ictum se inclinantis*. Lubinus supposes the figure to have been on the shield, and since the shield hung from the arm, the poet

may have called the figure "suspended." But this violates the construction, because the subject of *ostenderet* is not *miles*, but *cassis*. According to Britannicus, whatever stands high in the air might be called suspended, and hence this figure might have been either above or on the helmet. Some even read *perdentis* for *pendentis* in order to create an antithesis with the following *perituro*, which, however, no one but themselves could find admirable.

What does Addison have to say about this doubtful passage? The commentators, he says, are all wrong, and the correct meaning is surely this (see his *Travels*, German transl., p. 249):

> The Roman soldiers, who were not a little proud of their founder and the military spirit of their republic, used to wear a representation of the history of Romulus on their helmets—how he was begot by a god and suckled by a she-wolf. The figure of the god was shown about to descend on the priestess Ilia (or, as others call her, Rhea Silvia), and in this attitude it seemed to be suspended in air over the virgin, in which case the word *pendentis* is expressive and poetic. Besides the ancient bas-relief in Bellori, which first made me think of this interpretation, I have since encountered the same figure on a coin minted during the time of Antoninus Pius.

Spence finds this discovery of Addison such an extraordinarily happy one that he quotes it as a model of its kind and the best example of the usefulness of the works of ancient artists in explaining classical Roman poets. For that reason I cannot refrain from a somewhat closer examination of this explanation myself (*Polymetis*, Dial. VII, p. 77).

First, I must remark that merely the bas-relief and the coin would hardly have sufficed to make Addison think of the passage in Juvenal, unless he had remembered at the same time that in the old scholiast who reads *venientis*, instead of *fulgentis* in the penultimate line were the words: "Martis ad Iliam venientis ut concumberet." Suppose, however, that instead of this scholiast's reading we accepted Addison's. Would we then find even the slightest indication that the poet had

Rhea in mind? Would it not be a real *hysteronproteron* ["in-
verted sequence"] for him to speak of the she-wolf and the
young boys, and only afterwards of the event to which they
owed their existence? Rhea is not yet a mother, and the chil-
dren are already lying under the rock. And consider whether
a love scene would be a suitable emblem for the helmet of a
Roman soldier. The soldier was proud of the divine origin of
his founder; that was sufficiently established by the she-wolf
and the children. Would he also have needed to show Mars
performing an action in which he was anything but the terri-
ble Mars? Because his act of catching Rhea unawares might
have been represented on any number of old marble bas-
reliefs and coins does not mean that it was deemed suitable for
a piece of armor. Besides, where are those marbles and coins
on which Addison discovered it, and where he saw Mars in
this hovering position? The ancient bas-relief which he ad-
duces as support is supposed to be in Bellori, but we search
in vain for it in the *Admiranda,* a collection of the most
beautiful old bas-reliefs. I did not find it there, nor could
Spence have found it there or anywhere else, for he makes no
mention of it whatever. Hence everything depends on the
coin. Let us look at this in Addison's own work: we see a re-
clining Rhea; and since the die cutter had no room to draw
a figure on the same level with her, he placed Mars slightly
higher. That is all. Beyond this there is not the least indica-
tion of hovering. It is true that in the illustration Spence
uses, the hovering attitude is quite pronounced; the upper part
of the body is thrown considerably forward, and we can see
plainly that it is not a standing figure. If it is not falling, then
it must necessarily be hovering. Spence declares that this coin
is in his possession. It would be harsh to question a man's
veracity, even in a trifling matter, but a preconceived notion,
once accepted, may exercise an influence even on our eyes.
Besides, he may have considered it permissible and in the inter-
est of his readers to make the artist so emphasize Mars' posi-
tion as he himself thought he saw it on the coin that we might
feel as little doubt on the subject as he. It is certain, at any

rate, that Spence and Addison both refer to the same coin, and that accordingly the former must have greatly beautified or the latter greatly misrepresented it.

But I have another objection to make to this supposed hovering position of Mars, namely, a body hovering without a visible cause for its exemption from the law of gravity is an incongruity of which no example can be found in ancient works of art. Painting of our time does not allow this either; if a body is suspended in air, it must either have wings or appear to rest on something, if only a cloud. When Homer represents Thetis as ascending from the shore to Olympus on foot (Τὴν μὲν ἄρ' Οὔλυμπόνδε πόδες φέρον [*Iliad* XVIII. 148]), Count Caylus displays too great a knowledge of the demands of art to advise the artist to let the goddess stride unsupported through the air. She must make her way upon a cloud (*Tableaux tirés de l'Iliade*, p. 91), as on another occasion he puts her in a chariot (p. 131), although the poet actually says just the opposite. But how can it be otherwise? Although the poet causes us to picture to ourselves a human figure when we think of the goddess, he has removed any hint of gross and heavy matter, and has animated her human form with a power that exempts her from our laws of motion.

But how could painting distinguish between the corporeal figure of a deity and that of a man clearly enough to prevent our eyes from being offended at seeing completely different laws of motion, gravity, and equilibrium observed in the treatment of each? How else but by conventional symbols? A pair of wings and a cloud are, in fact, such symbols. But more of this in another place. It will suffice here to demand that the defenders of Addison's theory show me a similar figure in any monument of antiquity suspended freely as in air. Can this Mars have been the only one of its kind? Why? Had tradition transmitted another circumstance which made this hovering position necessary in this one case? There is no trace of this in Ovid (*Fasti* I). On the contrary, it can be shown that such a circumstance can never have existed, for there are other ancient works of art which depict the same story and in which

Mars is manifestly not hovering, but walking. Let us look at the bas-relief in Montfaucon (*Suppl.*, I, 183) which, if I am not mistaken, is at Rome in the Mellini palace. Here the sleeping Rhea is lying under a tree while Mars is stealthily approaching and at the same time extending his right hand backward in that significant movement by which we motion to those behind us either to stand still or to follow quietly. His posture is exactly the same as on the coin, except that in this case the lance is held in his right hand, and in the other case in his left. Famous statues and bas-reliefs are found copied on coins so frequently that it must have been the case here too, where the die cutter perhaps did not understand the backward gesture of the right hand and therefore thought it better to show it holding the lance.

If all these things are taken together, Addison's theory loses most of its probability, and little more than a bare possibility remains. But where are we to find a better explanation, if this one is worthless? Possibly there is a better one among those rejected by Addison. But if not, what then? This passage of the poet's work is corrupt; let it remain so, for remain so it will, though we were to dig up twenty new explanations for it. Such as this one, for example: *pendentis* must be taken in its figurative meaning, as "uncertain," "unresolved." *Mars pendens* would mean in that case *Mars incertus* or *Mars communis*. "Dii communes sunt," says Servius (on the *Aeneid* XII. 118), "Mars, Bellona, Victoria, quia hi in bello utrique parti favere possunt." † And the entire line, "Pendentisque Dei (effigiem) perituro ostenderet hosti," ‡ would mean that the old Roman soldier was accustomed to carrying the image of a common god under the very eyes of his enemy, who was nonetheless soon to fall by his hand. It is a neat touch to attribute the victories of the ancient Romans to their own valor instead of the assistance of their ancestors. But for all that *non liquet* ["it is not clear"].

* ["At that time the soldier, rough and lacking knowledge of Greek art, broke up the beakers of great artists which he found among his share of the plunder so that he might adorn his steed and decorate his well-worked helmet with the symbol of Romulus' animal (the she-wolf),

who had to become gentle as was decreed by imperial destiny; and so that he might display the brothers (Romulus and Remus) beneath the cliff of Quirino. It was also his desire to show to his enemy, fated for death, the naked figure of the god with his shield and spear as he descended (hovered)."]

† ["Mars, Bellona, and Victoria are impartial gods, because they can favor any side in a war."]

‡ ["to show to the enemy, fated for death, (the god) as he descended."]

NOTE b, p. 47

Spence says (*Polymetis*, Dial. XIII, p. 208): "Until I became acquainted with these *aurae*, or sylphs, I was always at a loss when reading the story of Cephalus and Procris in Ovid. I could not possibly imagine how Cephalus' crying out *Aura venias* (though in ever so tender and languishing a manner) could cause anyone to suspect that he was being untrue to his Procris. Since I had always been accustomed to think that *Aura* meant only air in general, or a gentle breeze in particular, Procris' jealousy seemed to me far more unfounded than even the most extravagant jealousies customarily are. But once I had learned that *Aura* could mean a beautiful maiden as well as the air, the whole aspect seemed different and the story seemed to me to take a very reasonable turn." I do not intend to withdraw in my footnote the praise which in the text I bestowed on this discovery, with which Spence is so obviously pleased. But I cannot refrain from observing that the passage would be quite natural and intelligible without it. All we needed to know was that among the ancients *Aura* was a very ordinary name for a woman. For example, according to Nonnus (*Dionys.* XLVIII), it was the name of a nymph, one of Diana's attendants, who, because she boasted that her beauty was more manly than that of the goddess, was punished for her presumption by being delivered up sleeping to the embraces of Bacchus.

NOTE C, p. 47

Juvenal, *Satyr.* VIII. 52-55:

> . . . At tu
> Nil nisi Cecropides; truncoque simillimus Hermae;
> Nullo quippe alio vincis discrimine, quam quod
> Illi marmoreum caput est, tua vivit imago.§

If Spence had included the Greek authors in his plan, an old Aesopian fable might perhaps—and again, perhaps not—have occurred to him, which uses the form of one of these pillars of Hermes to shed a light far more beautiful and indispensable to an understanding of its meaning than this passage from Juvenal. Mercury, Aesop tells us, desired to learn in what esteem he was held by man. He concealed his divinity, and went to a sculptor. Here he saw a statue of Jupiter and asked the artist its price. "A drachma," was the answer. Mercury smiled. "And this Juno?" he continued. "About the same." Meanwhile he caught sight of a statue of himself, and thought: I am the messenger of the gods. All gain comes from me, and so men must value me much more highly. "But this god here?" he said, pointing to his statue. "How much might this one be?" "This one?" the artist answered. "Oh, if you will buy the other two, I'll throw this one in free." Mercury was silenced. The sculptor, however, did not know him and therefore could not have intended to wound his vanity. There must have been something about the quality of the statues themselves that caused him to value the last so lightly and be willing to add it to the others as a gift. The lower rank of the god which it represented could have had nothing to do with it, for the artist values his productions according to the skill, the industry, and the labor which they require, and not according to the rank and dignity of the beings they represent. The statue of Mercury must have required less skill, less industry and labor than a statue of Jupiter or Juno, if it was to cost less. And such was the case here. The statues of Jupiter

and Juno were full figures of these gods; the statue of Mercury, on the other hand, was a plain, square pillar with his bust on top. What wonder, then, that it could be given away with the purchase of the other two? Mercury overlooked this circumstance because he had only his supposed superior merit in mind, and so his humiliation was as natural as it was deserved. We would search in vain for any trace of this explanation among the commentators, translators, and imitators of Aesop; but I could quote a whole list, if it were worth the trouble, of those who have understood the fable literally, that is, failed to understand it at all. They have either failed to perceive the incongruity which arises when the statues are assumed to be works of the same kind, or else they have greatly exaggerated it. The other thing which might perhaps seem objectionable in this fable is the price which the artist places on his Jupiter. Not even a potter could make a doll for one drachma, and consequently it must stand for a very low price in general (*Fab. Aesop.* 90, ed. Haupt, p. 70).

§ ["But you are nothing if not a descendant of Cecrops; in body you fully resemble a Herma, and exceed her only in that her head is marble while your form is a living image."]

Note d, p. 48

Lucretius, *De rerum natura* V. 736-47:

It Ver, et Venus, et Veneris [veris] praenuntius ante
Pinnatus [pennatus] graditur Zephyrus: vestigia propter
Flora quibus mater praespargens ante viai
Cuncta coloribus egregiis et odoribus opplet.
Inde loci sequitur Calor aridus, et comes una
Pulverulenta Ceres; et Etesia flabra Aquilonum.
Inde Autumnus adit; graditur simul Evius Evan
 [Euhius Evan]:
Inde aliae tempestates ventique sequuntur,
Altitonans Volturnus et Auster fulmine pollens.
Tandem Bruma nives adfert, pigrumque rigorem
Reddit, Hyems sequitur, crepitans ac dentibus Algus.
[prodit hiems, sequitur crepitans hanc dentibus algor] ‡

Spence calls this one of the most beautiful passages in Lucre-
tius' entire poem. Certainly it is one of those on which the
poet's fame is founded. But, surely, to say that the whole de-
scription was taken from an ancient procession of deities
representing the seasons would greatly diminish his renown,
or rob him of it entirely. And why? "Because," says the Eng-
lishman, "such processions of deities were formerly as common
among the Romans as those today in honor of some saints in
certain lands, and also because all the expressions that the
poet uses here come in very aptly, if applied to a procession."
Excellent reasons! But how much might be said against the
last! Even the adjectives which the poet uses to describe per-
sonified abstractions, "Calor aridus, Ceres pulverulenta, Vol-
turnus altitonans, fulmine pollens Auster, Algus dentibus
crepitans," show that they derive their being from him and
not from the artist, who would have had to characterize them
quite differently. Spence appears, moreover, to have come upon
this idea of a procession through Abraham Preigern, who says
in his note to these lines: "Ordo est quasi Pompae cuiusdam,
Ver et Venus, Zephyrus et Flora," etc. But Spence should have
stopped there. To tell us that the poet has the seasons pass
by as if in a procession is all very well, but to say that he bor-
rowed this idea from a procession shows great lack of taste.

‡ ["Spring and Venus appear, and feathered Zephyr, proclaimer of
Spring strides ahead; he is accompanied by Flora, the mother, who
strews his steps with lovely colors and fragrances. After them follows
dry Summer, at his side dust-covered Ceres and the breath of Etesian
winds. Behind them strides Autumn, and with him Evius Evan. Tem-
pests follow them in turn, and the winds and the storms, thundering
from high above, Volturnus, and the hurler of lightning bolts, Auster.
Finally Bruma brings the snow and the rigid-making cold and Winter
follows and teeth-chattering Frost."]

NOTES, CHAPTER EIGHT

NOTE a, p. 54

Argonautica II. 1-6. ["For, as her passion swells, she no longer wishes to seem kindly, or bind her hair with polished gold, as her glittering locks flow loosely. She is wild and terrible, her cheeks discolored with patches of rage; she bears a crackling torch and wears a black flowing robe like the maidens of Styx."]

NOTE b, p. 54

Thebaid V. 61-64. ["Leaving ancient Paphos and a hundred altars, her face and hair not being as they were before, she is said to have laid aside the girdle of love and dismissed the Idalic birds. There were indeed others who relate that the goddess, wielding in the darkness of the night other fires and greater darts, hovered with the sisters of Tartarus in bridal chambers, and filled the secret rooms of the houses with writhing serpents, and all the thresholds with a wild terror" (Howard, p. 375). Paphos was a city of Cyprus, sacred, like the whole island, to Venus. The Idalic birds were doves, so called from Mt. Idalion, the site of a temple of Venus in Cyprus. The sisters of Tartarus were the Furies.]

NOTES, CHAPTER NINE

NOTE a, p. 55

Valerius Flaccus, *Argonaut.* II. 265-273:

> Serta patri, iuvenisque comam vestesque Lyaei
> Induit, et medium curru locat; aeraque circum

Tympanaque et plenas tacita formidine cistas.
Ipsa sinus hederisque ligat famularibus artus:
Pampineamque quatit ventosis ictibus hastam,
Respiciens; teneat virides velatus habenas
Ut pater, et nivea tumeant ut cornua mitra,
Et sacer ut Bacchum referat scyphus.*

The word *tumeant* ["swell up from," "spring from"] in the penultimate line seems to indicate that the horns of Bacchus were not so small as Spence imagines.

* ["With the wreath, hair, and garments of young Lyaeus (Bacchus) she disguises her father, then places him upon a chariot and puts round about him the brazen cymbals, the drums, and chests full of the silent horror (the mystic serpent). Winding the priestly ivy about her own bosom and limbs, she brandishes with whistling strokes the wreathed thyrsus, looking back to see whether her veiled father holds the reigns wound with green leaves, whether the horns swell up from under the snow-white mitre, and whether the sacred goblet marks him as Bacchus" (Howard, p. 376).]

Note b, p. 55

The so-called Bacchus in the gardens of the Medici at Rome (Montfaucon, *Suppl. aux. Ant.*, I, 254) has small horns sprouting from his forehead; but there are critics who for that very reason prefer to think of him as a faun. Indeed, such natural horns are a degradation of the human form and can be becoming only to beings who are given a kind of intermediate form between man and animal. The attitude also—greedily looking at the grapes held above him—is more becoming to an attendant of the god of wine than to the god himself. I recall here what Clemens Alexandrinus says of Alexander the Great: (*Protrepticus,* p. 48, ed. Pott.): Ἐβούλετο δὲ καὶ ᾿Αλέξανδρος ῎Αμμωνος υἱὸς εἶναι δοκεῖν, καὶ κεράσφορος ἀναπλάττεσθαι πρὸς τῶν ἀγαλματοποιῶν, τὸ καλὸν ἀνθρώπου ὑβρίσαι σπεύδων κέρατι.† It was Alexander's express wish that the sculptor represent him as having horns; and he was quite content that the human beauty of his form should be degraded by them, as long as people believed that that he was of divine origin.

† [Lessing quotes from John Potter's edition (Oxford, 1715) of the works of Clemens: "Alexander even wanted to be taken for the son of

Ammon and to be represented by the sculptors as having horns, being determined as he was to disfigure the beauty of man through such horns."]

NOTE C, p. 56

When I asserted above that the ancient artists had never represented a Fury, I had not overlooked the fact that the Furies had more than one temple, and that these temples were certainly not without statues of them. In that of Cerynea Pausanias found some made of wood,‡ which were neither large nor particularly remarkable. It seemed that art, unable to display itself in the statues of these goddesses, did so in the statues of their priestesses which stood in the vestibule of the temple and were beautifully executed in stone (Pausanias, *Achaic.* [AXAIKA, *Achaia,* Bk. VII], chap. 25, p. 587., ed. Kuhn.) Nor had I forgotten that their heads may be seen, as is believed, on an abraxas made known by Chiffletius,§ and on a lamp in Licetus (*Dissertation sur les Furies par Bannier, Mémoires de l'Académie des Inscriptions,* V, 48). Even the urn of Etruscan workmanship in Gorius (Tab. 151, Musei Etrusci) on which Orestes and Pylades are shown being attacked by two torch-bearing Furies, was not unknown to me. But I was speaking of works of art only, from which I believed myself justified in excluding all these pieces. And even if the last-mentioned work were not to be excluded along with the others, it serves, when considered from another aspect, to strengthen rather than to contradict my opinion. For, little as the Etruscan artists seemed to have beauty as their aim, their Furies still appear to be characterized less by horrible features than by their costumes and attributes. They thrust their torches in the very faces of Orestes and Pylades with such calm that they seem almost to be frightening them in jest. We may infer how terrible they appeared to Orestes and Pylades only from the terror of these latter, not from the figures of the Furies themselves. Thus they are Furies, and yet not Furies; they perform the functions of Furies, but without the expression of rage and

anger that we are accustomed to associate with them; not with a brow which, as Catullus says, *expirantis praeportat pectoris iras.#*

Just recently Herr Winckelmann thought he had discovered a Fury, running, with disheveled hair and dress and a dagger in her hand. It was on a cornelian in Stoss's collection (*Bibl. der schönen Wiss.,* V, 30). Herr von Hagedorn thereupon urged the artists to put this discovery to use and depict the Furies this way in their paintings (*Betrachtungen über die Malerei,* p. 222). But Herr Winckelmann himself has now cast some doubt on his discovery, because he has not found anything to support the belief that among the ancients the Furies were armed with daggers rather than torches (*Descriptions des Pierres gravées,* p. 84). Doubtless, therefore, he does not recognize the figures on the coins of the towns of Lyrba and Massaura which Spannheim calls Furies as being such, but rather as a Hecate *Triformis;* for otherwise we should have here a Fury holding a dagger in each hand; and it is strange that this figure too appears with bare head and disheveled hair, whereas in the other cases the hair is covered by a veil. But even if we supposed that Winckelmann's first conjecture were correct, the same would apply to the engraved stone as to the Etruscan urn unless features cannot be recognized because of the minuteness of the object. Besides, engraved stones generally belong to symbolical language because of their use as seals; and the figures on them are arbitrary emblems more often than independent, spontaneous works of the artist.

‡ [Cerynea was a city in Archaia. Pausanias of Magnesia (second half of the second century A.D.) was an authority on Greek topography and art. Lessing quotes from a Greek edition of his *Descriptive Guide to Greece* (Περιήγησις τῆς Ἑλλάδος), a massive work in ten volumes.]

§ [The abraxas was a mystical word used as a symbol of divinity. It was also applied to gems on which the word was engraved.]

[The *expirantis praeportat pectoris iras,* which Lessing quotes, is from Catullus' *Carmina* (64, 193-4):

Eumenides, quibus anguino redimita capillo
Frons expirantis praeportat pectoris iras.

Howard translates (p. 379): "Furies, whose brow, enclosed with snakes in place of hair, portends bursts of wrath from the breast."]

NOTE d, p. 57

Fasti VI. 295-98:

Esse diu stultus Vestae simulacra putavi:
Mox didici curvo nulla subesse tholo.
Ignis inexstinctus templo celatur in illo.
Effigiem nullam Vesta, nec ignis, habet.||

Ovid is speaking only of the worship of Vesta in Rome, and
of the temple which Numa built for her there and about
which he says shortly before this (259-260):

Regis opus placidi, quo non metuentius ullum
Numinis ingenium terra Sabina tulit.**

|| ["Fool that I was, I long supposed there were images of Vesta; but
I later learned that there were none under the round dome. Inextin-
guishable fire is hidden in that temple; but neither Vesta nor fire has
an image" (Howard, p. 379).]

** ["It was the work of the gracious king, than whom the Sabine land
has never borne a more god-fearing spirit."]

NOTE e, p. 57

Fasti III. 145-46:

Sylvia fit mater: Vestae simulacra feruntur
Virgineas oculis opposuisse manus.††

Spence should have compared different passages of Ovid in
this way. The poet speaks of different periods; in the first pas-
sage, the period preceding Numa, and in the second, that after
him. During the former, statues of her were worshiped in Italy
as they were in Troy, from whence Aeneas had introduced her.

. . . Manibus vittas, Vestamque potentem,
Aeternumque adytis effert penetralibus ignem ‡‡

says Virgil of the spirit of Hector after he has advised Aeneas
to flee. Here a distinction is clearly made between the eternal

fire and Vesta herself or her statue. Spence did not read the Roman poets carefully enough for his purposes, since this passage escaped him.

†† ["Sylvia became a mother; and the images of Vesta, so it is said, covered their eyes with their virgin hands."]

‡‡ ["With his own hands he bore the fillets, the mighty Vesta, and the eternal fire from the innermost sanctuary of the temple" (*Aeneid* II. 296ff.).]

NOTE f, p. 57

Pliny, XXXVI. 4, 727, ed. Hard.

> Scopas fecit . . . Vestam sedentem laudatam in Servilianis hortis.

["Scopas made the famous seated Vesta in the Servilian gardens."] Lipsius must have had this passage in mind when he wrote (*de Vesta* 3): "Plinius Vestam sedentem effingi solitam ostendi, a stabilitate." ["Pliny states that Vesta was usually depicted in a sitting position because of her steadfastness."] Yet he had no right to apply what Pliny said about only one work of Scopas as a general characteristic to all the statues of that goddess. He himself remarks that on the coins Vesta appears standing as often as seated, but this remark serves not to correct Pliny, but his own mistaken notions.

NOTE g, p. 58

Georgius Codinus, *de Originibus Constantinopolitanis*, ed. Venet., p. 12. Τὴν γῆν λέγουσιν Ἑστίαν, καὶ πλάττουσιν αὐτὴν γυναῖκα, τύμπανον βαστάζουσαν, ἐπειδὴ τοὺς ἀνέμους ἡ γῆ ὑφ' ἑαυτὴν συγκλείει [Lessing's translation below]. Suidas, drawing either from him or perhaps from a common source, says the same thing in his explanation of the word Ἑστία. "The earth is represented under the name of Vesta as a woman carrying a tympan, in which she holds the winds confined." The reason is somewhat

absurd. It would have been much more reasonable to say that she was carrying a tympan because the ancients thought that her figure resembled it; σχῆμα αὐτῆς τυμπανοειδὲς εἶναι §§ (Plutarch, de placitis Philos. 10; idem, de facie in orbe Lunae). In this case it is possible that Codinus was mistaken about the figure, or the name, or both. Perhaps he knew of no better name to give what he saw Vesta carrying than "tympan," or heard it called that and did not stop to think that a tympan could also be something besides the instrument which we call a kettledrum. Actually, tympans were also a kind of wheel: "Hinc radios trivere rotis, hinc tympana plaustris Agricolae" ## (Virgil, Georgics II. 444). What we see in the hands of the Vesta of Fabretti (Ad Tabulam Iliadis, p. 334) and what the scholar takes to be a handmill appears to me to be very much like such a wheel.

§§ ["that her figure was orbicular in shape."]
["The farmer rounds spokes in the wheel and rollers (wheels, tympana) for the cart."]

NOTE, CHAPTER TEN

NOTE a, p. 61

The picture which Horace draws of Necessity has perhaps a greater wealth of attributes than any other among the ancient poets (Odes I.35.17):

Te semper anteit saeva Necessitas;
Clavos trabales et cuneos manu
Gestans ahenea; nec severus
Uncus abest liquidumque plumbum. . . . *

Whether we take the nails, the clamps, and the molten lead to be means of fastening or instruments of punishment, they still belong to the class of poetical rather than allegorical

attributes. But even as such there are too many of them, and this passage is one of the dullest in Horace. Sanadon says:

> J'ose dire que ce tableau pris dans le détail seroit plus beau sur la toile que dans une ode héroique. Je ne puis souffrir cet attirail patibulaire de clous, de coins, de crocs, et de plomb fondu. J'ai cru en devoir décharger la traduction, en substituant les idées générales aux idées singuliéres. C'est dommage que le Poëte ait eu besoin de ce correctif.†

Sanadon's feelings were correct and refined, but the reasons he adduces to justify them are not sound. This is not because the attributes used are an *attirail patibulaire* ["hangman's kit"] (for he could have interpreted them in their other sense and thus made the instruments of execution into the most efficient structural elements of architecture), but because they are attributes intended for the eye and not the ear. All concepts which we acquire through the eyes would require a much greater effort and produce less clarity were they to be conveyed through the ear.

The continuation of the stanza from Horace quoted above reminds me, incidentally, of a few errors on the part of Spence which do not give the most favorable impression of the accuracy with which he claims to have examined the passages he quotes from the ancient poets. He speaks of the image by which the Romans represented Fidelity, or Honesty (Dial. X, 145). "The Romans," Spence says, "called her *Fides;* and when they called her *Sola Fides,* they appear to have meant that higher degree of this quality which the Germans express by the word *grundehrlich* (in English, 'downright honesty'). She is represented with a frank and open expression and with nothing on but a thin robe, so thin as to be transparent. Horace accordingly calls her 'thinly-clad' in one of his odes, and 'transparent' in another."

There are no less than three rather serious mistakes in this short passage. First, it is not true that *Sola* is a special epithet which the Romans applied to the goddess *Fides.* In both passages from Livy which Spence quotes as proof of this (I. 21; II. 3), it means nothing more than it does everywhere else

it occurs: "the exclusion of everything else." In one passage even the *soli* appears suspicious to the critics and is believed to have crept into the text through an error in copying, caused by the *solenne* standing next to it. In the other passage Livy is not talking about Fidelity, but about Innocence. Secondly, he says that Horace bestowed the epithet "thinly-clad" on her in one of his odes (i.e., in the one mentioned above, I. 35):

> Te spes, et albo rara fides colit
> Velata panno . . .

["Hope and such rare fidelity in white-colored garment honor thee."] It is true that *rarus* also means "thin"; but here it is simply "rare," or "that which seldom occurs," and is an epithet applied to *Fides* herself, not to her clothing. Spence would have been right if the poet had said, *Fides raro velata panno.* Thirdly, Horace is said to have called Fidelity or Honesty "transparent" in another passage in order to indicate what we customarily say in our professions of friendship: "I wish that you could read my heart." The passage meant here is the following line from the eighteenth ode of the first book:

> Arcanique Fides prodiga, pellucidior vitro.

["Fidelity, more transparent than glass, shows the secret."] How can one possibly be so misled by a mere word? Does *Fides arcani prodiga* mean Fidelity, or does it not rather mean Infidelity? It is about this last and not about Fidelity that Horace is speaking when he says that she was transparent as glass, because she exposes to every gaze the secrets entrusted to her.

* ["Cruel necessity always precedes thee, carrying spikes and wedges in her brazen hand; nor are the unyielding clamp nor the molten lead wanting."]

† [Lessing quotes from *Oeuvres d'Horace en Latin, traduites en français par M. Dacier et le P. Sanadon* (Amsterdam, 1735), II, 400: "I dare say that this picture, taken in detail, would be more beautiful on canvas than in a heroic ode. I cannot bear such a hangman's kit of spikes, wedges, hooks, and molten lead. I have felt in duty bound to lighten this ballast by substituting in the translation general for particular ideas. It is to be regretted that the poet needs this corrective."]

NOTES, CHAPTER ELEVEN

NOTE a, p. 62

Apollo hands over the purified and embalmed body of Sarpe-
don to Death and Sleep to carry to his fatherland (*Iliad* XVI.
681-82):

> πέμπε δέ μιν πομποῖσιν ἅμα κραιπνοῖσι φέρεσθαι,
> Ὕπνῳ καὶ Θανάτῳ διδυμάοσιν.

["And send him to be wafted away by swift convoy, the twin
brothers Sleep and Death."] Caylus recommends this idea to
the painter, but adds: "Il est fâcheux, qu'Homére ne nous ait
rien laissé sur les attributs qu'on donnoit de son tems au som-
meil; nous ne conaissons, pour caractériser ce Dieu, que son
action même, et nous le couronnons de pavots. Ces idées sont
modernes; la première est d'un mèdiocre service, mais elle ne
peut être employée dans les cas présent, ou même les fleurs me
paroissent déplacées, surtout pour une figure qui groupe avec
la mort" * (*Tableaux tirés de l'Iliade, de l'Odyssée d'Homère
et de l'Énéide de Virgile, avec des observations générales sur
le costume* [Paris, 1757-58]). That is tantamount to requiring
from Homer one of those insignificant ornaments which are
most out of keeping with the grandeur of his style. The most
ingenious attributes he could have bestowed on Sleep would
not have characterized him nearly so well, nor have awakened
in us nearly so vivid an image as the single feature by which
he represents him as the twin of Death. If the artist expresses
this, he may dispense with all other attributes. In fact, the
ancient artists actually depicted Death and Sleep with a re-
semblance which we naturally expect to find in twins. They
were shown on a chest of cedar in the temple of Juno at Elis as
two boys, sleeping in the arms of Night. Only the one was white
and the other black; the one slept while the other appeared
to be sleeping; both had their feet crossed. I prefer to translate

Pausanias' words (*Elis*, Vol. I, Bk. XVIII, p. 422, ed. Kuhn.) ἀμφοτέρους διεστραμμένους τοὺς πόδας,† this way rather than by "with crooked feet" or, as Gedoin has rendered it in his language, *les pieds contrefaits*. What could "crooked feet" mean here? The normal position of sleepers is with feet crossed, and this is precisely the attitude in which Maffei's "Sleep" is shown (*Raccol.*, plate 151 [*Raccolta delle cose spettanti a Cenomani*, Venice, 1719]). Later artists have completely abandoned this similarity between Sleep and Death which the ancients maintained, and it has become their custom to represent Death as a skeleton, or at best as a skeleton covered with skin. Caylus should have been careful to tell the artist whether to follow the old or the new custom in depicting death. Yet he appears to have declared himself in favor of the moderns, since he regards Death as a figure next to which another, crowned with flowers, could not well be placed. But did he first consider how inappropriate this modern idea would be in a Homeric picture? And how can its disgusting aspect have failed to strike him as objectionable? I cannot bring myself to believe that the little metal figure in the ducal gallery at Florence showing a skeleton lying with one arm resting on an urn (Spence's *Polymetis*, tab. LXI) is a genuine relic of antiquity. In any case, it cannot possibly represent Death because the ancients represented him differently. Even their poets never thought of him in this repulsive form.

* ["It is regrettable that Homer has left us no account of the attributes given to Sleep in his time. To characterize this god we know of nothing but his action itself, and we crown him with a wreath of poppy. These ideas are modern; the first is of some use, but it cannot be applied to the present case, in which even the flowers seem to me to be out of place, especially for a figure associated with Death."]

† [Lessing's translation of this passage is "both had their feet crossed." Although both the Latin and French translators (*distortis utrimque pedibus*, Amasaeus; *les pieds contrefaits*, Gedoin) accepted the idea of "crooked" or "distorted," Lessing objected to such a rendering on the grounds that "crooked feet" makes no sense in the passage. Most commentators are now agreed that Lessing's translation is contrary to Greek usage and that the correct translation of the passage is "with crooked (distorted) feet." Nevertheless, no fully satisfactory explanation of this unusual expression has yet been found.]

NOTE b, p. 65

Richardson mentions Pliny's work when he wants to illustrate the rule that in a painting nothing, however excellent per se, should divert the spectator's attention from the principal figure. "Protogenes," he says, "had introduced into his famous painting of Ialysus a partridge drawn so skillfully that it seemed to be alive. It was admired by all Greece, but because it attracted everyone's attention, to the disadvantage of the main subject, he completely effaced it" (*Traité de la Peinture*, I, 46). Richardson is mistaken. The partridge was not in the Ialysus, but in another painting by Protogenes called the reposing, or idle satyr, Σάτυρος ἀναπαυόμενος. I should hardly have mentioned this error, which occurred because a passage in Pliny was misunderstood, if I had not found it also in Meursius (*Rhodi*, Bk. I, chap. 14, p. 38): "In eadem, tabula sc.[ilicet], in qua Ialysus, Satyrus erat, quem dicebant Anapauomenon, tibias tenens." And the same thing occurs in Winckelmann (*Von der Nachahm. der Gr. Werke in der Mal. und Bildh.*, p. 56). ["In the same painting in which Ialysus was found was also the satyr holding the flute, whom one called the reposing satyr."] Strabo is the only authority for this story of the partridge, and he expressly distinguishes between the picture of Ialysus and that of a satyr leaning against a pillar on which the partridge sits (Bk. XIV, p. 750, ed. Xyl.). Meursius, Richardson, and Winckelmann have misunderstood this passage (Pliny, XXXV. 36, p. 699), because they did not realize that two different pictures were meant; one, which was hung in a town that Demetrius refrained from seizing because that painting was there; another, which Protogenes painted during this siege. The first was Ialysus, the second the satyr.

NOTES, CHAPTER TWELVE

NOTE a, p. 67

Quintus Calaber has imitated this invisible battle of the gods in his twelfth book (ll. 158-85) with the obvious intention of improving on his model. The grammarian seems to have found it improper for a god to be struck to the ground by a stone. He represents the gods as hurling great masses of rock, torn from Mount Ida, at one another, to be sure, but the rocks shatter against the indestructible limbs of the gods and are scattered about them like sand:

> . . . οἱ δὲ κολώνας
> χερσὶν ἀπορρήξαντες ἀπ' οὔδεος Ἰδαίοιο
> βάλλον ἐπ' ἀλλήλους· αἱ δε ψαμάθοισι ὅμοιαι
> δεῖα διεσκίδναντο θεῶν περὶ δ' ἄσχετα γυῖα
> ῥηγνύμενα διὰ τυτθά. . . . *

This is an artificial refinement that ruins the main subject. It heightens our concept of the bodies of the gods and makes the weapons they use against one another appear ridiculous. When gods throw stones at each other, the stones must be capable of injuring them, or else we see what looks like mischievous boys pelting one another with clods. And so here, too, Homer proves himself to be the wisest of all, and all the censure that cold critics direct against him, and all the rivalry with which lesser geniuses have contended against him serve to do nothing more than set his wisdom in its best light. I do not deny, however, that Quintus' description has excellent and original things in it, but they are features more suited to the stormy fire of a modern poet than the modest greatness of Homer. It seems to me significant that the cry of the gods, which resounds to the heights of heaven and the depths of the earth, which causes the mountain, the town, and the fleet to tremble, is not

heard by man. The cry was too mighty for the diminutive human organs of hearing to perceive.

* ["But they tore mighty boulders from the soil of Mount Ida with their hands and threw them at each other. These disintegrated like grains of sand, however, breaking into many pieces against the irresistible limbs of the gods."]

NOTE b, p. 68

No one who has read Homer even cursorily will question this assertion in regard to strength and speed. But possibly he has forgotten momentarily the examples which make it clear that the poet also attributed superhuman size to his gods. I refer the reader, therefore, in addition to the above-quoted passage in which Mars's fallen body is described as covering seven acres of land, to the description of Minerva's helmet (κυνέην ἑκατὸν πολίων πρυλέεσσ᾽ ἀραρυῖαν [*Iliad* V. 744]), under which as many troops could hide as a hundred cities could bring into the field; to the stride of Neptune (*Iliad* XIII. 20); and, as the principal proof, to these lines from the description of the shield, where Mars and Minerva are at the head of the troops of the besieged town (*Iliad* XVIII. 516-19):

> ἦρχε δ᾽ ἄρα σφῖν Ἄρης καὶ Παλλὰς Ἀθήνη,
> ἄμφω χρυσείω, χρύσεια δὲ εἵματα ἕσθην,
> καλὼ καὶ μεγάλω σὺν τεύχεσιν, ὥστε θεώ περ,
> ἀμφὶς ἀριζήλω· λαοὶ δ᾽ ὑπ᾽ ὀλίζονες ἦσαν.†

Even the commentators on Homer, ancient as well as modern, do not seem to have paid sufficient attention to the extraordinary size of the poet's gods. This may be gathered from the modifications they feel compelled to make in their explanations of the great size of Minerva's helmet. (See the notes on the above-quoted passage in the Clark-Ernesti edition.) But we lose infinitely much of the sublime aspect of Homer's gods by thinking of them as of ordinary size, such as they are generally depicted, in the company of mortals, on canvas. Painting, it is true, cannot represent them as being of extraordinary dimensions, but sculpture may, to a certain degree. I am convinced that the old masters are indebted to Homer not only

for the forms of their gods in general, but specifically for the colossal size which they often bestow on them in their statues (Herodotus, II, p. 130, ed. Wessel). I shall reserve for another place some special remarks on the colossal and the reasons for its having such a powerful effect in sculpture, but none at all in painting.‡

† ["led by Ares and Pallas Athene; both were of gold and wore golden garments. They were large of figure and heavily armed, as is befitting for gods, setting themselves off sharply from the horde of smaller-sized common people."]

‡ [Presumably Lessing intended to treat this subject in Part Two. See Introduction, pp. xxv-xxvi.]

NOTE c, p. 70

Homer also has divinities conceal themselves in a cloud now and then, but it is only when they do not want to be seen by their fellow gods; e.g., *Iliad* XIV. 282, where Juno and Sleep (ἠέρα ἐσσαμένω) go to Mount Ida. The cunning goddess's chief care is not to be seen by Venus, whose girdle she had borrowed on the pretext of making a very different journey. In the same book (line 344), a golden cloud is used to conceal the love-drunken Jupiter and his spouse, in order to overcome her chaste refusal:

Πῶς κ' ἔοι, εἰ τις νῶϊ Θεῶν αἰειγενετάων
Εὕδοντ' ἀθρήσειε; . . . ‡

Juno was not afraid of being seen by men, but by gods. Although Homer has Jupiter say some lines later—

Ἥρη, μήτε θεῶν τόγε δείδιθι μήτε τιν' ἀνδρῶν
ὄψεσθαι· τοῖόν τοι ἐγὼ νέφος ἀμφικαλύψω,
χρύσεον §—

it does not follow that this cloud was necessary to conceal them from the eyes of men. What is meant here is simply that in this cloud Juno would be just as invisible to the gods as she is always to men. So, too, when Minerva puts on Pluto's helmet (*Iliad* V. 845), which had the same effect as concealment in a cloud, she does it not in order to hide herself from the Trojans, who either did not see her at all or else saw her in

the form of Sthenelus [Diomedes' charioteer], but simply in
order that Mars should not recognize her.

‡ ["lest perhaps one of the eternal gods see us both bedded together."]
§ ["Be not concerned, Hera. No god, no mortal shall behold it, for I
think to cover you so completely within a golden cloud" (line 342).]

NOTES, CHAPTER THIRTEEN

NOTE a, p. 71

["and strode down along the pinnacles of Olympos, angered
in his heart, carrying across his shoulders the bow and the
 hooded
quiver; and the shafts clashed on the shoulders of the god
 walking
angrily. He came as night comes down and knelt then
apart and opposite the ships and let go an arrow.
Terrible was the clash that rose from the bow of silver.
First he went after the mules and the circling hounds, then
 let go
a tearing arrow against the men themselves and struck them.
The corpse fires burned everywhere and did not stop burning."

(*Iliad* I. 44-53, tr. Lattimore)]

NOTE b, p. 72

["Now the gods at the side of Zeus were sitting in council
over the golden floor, and among them the goddess Hebe
poured them nectar as wine, while they in the golden
 drinking-cups
drank to each other, gazing down on the city of the Trojans."

(*Iliad* IV. 1-4, tr. Lattimore)]

NOTES, CHAPTER FOURTEEN

NOTE a, p. 74

[Caylus], *Tableaux tirés de l'Iliade,* Avert., p. v.: "On est toujours convenu, que plus un Poëme fournissoit d'image et d'actions, plus il avoit de supériorité en Poësie. Cette réflexion m'avoit conduit à penser que le calcul des différens Tableaux, qu'offrent les Poëmes, pouvoit servir à comparer le mérite respectif des Poëmes et des Poëtes. Le nombre et le genre des Tableaux que présentent ces grands ouvrages, auroient été une espèce de pierre de touche, ou plutôt une balance certaine du mérite de ces Poëmes et du génie de leurs Auteurs." ["It has always been agreed upon that the more images and the more action a poem presents, the higher type of poetry it is. This has led me to think that calculation of the number of different pictures offered by poems might serve as a basis for comparing the merits respectively of poems and poets. The number and the sort of pictures that these great works present would be, accordingly, a kind of touchstone, or rather an infallible pair of scales for weighing the merit of poems, and the genius of their authors" (Howard, p. 387).]

NOTE b, p. 75

What we call "poetic pictures" were *phantasiae* to the ancients, as we recall from Longinus. And what we call "illusion," the deceptive element of these pictures, they termed *enargia.* For this reason, as Plutarch mentions (*Erot.,* ['Ερωτικός, i.e., the *Amatorius*], Vol. II, ed. Henr. Steph., p. 1351), someone said that poetic *phantasiae* were, because of their *enargia,* waking dreams: Αἱ ποιητικαὶ φαντασίαι διὰ τὴν ἐνάργειαν ἐγρηγορότων ἐνύπνιά εἰδιτ. I wish very much that modern treatises on poetry

had used this terminology and had dropped the word "picture" altogether. They would have spared us a great number of half-valid rules which rest mainly on the identity of an arbitrary term. Poetical *phantasiae* would not have been so readily confined to the limits of a material painting. But as soon as *phantasiae* began to be called "poetic pictures," the basis for the error was established.

NOTES, CHAPTER FIFTEEN

NOTE a, p. 76

[In Chapter Fourteen, Lessing argues that a poem may be highly suggestive for the artist without necessarily being picturesque itself. In other words, a poetical picture cannot always be converted into a material painting; and Lessing concludes that the two are quite different things, which unfortunately are often confused because of the ambiguity of the word "picture." By this reasoning Lessing condemns the arguments and, to his mind, faulty method of Caylus, who attempted to induce the artists of his time to imitate some of the descriptions in Homer. Lessing's criticism of Caylus (chaps. 11-15), often quite sharp in tone, tends to make us forget or overlook the merit of Caylus' *Tableaux* and the striking similarity of its conclusions and those of the *Laocoön*. The following passage from the *Tableaux,* with its lines from La Fontaine, may serve to illustrate this similarity and remind us that Caylus, too, was concerned with how poetic pictures differ from those on canvas:

> Poetry, which is older than painting, also enjoys a great advantage over it. A happy and just choice of a few words is sufficient for it to express the greatest and largest ideas, to connect them to the preceding and succeeding ones, and to render them clearly and without any ambiguity. It does

more: it depicts a succession of time, it expresses the movements, the passing nuances, and the interconnection of actions. Painting, more limited in its means, slower in its operations, more restricted in resources, is able to present to the eye only the happy moment of a striking nature, in combining all that which is capable of helping to depict clarity of spirit and producing on the soul the strongest impression and the liveliest sentiment. La Fontaine, in his *Tableaux*, furnishes me with two verses which contain, to my mind, all that I might say about the spirit with which one must read the collections of the compositions:

Les mots et les couleurs ne sont chose pareilles,
Ni les yeux ne sont les oreilles.

("Words and colors are not the same thing, nor are eyes ears.") S. Rocheblave, *Essai sur le Comte de Caylus* (Paris, 1889).]

NOTE b, p. 76

Iliad IV. 105ff.:

αὐτίκ' ἐσύλα τόξον ἐΰξοον . . .
καὶ τὸ μεν εὖ κατέθηκε τανυσσάμενος, ποτὶ γαίῃ
ἀγκλίνας· . . .
αὐτὰρ ὁ σύλα πῶμα φαρέτρης, ἐκ δ' ἕλετ' ἰὸν
ἀβλῆτα πτερόεντα, μελαινέων ἕρμ' ὀδυνάων·
αἶψα δ' ἐπὶ νευρῇ κατεκόσμει πικρὸν ὀϊστὸν, . . .
ἕλκε δ' ὁμοῦ γλυφίδας τε λαβὼν καὶ νεῦρα βόεια·
νευρὴν μὲν μαζῷ πέλασεν, τόξον δέ σίδηρον.
αὐτὰρ ἐπειδὴ κυκλοτερὲς μέγα τόξον ἔτεινεν,
λίγξε βιός, νευρὴ δὲ μέγ' ἴαχεν ἆλτο δ' ὀϊστὸς
ὀξυβελής, καθ' ὅμιλον ἐπιπτέσθαι μενεαίνων.

["Straightway he unwrapped his bow, . . .

He stripped away the lid of the quiver, and took out an arrow feathered, and never shot before, transmitter of dark pain.

Pandaros strung his bow and put it in position, bracing it against the ground, . . .

He drew, holding at once the grooves and ox-hide bowstring
and brought the string against his nipple, iron to the bowstave.
But when he had pulled the great weapon till it made a circle,
the bow groaned, and the string sang high, and the arrow,
 sharp-pointed,
leapt away, furious, to fly through the throng before it."

 (*Iliad* IV. 105ff., tr. Lattimore)]

NOTES, CHAPTER SIXTEEN

Note a, p. 79

[Lessing's play on the words "palette" (*der Farb*[*en*]*stein*,
literally "color-stone") and "touchstone" (*der Probierstein*,
literally "testing-stone") is untranslatable, and the irony of
the lines is unfortunately much weaker in the English version.
The translation of *Farbstein* as "palette" is somewhat free,
since the word actually means "pigment cake," or, in Lessing's
time, the stone on which the painter prepared his colors.]

Note b, p. 80

["Then Hebe in speed set about the chariot the curved wheels
eight-spoked and brazen, with an axle of iron both ways.
Golden is the wheel's felly imperishable, and outside it
is joined, a wonder to look upon, the brazen running-rim,
and the silver naves revolve on either side of the chariot,
whereas the car itself is lashed fast with plaiting of gold
and silver, with double chariot rails that circle about it,
and the pole of the chariot is of silver, to whose extremity
Hebe made fast the golden and splendid yoke, and fastened
the harness, golden and splendid, . . ."

 (*Iliad* V. 722-31, tr. Lattimore)]

NOTE c, p. 81

["... and put on his tunic,
beautiful, fresh woven, and threw the great mantle over it.
Underneath his shining feet he bound the fair sandals
and across his shoulders slung the sword with the nails of silver,
and took up the sceptre of his fathers, immortal forever."

(*Iliad* II. 43-47, tr. Lattimore)]

NOTE d, p. 81

["... Powerful Agamemnon
stood up holding the sceptre Hephaistos had wrought him
 carefully.
Hephaistos gave it to Zeus the king, the son of Kronos,
and Zeus in turn gave it to the courier Argeïphontes,
and Lord Hermes gave it to Pelops, driver of horses
and Pelops again gave it to Atreus, the shepherd of the people.
Atreus dying left it to Thyestes of the rich flocks,
and Thyestes left it in turn to Agamemnon to carry
and to be lord of many islands and over all Argos."

(*Iliad* II. 101-8, tr. Lattimore)]

NOTE e, p. 83

["in the name of this sceptre, which never again will bear leaf
 nor
branch, now that it has left behind the cut stump in the
 mountains,
nor shall it ever blossom again, since the bronze blade stripped
bark and leafage, and now at last the sons of the Achaians
carry it in their hands in state when they administer

the justice of Zeus. And this shall be a great oath before you: . . . "

(*Iliad* I. 234-39, tr. Lattimore)]

NOTE f, p. 84

["Straightway he unwrapped his bow, of the polished horn from
a running wild goat he himself had shot in the chest once,
lying in wait for the goat in a covert as it stepped down
from the rock, and hit it in the chest so it sprawled on the boulders.
The horns that grew from the goat's head were sixteen palms' length.
A bowyer working on the horn then bound them together,
smoothing them to a fair surface, and put on a golden string hook."

(*Iliad* IV. 105-11, tr. Lattimore)]

NOTES, CHAPTER SEVENTEEN

NOTE a, p. 87

[The two strophes which Lessing quotes are taken from a well-known poem, *Die Alpen* ("The Alps"), by Albrecht von Haller (1708-77). Von Haller was a Swiss botanist and physician who became a professor of medicine and botany at the University of Göttingen. From early youth he wrote poetry and considered Virgil his ideal. *Die Alpen,* which appeared in 1732, betrays the influence of Thomson without, however, really achieving the poetic quality of the "Seasons." Von Haller, like

Thomson, was a nature lover and yearned to restore man to his original, "natural" goodness. Combined with this was a strong tendency to moralize and teach, and it is possibly this latter quality that gives his poetic works their unmistakable prosaic form. The strophes quoted are representative of the man and clearly reveal the descriptive or pictorial nature of his poetry:

> There towers the noble gentian's lofty head,
> Far o'er the common herd of vulgar plants,
> A whole flower people 'neath his flag is led,
> E'en his blue brother bends and fealty grants.
> In circled rays his flowers of golden sheen
> Tower on the stem, and crown its vestments grey;
> His glossy leaves of white bestreak'd with green
> Gleam with the watery diamond's varied ray.
> O law most just! that Might consort with Grace,
> In body fair a fairer soul has place.
>
> Here, like grey mist, a humble earth-plant steals,
> Its leaf by Nature like a cross disposed;
> The lovely flower two gilded bills reveals,
> Borne by a bird of amethyst composed.
> There finger-shaped a glancing leaf endues
> A crystal stream with its reflexion green:
> The flower's soft snow, stain'd with faint purple hues,
> Clasps a striped star its blanchèd rays within.
> On trodden heath the rose and emerald bloom,
> And craggy hills a purple robe assume.

> *(Lessing's Prose Works,* ed. Edward Bell
> [London, 1890], p. 99.)]

Note b, p. 89

["The best cow is ugly-shapen; her head coarse, her neck of the largest, with dewlaps hanging down from chin to leg; and to her length of flank there is no limit; large of limb and of foot, and with shaggy ears under inward-curving horns. Nor would I quarrel with one marked with spots of white, or one

reluctant to the yoke and sometimes hasty with her horn, and almost like a bull to view, and tall all her length, with a tail that sweeps her footprints below her as she moves."

<div align="right">(Georgics III. 51-62, tr. Mackail)]</div>

<div align="center">NOTE c, p. 89</div>

[" . . . his are a high crest and fine head, a short belly and fleshy back, and a breast rippling in proud slopes of muscle."

<div align="right">(Georgics III. 79-80, tr. Mackail)]</div>

<div align="center">NOTE d, p. 90</div>

Prologue to the Satires [lines 340-41, 148-49]:

> That not in Fancy's maze he wander'd long,
> But stoop'd to Truth, and moraliz'd his song.

> . . . who could take offence,
> While pure Description held the place of Sense?

Warburton's remark on this last passage may be considered as an authentic explanation by the poet himself:

> He uses PURE equivocally, to signify either chaste or empty; and has given in this line what he esteemed the true Character of descriptive Poetry, as it is called. A composition, in his opinion, as absurd as a feast made up of sauces. The use of a pictoresque imagination is to brighten and adorn good sense; so that to employ it only in Description, is like children's delighting in a prism for the sake of its gaudy colours; which when frugally managed, and artfully disposed, might be made to represent and illustrate the noblest objects in nature.

Both poet and commentator seem to have looked at the matter more from its moral than from its artistic side. But so much the better; it appears as worthless from one point of view as from the other.

NOTE e, p. 90

Poétique Française, II, 501: "J'écrivois ces réflexions avant que les essais des Allemands dans ce genre (l'Eglogue) fussent connus parmi nous. Ils ont exécuté ce que j'avois conçu; et s'ils parviennent à donner plus au moral et moins au détail des peintures physiques, ils excelleront dans ce genre, plus riche, plus vaste, plus fécond, et infiniment plus natural et plus moral que celui de la galanterie champêtre. ["I wrote these reflections before the attempts of the Germans in this genre (eclogue) became known to us. They have put into practice what I already knew and if they should succeed in paying more attention to the moral content and less to the details of description, they would excel in this genre, which is richer, more extensive, more fruitful, and infinitely more natural and moral than that of the gallantry of the pastoral."]

NOTES, CHAPTER EIGHTEEN

NOTE a, p. 95

I see that Servius justifies Virgil in a different way. He too has noticed the difference between the two shields: "Sane interest inter hunc et Homeri Clypeum: illic enim singula dum fiunt narrantur; hic vero perfecto opere noscuntur: nam et hic arma prius accipit Aeneas, quam spectaret; ibi postquam omnia narrata sunt, sic a Thetide deferuntur ad Achillem" * (*Aeneid* VIII. 625). And why? Because, says Servius, there were illustrations on Aeneas' shield not only of the few events which the poet mentions, but also

... genus omne futurae
Stirpis ab Ascanio, pugnataque in ordine bella.†

Thus, it would not have been possible for the poet to mention the long line of descendants individually and for the wars to have been fought in chronological order as quickly as they were illustrated on the shield by Vulcan. This is the meaning of the somewhat obscure words of Servius: "Opportune ergo Virgilius, quia non videtur simul et narrationis celeritas potuisse connecti, et opus tam velociter expediri, ut ad verbum posset occurrere." ‡ Virgil was able to bring forward only a small part of the *non enarrabile texto Clypei*,§ and he could not do even this while Vulcan was working on the shield, but had to wait until it was finished. I wish very much for Virgil's sake that Servius' reasoning were without foundation here; and my defense would do him much more credit. For why was it necessary to introduce the whole of Roman history on a shield? Homer was able to make his shield the very essence of all that had happened in the world by means of but a few pictures. Does it not almost seem that Virgil, since he could not surpass him in the execution of the shield or in the choice of subjects on it, wanted at least to exceed him in the number of his subjects? And what could have been more childish than that?

* ["There is an essential difference between this shield and that of Homer. In the latter, each detail is described as it is being carried out, but in the former case we know the shield only after it is completed; and here, too, Aeneas receives the weapons before he has looked at them more closely. In Homer, however, they are brought to Achilles by Thetis only after everything has been related."]

† ["the entire family, which is supposed to be described from Ascaius, and the wars fought by it in their proper order."]

‡ ["Virgil has done this very cleverly, because it does not appear that on the one hand the rapidity of the narration can be drawn out, while on the other the work could be carried on so quickly that it corresponded in time with the words."]

§ ["subjects on the shields which were not narratable."]

Note b, p. 96

["They fashion a huge shield, a single shield
That all the darts of Latins should withstand
And weld its seven circles plate on plate.

In breezy bellows some entrap the air
And give it forth too; others in the pool
Anneal the hissing brass; the cavern groans
With range of anvils. With his fellows each
Lifts with stout strength his arms in measured time,
And turns the bloom about with gripping tongs."

(*Aeneid* VIII. 447-54, tr. Delabère-May)]

NOTES, CHAPTER NINETEEN

NOTE a, p. 98

" . . . Scuto eius, in quo Amazonum praelium caelavit intumescente ambitu parmae; eiusdem concava parte Deorum et Gigantum dimicationem." Pliny, XXXVI. 4, p. 726, ed. Hard. [" 'Her shield in which he carved, on the convex side, the battle of the Amazons, and on the concave the strife of the gods and the giants.' The shield in question is that of Athena in the Parthenon" (Howard, p. 400).]

NOTE b, p. 99

["The people were assembled in the market place, where a
 quarrel
had arisen, and two men were disputing over the blood price
for a man who had been killed. One man promised full
 restitution
in a public statement, but the other refused and would accept
 nothing.
Both then made for an arbitrator, to have a decision;
and people were speaking up on either side, to help both men.
But the heralds kept the people in hand, as meanwhile the
 elders

were in session on benches of polished stone in the sacred
 circle
and held in their hands the staves of the heralds who lift
 their voices.
The two men rushed before these, and took turns speaking
 their cases,
and between them lay on the ground two talents of gold, to be
 given
to that judge who in this case spoke the straightest opinion."

<div align="right">(Iliad XVIII. 497-508, tr. Lattimore)]</div>

Note c, p. 100

["There he wrought," or "there he made," or "there he put,"
or "there the limping god represented."] The first begins with
line 483 and runs through line 489; the second runs from
490 to 509; the third from 510 to 540; the fourth from 541 to
549; the fifth from 550 to 560; the sixth from 561 to 572; the
seventh from 573 to 586; the eighth from 587 to 589; the ninth
from 590 to 605; and the tenth from 606 to 608. The third pic-
ture is the only one without the introductory words quoted
above; but from the words which begin the second one, ἐν δὲ
δύω ποίησε πόλεις, and from the nature of the matter itself, it is
plain enough that it must be a separate picture.

Note d, p. 101

To show that I am being just in my judgment of Pope, I shall
quote the original of the following passage from him: * "That
he was no stranger to aerial Perspective, appears in his ex-
pressly marking the distance of object from object: he tells
us," etc. I say again that Pope has incorrectly used the ex-
pression "aerial Perspective" (Perspective aérienne); it has
nothing to do with decrease of size in proportion to distance,

but simply means the diminution of color intensity and change of color according to the condition of the air or the medium through which the object is seen. Anyone who could make a mistake like this must have been ignorant of the whole subject.

* [The passage from Pope which Lessing quotes may be found in the essay *Observations on the Shield of Achilles,* in Pope's *Iliad,* Bk. XVIII, ed. Gilbert Wakefield (London, 1796), V, 169.]

NOTES, CHAPTER TWENTY

NOTE a, p. 105

["She was a very beautiful woman, with lovely eyebrows
 and complexion,
With beautiful cheeks and face, ox-eyes, snow-white skin;
Dark-eyed, tender, a grove full of charms,
White armed, delicate breathing, beauty undisguised;
The complexion fair, the cheek rosy,
The countenance pleasing, the eye beautiful.
Inartificial loveliness undyed, natural;
A rose-coloured fruit tinged her whiteness,
As if one should dye ivory with splendid purple.
Long-necked, dazzling white, whence she was often called—
Swan-born lovely Helen."

(Tr. Phillimore)]

Constantinus Manasses, *Compendium Chronicum,* p. 20, ed. Venet. Madame Dacier was well pleased with this portrait by Manasses except for the tautologies: "De Helenae pulchritudine omnium optime Constantinus Manasses, nisi in eo tautologiam reprehendas" (*Ad Dictyn Cretensem* I. 3, p. 5 ["Constantinus Manasses described least of anyone Helen's beauties; only his repetitions are perhaps reprehensible"]). According to Mezeriac (*Commentaire sur les Epitres d'Ovide,* II, 361), she also quotes the descriptions which Dares Phrygius, and Cedremus give of Helen's beauty. In the first there occurs

a feature which sounds a little strange. Dares says that Helen had a mole between her eyebrows: *notam inter duo supercilia habentem.* Surely there was nothing beautiful in that! I wish that the Frenchwoman had expressed her opinion on this. For my part, I believe the word *nota* to be a corruption, and that Dares is speaking of what the Greeks called μεσόφρυον, and the Latins *glabella* ["space between the eyebrows"]. Helen's eyebrows, he intends to say, did not meet, but were slightly separated. On this point the ancients differed in their taste. Some liked such a separation, others did not (Junius, *De Pictura Vet.* III. 9, p. 245). Anacreon took a middle course: the eyebrows of his beloved maiden were neither noticeably separated nor completely joined together, but gently ran together into a single point. He says to the artist who is painting her (*Ode* 28):

> τὸ μεσόφρυον δὲ μέ μοι
> διάκοπτε, μήτε μίσγε,
> ἐχέτω δ' ὅπως ἐκείνη
> τὶ λεληθότως σύνοφρυν
> βλεφάρων ἴτυν κελαινήν.*

This is Pauw's reading, but the meaning is the same in the other versions and is correctly given by Heinrich Stephano:

> Supercilii nigrantes
> Discrimina nec arcus,
> Confundito nec illos:
> Sed iunge sic ut anceps
> Divortium relinquas,
> Quale esse cernis ipsi.

But if I have correctly interpreted Dare's meaning, what word must be read for *notam? Moram* perhaps? It is certain, at any rate, that *mora* means not only the lapse of time before something happens, but also the barrier, the space which separates one thing from another.

> Ego inquieta montium iaceam mora †

is the wish of the raging Hercules in Seneca (line 1215), a line which Gronovius explains this way: "Optat se medium iacere inter duas Symplegades, illarum velut moram, impedimentum,

obicem; qui eas moretur, vetet aut satis arcte coniungi, aut rursus distrahi." ‡ The same poet uses *lacertorum morae* to mean the same as *iuncturae* (Schroeder on *Thyestes* 762).

* ["And you must neither separate the eyebrows nor run them together. Make them in your picture, as with the other, almost unnoticeably joined together, as a dark arch for the lashes."]

† ["Oh, if I but lay there, restless, as an obstacle of mountains!"]

‡ ["He wishes to lie between the two Symplegades, as delayer, as an obstacle, so to speak; as a hindrance, which checks them and prevents them from either closely uniting or separating again."]

Note b, p. 106

Orlando Furioso, Canto VII. 11-15. [In this footnote Lessing gives a German translation of the five stanzas of Ariosto quoted on pages 105 and 106, with the notation "after the translation of Meinhardt in his *Versuch über den Charakter und die Werke der besten italienischen Dichter,* II, 228." An English version of the same passage follows:

Her shape is of such perfect symmetry,
As best to feign the industrious painter knows,
With long and knotted tresses; to the eye
Not yellow gold with brighter lustre glows.
Upon her tender cheek the mingled dye
Is scattered, of the lily and the rose.
Like ivory smooth, the forehead gay and round
Fills up the space, and forms a fitting bound.

Two black and slender arches rise above
Two clear black eyes, say suns of radiant light;
Which ever softly beam and slowly move;
Round these appears to sport in frolic flight,
Hence scattering all his shafts, the little Love,
And seems to plunder hearts in open sight.
Thence, through mid visage, does the nose descend,
Where Envy finds no blemish to amend.

As if between two vales, which softly curl,
The mouth with vermeil tint is seen to glow:
Within are strung two rows of orient pearl,
Which her delicious lips shut up or show.

Of force to melt the heart of any churl,
However rude, hence courteous accents flow;
And here that gentle smile receives its birth,
Which opes at will a paradise on earth.

Like milk the bosom and the neck like snow;
Round is the neck, and full and large the breast;
Where, fresh and firm, two ivory apples grow,
Which rise and fall, as, to the margin pressed
By pleasant breeze, the billows come and go,
Not prying Argus could discern the rest.
Yet might the observing eye of things concealed
Conjecture safely, from the charms revealed.

To all her arms a just proportion bear,
And a white hand is oftentimes descried
Which narrow is, and some deal long; and where
No knot appears, nor vein is signified.
For finish of that stately shape and rare,
A foot, neat, short, and round, beneath is spied.
Angelic visions, creatures of the sky,
Concealed beneath no covering veil can lie."

(Tr. Rose)]

NOTE c, p. 106

Dialogo della Pittura, intitolato l'Aretino (Florence, 1735), p. 178: "Se vogliono i Pittori senza fatica trovare un perfetto esempio di bella Donna, leggano quelle Stanze dell' Ariosto, nelle quali egli discrive mirabilmente le bellezze della Fata Alcina: e vedranno parimente, quanto i buoni Poeti siano ancora essi Pittori." ["If painters wish to find without difficulty the perfect specimen of a beautiful woman, let them read those stanzas of Ariosto in which he admirably describes the beauties of the fairy Alcina. They will recognize at the same time how good poets are also good painters."]

NOTE d, p. 107

Ibid. "Ecco, che, quanto alla proportione, l'ingeniosissimo Ariosto assegna la migliore, che sappiano formar le mani de più eccellenti Pittori, usando questa voce industri, per dinotar la diligenza, che conviene al buono artefice." ["Well then, as far as proportion is concerned, the most ingenious Ariosto achieves (in his poetry) the very best that the greatest painters could produce, employing this industrious voice (*voce industri*) to denote the diligence that is characteristic of a good artificer."]

NOTE e, p. 107

Ibid., p. 182: "Qui l'Ariosto colorisce, e in questo suo colorire dimostra essere un Titiano." ["Here Ariosto employs color, and in doing so shows himself to be another Titian."]

NOTE f, p. 107

Ibid., p. 180: "Poteva l'Ariosto nella guisa, che ha detto chioma bionda, dir chioma d'oro: ma gli parve forse, che havrebbe havuto troppo del Poetico. Da che si può ritrar, che'l Pittore dee imitar l'oro, e non metterlo (come fanno i Miniatori) nelle sue Pitture, in modo, che si possa dire, que' capelli non sono d'oro, ma par che risplendano, come l'oro." # What Dolce subsequently quotes from Athenaeus is remarkable only for its inaccuracy. I speak of this in another place.

["Ariosto might have said that anyone who speaks of blond hair could just as well have said golden locks. But perhaps it seemed to him that this latter was too poetic. From this we can deduce that the painter has to imitate gold, and not put it (as do some painters of miniatures) in his works, in such a fashion that one would be able to say: this hair is not of gold, but it gleams like gold."]

Note g, p. 107

Ibid., p. 182: "Il naso, che discende giù, havendo peraventura la consideratione a quelle forme de' nasi, che si veggono ne' ritratti delle belle Romane antiche." ["The descending nose, for he happened to think of the kinds of noses one sees in pictures of beautiful Roman women of antiquity."]

Note h, p. 108

["At length she issues, a great throng around,
Clad in Sidonian cloak, with purple fringe;
Her quiver wrought of gold, her tresses tied
With knot of golden braid, a golden clasp
Binds up her purple robe. . . ."

(*Aeneid* IV. 136-39, tr. Delabère-May)]

Note i, p. 109

["But enough! herself I look on!
Sure the wax will soon find language."]

Note j, p. 110

["When his face is done, draw him an ivory neck surpassing even that of Adonis. Give him the breast and the two hands of Hermes, the thighs from Pollux and the abdomen from Dionysius—take here this Apollo and make a Bathyllus."]

NOTE, CHAPTER TWENTY-ONE

NOTE a, p. 111

[" 'Surely there is no blame on Trojans and strong-greaved
 Achaians
if for long time they suffer hardship for a woman like this one.
Terrible is the likeness of her face to immortal goddesses.' "

(Iliad III. 156-58, tr. Lattimore)]

NOTES, CHAPTER TWENTY-TWO

NOTE a, p. 116

["Still, though she be such, let her go away in the ships, lest
she be left behind, a grief to us and our children."

(Iliad III. 159-60, tr. Lattimore)]

NOTE b, p. 116

["And at once, wrapping herself about in shimmering garments,
she went forth from the chamber, . . . "]

(Iliad III. 141-43, tr. Lattimore)]

NOTE c, p. 117

Pliny says of Apelles (XXXV. 36, p. 698, ed. Hard.): "Fecit et
Dianam sacrificantium virginum choro mixtam: quibus vicisse
Homeri versus videtur id ipsum describentis." * Nothing can

be more just than this praise. Beautiful nymphs surrounding a beautiful goddess who towers above them with her majestic brow, are indeed a subject more fitting for painting than for poetry. However, the word *sacrificantium* is, to my mind, highly suspicious. What is the goddess doing among sacrificing virgins? Is this the occupation which Homer gives the companions of Diana? Not at all; they roam the hills and woods with her, they hunt, they play and dance (*Odyssey* VI. 102-6):

οἵη δ' Ἄρτεμις εἶσι κατ' οὔρεος ἰοχέαιρα
ἢ κατὰ Τηΰγετον περιμήκετον, ἢ Ἐρύμανθον
τερπομένη κάπροισι καὶ ὠκείῃς ἐλάφοισιν·
τῇ δέ θ' ἅμα Νύμφαι, κοῦραι Διὸς αἰγιόχοιο
ἀγρονόμοι παίζουσι . . . †

Pliny must therefore have written, not *sacrificantium*, but *venantium* ["hunting"], or something similar; perhaps *sylvis vagantium* ["roaming in the forests"], an amendment which would have had approximately the same number of letters. The *saltantium* would correspond more closely to Homer's παίζουσι ["dance"]. Virgil, moreover, in his imitation of this passage has Diana dancing with her nymphs (*Aeneid* I. 498-99):

Qualis in Eurotae ripis, aut per iuga Cynthi
Exercet Diana choros. . . . ‡

Spence has a strange idea about this passage (*Polymetis,* Dial. VIII, p. 102): "This Diana," he says, "both in the picture and in the descriptions, was the Diana Venatrix, tho' she was not represented either by Virgil, or Apelles, or Homer, as hunting with her Nymphs, but as employed with them in that sort of dances which of old were regarded as very solemn acts of devotion." And in a note he adds: "The expression of παίζειν, used by Homer on this occasion, is scarce proper for hunting, as that of *Choros exercere* in Virgil should be understood of the religious dances of old, because dancing, in the old Roman idea of it, was indecent even for men, in public, unless it were the sort of dances used in Honour of Mars, or Bacchus, or some

other of their gods." Spence is referring to those ceremonial dances which the ancients considered a part of their religious ceremonies. For that reason, he thinks, Pliny uses the word *sacrificare:* "It is in consequence of this that Pliny, in speaking of Diana's Nymphs on this very occasion, uses the word *sacrificare* of them, which quite determines these dances of theirs to have been of the religious kind." He forgets that in Virgil Diana herself takes part in the dancing: *exercet Diana choros.* But if this dance was a religious one, in whose honor was Diana supposed to have danced? In her own? Or in honor of another divinity? Both notions are absurd. And even if the ancient Romans did not consider dancing in general to be very becoming to a serious person, this does not mean that their poets were obliged to transfer the seriousness of their people to the gods, whose customs had already been described quite differently by the Greek poets. When Horace says of Venus (*Odes* I. 4. 5-7):

Iam Cytherea choros ducit Venus, imminente luna:
Iunctaeque Nymphis Gratiae decentes
Alterno terram quatiunt pede . . . §

does he mean that these, too, were religious dances? But I am wasting too many words on such a minor thing as this.

* ["He also painted a Diana in the midst of a circle of sacrificing virgins. With this picture he appears to have topped the verses of Homer, who describes the same thing."]

† ["Just as down from Taygetos' heights, from Mount Erymanthos Artemis strides, pleased at sending her missiles and gaily hunting boar and fleet stags, the nymphs of the woods, daughters of Zeus, play about her as her attendants."]

‡ ["As Diana inspirits dancing rows on the shores of Eurota and on airy heights of Cynthus."]

§ ["Cytherea also leads the dance already, where Luna looks down. And the graces, charmingly joining the nymphs, beat the ground with their feet in alternating rhythm."]

Note d, p. 118

["He spoke, the son of Kronos, and nodded his head with the dark brows,

and the immortally anointed hair of the great god
swept from his divine head, and all Olympos was shaken."

(*Iliad* I. 528-30, tr. Lattimore)]

NOTE e, p. 119

Pliny, XXXIV. 19, p. 651: "Ipse tamen corporum tenus curi-
osus, animi sensus non expressisse videtur, capillum quoque
et pubem non emendatius fecisse, quam rudis antiquitas
instituisset." ["Although exercising care in regard to the bod-
ies, he appears not to have expressed the feelings of the soul,
nor to have reproduced hair and beard any better than coarse
antiquity did."]

NOTES, CHAPTER TWENTY-FIVE

NOTE a, p. 132

["M. But lately of a thought magnificent
 A lizard robbed him. ST. How? I pray thee, tell me.
 M. As he was contemplating with open mouth
 The ways and changes of the varying moon,
 A lizard from the roof dropped filth upon him.
 ST. O clever lizard that could foul the mouth of Socrates."

(*Clouds* 169-74, tr. Phillimore)

Translators and commentators generally agree on "lizard"
as the correct rendering of γαλεώτης. Lessing's "weasel" is in-
correct, although Grimm's dictionary (1960 edn.; Vol. XIV, p.
1594) lists a few occurrences of the word *Wiesel* ("weasel") in
the meaning of *Eidechse* ("lizard").]

Note b, p. 132

The Connoisseur, Vol. I, No. 21. Concerning the beauty of Knonmquaiha we read: "He was struck with the glossy hue of her complexion, which shone like the jetty down on the black hogs of Hessaqua; he was ravished with the prest gristle of her nose; and his eyes dwelt with admiration on the flaccid beauties of her breasts, which descended to her navel." And how did art contribute to putting so many charms in their most advantageous light? "She made a varnish of the fat of goats mixed with soot, with which she annointed her whole body, as she stood beneath the rays of the sun: her locks were clotted with melted grease, and powdered with the yellow dust of Buchu: her face, which shone like the polished ebony, was beautifully varied with spots of red earth, and appeared like the sable curtain of the night bespangled with stars: she sprinkled her limbs with wood-ashes, and perfumed them with the dung of Stinkbingsem. Her arms and legs were entwined with the shining entrails of an heifer: from her neck there hung a pouch composed of the stomach of a kid: the wings of an ostrich overshadowed the fleshy promontoryes behind; and before she wore an apron formed of the shaggy ears of a lion." To this description I shall add that of the marriage ceremony of the enamored pair: "The Surri or Chief Priest approached them, and in a deep voice chanted the nuptial rites to the melodious grumbling of the Gom-Gom; and at the same time (according to the manner of Caffraria) bedewed them plentifully with the urinary benediction. The bride and bridegroom rubbed in the precious stream with ecstasy, while the briny drops trickled from their bodies, like the oozy surge from the rocks of Chirigriqua."

NOTE c, p. 134

["NE: I see no trace of human creature here.
 OD: Nor food, nor household implements to cook it?
 NE: A mass of leaves heaped up to form a couch.
 OD: All bare besides? Naught else beneath the roof?
 NE: A bowl made all of wood, the workmanship
 Of some rude hand; see, too, some firewood.
 OD: And this is all the treasure that he hath.
 NE: Alas! alas! these reeking rags behold,
 The solace of his wounds, laid here to dry."

 (*Philoctetes* 31-39, tr. Phillimore)]

NOTE d, p. 134

["And as he cried the skin cracked from his body
In one wound, blood streaming over muscles,
Veins stripped naked, pulse beating; entrails could be
Counted as they moved; even the heart shone red
Within his breast. . . ."

 (*Metamorphoses* VI. 387ff., tr. Gregory)]

NOTE e, p. 135

["While from far off the nymph looked down at her . . .
She raised her voice to call out Ceres' orders
And then stepped back. Although her stay was short,
She felt the chill of Famine in the air. . . . "

 (*Metamorphoses* VIII. 809ff., tr. Gregory)]

NOTE f, p. 136

["Even from the trifling food that they may leave
Rises a foul intolerable smell,

> Such as no mortal could endure to face,
> Nor had he heart of beaten adamant,
> But bitter need of food compelleth me
> To stay, and staying fill my wretched maw."
>
> 　　　(*Argonautica* II. 228-33, tr. Phillimore)]

NOTE g, p. 136

[In the third book of the *Aeneid* (212ff.) Virgil tells how the Harpies went to the Strophadian Islands after having been driven away from Phineus. In his wanderings, Aeneas lands there and is disturbed by them at his meal. A battle ensues, and after one of the monsters, Celaeno, has been overcome, she prophesies that the Trojans will find the land for which they are searching (Latium), but that they will not found a city there until hunger has driven them to eat the very tables on which their food is placed. When the Trojans arrive in Latium, they use the loaves as tables on which to put their meat, thus fulfilling the Harpy's prophecy.]

NOTE h, p. 137

[In the *Inferno* (33rd canto) Dante depicts Ugolino, Count of Donoratico and a member of the Guelph family, eating the head of his enemy, Archbishop Ruggieri degli Ubaldini, leader of the Ghibellines. In 1288 Ugolino plotted with Ruggieri to do away Nino de' Visconti, Ugolino's nephew and coleader of the Guelph factions at Pisa. The plot was successful, but the Guelphs were so weakened thereby that Ruggieri, seeing a chance to destroy the party, betrayed Ugolino and threw him and his sons and grandsons into prison. The prison was sealed up and they were left to starve. Dante places both Ruggieri and Ugolino in the deepest circle of Hell, where, in symbolic retribution, Ruggieri must himself become the food for his victim.]

NOTE i, p. 137

The Sea Voyage, Act III, scene 1. A French pirate ship is
driven onto a desert island. Greed and envy cause a quarrel
among the crew, affording a few poor wretches, who had been
exposed to direst need on the island for some time, the op-
portunity to make off with the ship. Being thus deprived of
all the necessities of life, the scoundrels suddenly see nothing
but the prospect of a cruel death. One of them expresses his
hunger and desperation to the others in the following manner:

LAMURE: Oh, what a Tempest have I in my Stomach!
 How my empty Guts cry out! My wounds ache,
 Would they would bleed again, that I might get
 Something to quench my thirst.

FRANVILLE: O Lamure, the Happiness my dogs had
 When I kept house at home! They had a storehouse,
 A storehouse of most blessed bones and crusts,
 Happy crusts. Oh, how sharp Hunger pinches me!

LAMURE: How now, what news?

MORILLAR: Hast any Meat yet?

FRANVILLE: Not a bit that I can see:
 Here be goodly quarries, but they be cruel hard
 To gnaw: I ha' got some mud we'll eat it with spoons,
 Very good thick mud; but it stinks damnably,
 There's old rotten trunks of trees too,
 But not a leaf nor blossom in all the island.

LAMURE: How it looks!

MORILLAR: It stinks too.

LAMURE: It may be poison.

FRANVILLE: Let it be any thing;
 So I can get it down. Why, Man,
 Poison's a princely dish.

MORILLAR: Hast thou no bisket?
 No crumbs left in thy pocket? Here is my doublet,
 Give me but three small crumbs.

FRANVILLE: Not for three Kingdoms,
 If I were Master of 'em. Oh, Lamure,
 But one poor joint of Mutton, we ha' scorn'd, Man.

LAMURE: Thou speak'st of Paradise;
 Or but the snuffs of those Healths,
 We have lewdly at midnight flung away.

MORILLAR: Ah! but to lick the glasses.

But this is nothing compared to the next scene, when the
ship's surgeon makes his appearance:

FRANVILLE: Here comes the Surgeon. What
 Hast thou discover'd? Smile, smile and comfort us.

SURGEON: I am expiring,
 Smile they that can. I can find nothing, Gentlemen,
 Here's nothing can be meat, without a miracle.
 Oh that I had my boxes and my lints now,
 My stupes, my tents, and those sweet helps of Nature,
 What dainty dishes could I make of 'em.

MORILLAR: Hast ne'er an old suppository?

SURGEON: Oh would I had, Sir.

LAMURE: Or but the paper where such a cordial
 Potion, or pills hath been entomb'd.

FRANVILLE: Or the best bladder where a cooling-glister.

MORILLAR: Hast thou no searcloths left?
 Nor any old pultesses?

FRANVILLE: We care not to what it hath been minist'red.

SURGEON: Sure I have none of these dainties, Gentlemen.

FRANVILLE: Where's the great wen
 Thou cut'st from Hugh the sailor's shoulder?
 That would serve now for a most princely Banquet.

SURGEON: Ay if we had it, Gentlemen.

I flung it over-bord, Slave that I was.

LAMURE: A most improvident Villain.

NOTES, CHAPTER TWENTY-SIX

NOTE a, p. 138

[Winckelmann's work appeared in 1764 under the title *Geschichte der Kunst des Altertums,* and Lessing tells us at the beginning of this chapter that he must first study this critic's book before continuing his *Laocoön.* Lessing's treatise on the limits of painting and poetry actually closes, then, with the preceding chapter (XXV). The remaing four chapters are devoted to some general observations on certain points of art history which interested Lessing particularly.]

NOTE b, p. 141

["Beyond these, there are not many sculptors of high repute, for in the case of several works of very great excellence, the number of artists that have been engaged upon them has proved a considerable obstacle to the fame of each, no individual being able to engross the whole of the credit, and it being impossible to award it in due proportion to the names of the several artists combined. Such is the case of the Laocoön, for example, in the palace of the Emperor Titus, a work that may be looked upon as preferable to any other production of the art of painting or of statuary. It is sculptured from a single block,* both the main figure as well as the children, and the serpents with their marvelous folds. This group was made in concert by three eminent artists, Agesander, Polydorus, and Athenodorus, natives of Rhodes. In a similar manner also the

palaces of the Caesars in the Palatium have been filled with most splendid statuary, the work of Craterus in conjunction with Pythodorus, of Polydeuces and Hermolaus, and of another Pythodorus with Artemon; some of the statues, also, are by Aphrodisius of Tralles, who worked alone. The Pantheon of Agrippa has been decorated by Diogenes of Athens, and the Caryatides by him, which form the columns of that temple, are looked upon as masterpieces of excellence: the same is also the case with the statues that are placed upon the roof, though, in consequence of the height, they have not had an opportunity of being so well appreciated" (Hamann, pp. 289-90).]

* [The work consists of six pieces, not one, as Pliny says.]

NOTES, CHAPTER TWENTY-SEVEN

NOTE a, p. 148

["Yet lest I should seem to be altogether attacking the Greeks, I should like to be thought to belong to those first masters of painting and modeling, whom you will find in these books writing on their completed works (works which we are never tired of admiring) an inscription denoting incompleteness, as 'Apelles was making,' or 'Polycletus,' as if the work was ever inchoate and imperfect; so that from the varieties of criticism the artist might have a way of escape towards pardon, as being ready to correct whatever was desired, if he had not been cut off. How modest it was of them to inscribe all their works, as if they were their last, and as if in each case they had been meanwhile cut off by fate. Three works and no more, I believe, which I shall describe in their turn, are said to have been inscribed, as if finished, "he made," by which it appeared that the artist had the greatest confidence in his work, and for this reason all these were regarded with great dislike" (Hamann, p. 292).]

Note b, p. 149

At least he expressly promises to do so: *quae suis locis reddam* ["about which I shall speak in an appropriate place"]. Even if he has not entirely forgotten it, he does no more than mention it in passing, and not at all in the way that one would expect after such a promise. For example, when he writes (XXXV. 39.): "Lysippus quoque Aeginae picturae suae inscripsit, ἐνέκαυσεν: quod profecto non fecisset, nisi encaustica inventa," * it is evident that he is using the word ἐνέκαυσεν to prove something quite different. If, as Hardouin supposed, he had mentioned it as one of the works whose inscription was written in the aorist, it would certainly have been worth his trouble to have said something about it. Hardouin believes he has found the other two works of this kind in the following passage:

> Idem (Divus Augustus) in Curia quoque, quam in comitio consecrabat, duas tabulas impressit parieti: Nemeam sedentem supra leonem, palmigeram ipsam, adstante cum baculo sene, cuius supra caput tabula bigae dependet. Nicias scripsit se inussisse: tali enim usus est verbo. Alterius tabulae admiratio est, puberem filium seni patri similem esse, salva aetatis differentia, supervolante aquila draconem complexa. Philochares hoc suum opus esse testatus est † (XXXV. 10).

Here two different pictures are described, which Augustus had exhibited in his newly built senate house. The first was by Nicias, the second by Philochares. What is said of Philochares is clear enough, but there are some difficulties concerning Nicias. His picture shows Nemea seated on a lion and holding a palm branch in her hand; next to her is an old man with a staff, *cuius supra caput tabula bigae dependet*. What does this mean? That a tablet hung above his head, on which a two-horse chariot was painted? That is, after all, the only meaning we can give these words. Accordingly, another, smaller picture

was hung over the main one. Were both of them by Nicias, then? This is what Hardouin must have understood, for how else could there have been two pictures by Nicias here, since one was expressly ascribed to Philochares? "Inscripsit Nicias igitur geminae huic tabulae suum nomen in hunc modum: Ο ΝΙΚΙΑΣ ΕΝΕΚΑΤΣΕΝ; atque adeo e tribus operibus, quae absolute fuisse inscripta, ILLE FECIT, indicavit Praefatio ad Titum, duo haec sunt Niciae.‡ I should like to ask Hardouin this: assuming that Nicias had really used the imperfect rather than the aorist, and Pliny had simply wanted to say that the artist used ἐγκαίειν ["burn in"] instead of γράφειν ["paint"], would he not have had to say in his own language: "Nicias scripsit se inussisse" ["Nicias wrote that he burned it in"]? But I will not insist on this; it may really have been Pliny's intention to indicate in this way one of the works in question. But who would let himself be convinced that there are two pictures, one hanging above the other? I, for one, never could. Consequently, the words *cujus supra caput tabula bigae dependet* must be a corruption. *Tabula bigae,* a painting of a two-horse chariot, does not sound very much like Pliny, even granting the fact that he uses *bigae* elsewhere in the singular. And what sort of a two-horse chariot? Possibly the kind used in the Nemean games, in which case the smaller picture would have a connection with the larger one in regard to subject. But that cannot be, for four-horse chariots, not two, were customarily used in the Nemean games (Schmidius in *Prologus ad Nemeonicas,* p. 2). Once it occurred to me that Pliny might have written a Greek word instead of *bigae,* and that the scribes did not understand it. I am thinking of the word πτυχίον. For we know from a passage in Antigonus Carystus, quoted by Zenobius (cf. Gronovius, *Antiquit. Graec. Praef.,* IX, 7), that ancient artists did not always inscribe their names on the works themselves but sometimes on a small tablet attached to the painting or statue. Such a tablet was called πτυχίον. Possibly this Greek word was explained by *tabula, tabella* in the manuscript's gloss, and then finally found its way into the text itself. *Bigae* arose from πτυχίον, thus explain-

ing the reading *tabula bigae*. Nothing would fit better with
what follows than this πτυχίον, for the subsequent line con-
tains what was inscribed on it. Thus the whole passage would
read: "cuius supra caput πτυχίον dependet, quo Nicias scripsit
se inussisse" ["above whose head a tablet hangs, upon which
Nicias wrote that he inscribed (it)"]. I must confess that this
correction is a little bold, but why should we be obliged to
offer an emendation to everything that we can prove to be
corrupt? I am content with having done the latter here, and
I leave the correction to an abler hand. But to return to the
matter in question. If Pliny speaks of only one painting by
Nicias, on which the inscription was written in the aorist, and
the second painting of this kind was that by Lysippus men-
tioned above, where, then, is the third? I do not know. If I had
the task of finding it in any author other than Pliny, I should
feel no difficulty. But it is supposed to be in Pliny, and, I re-
peat, I do not find it there.

* ["Lysippus also wrote on a painting by himself to be found in
Aegina ἐνέκαυσεν ('he burned it in'), which he could certainly have done
only after the invention of encaustics."]

† ["And the same one (Augustus) also had two paintings placed in
the wall in the Curia, which he dedicated at the comitia: Nemea,
sitting on a lion and holding a palm branch in her hand. And beside
her an old man with a staff, above whose head hung a small tablet with
a carriage and horses. Nicias wrote that he 'burned it in,' for that is the
expression which he used. The other picture is admired principally be-
cause the grown son closely resembles his father, and yet at the same
time the difference of age has been preserved. About him an eagle is
flying, holding a serpent in his beak. Philochares designated this work
as one of his own."]

‡ ["Nicias therefore placed his name on this double painting in the
following manner: 'Nicias has inscribed it,' and to this degree two of
those three works which, as the preface to Titus indicates, were defi-
nitely designated by 'this person painted it,' are from the hand of
Nicias."]

NOTE, CHAPTER TWENTY-EIGHT

NOTE a, p. 151

["He too was reckoned among the greatest generals, and accomplished many memorable deeds. But the most brilliant among these was the maneuver he invented in the battle near Thebes, when he came to the assistance of the Boeotians. For when in that battle Agesilaus, the commander-in-chief, was now sure of victory, as he had already beaten back the mercenaries, Chabrias forbade the remainder of his phalanx to stir from the spot, and taught them how to receive the onset of the enemy, leaning their knees against their shields and stretching their lances forward. When Agesilaus perceived this novelty he did not care to advance, and recalled his men, who had begun the attack, with the tuba. This deed became so famous in all Greece that Chabrias wished for himself a statue in that attitude, and it was erected to him in the market place at Athens at the expense of the state. Hence it came to pass that aferwards athletes and other artists had themselves represented in their statues in such attitudes in which they had gained the victory" (Hamann, p. 294).]

NOTES, CHAPTER TWENTY-NINE

NOTE a, p. 154

["And that the rhetorical imagination requires one thing and that of poets another, you will not fail to perceive, nor that the end of imagination in poetry is to astonish, and in oratory to make vivid. Not but that the language used by the poets has an extravagance more fabulous, and every way transcending what is credible, but the best part of the rhetorical imagination is ever that which is practicable and true" (Hamann, p. 295).]

NOTE b, p. 156

[Juvenal, *Satires* XII. 43ff.:

> "('Away with all that's mine,' he cries, 'away!'
> And plunges in the deep without delay,
> Purples . . .)
> With these, neat baskets from the Britons bought,
> Rich silver chargers by Parthenius wrought,
> A huge, two-handed goblet, which might strain
> A Pholus, or a Fuscus' wife to drain;
> Followed by numerous dishes, heaps of plate
> Plain and enchased, which served, of ancient date,
> The wily champion of the Olynthian State."

<div style="text-align: right">(Tr. Gifford)]</div>

NOTE c, p. 156

["But he showed favor also to Tychios, the worker in leather, who received him when he came to his shop, by inserting the following passage in the *Iliad:*

Now Aias came near him, carrying like a wall his shield
of bronze and seven-fold ox-hide which Tychios wrought him
 with much toil;
Tychios, at home in Hyle, far best of all workers in leather
who had made him the great gleaming shield of sevenfold
 ox-hide
from strong bulls, and hammered an eighth fold of bronze
 upon it."

<div style="text-align: right">(Iliad VII. 219-23, tr. Lattimore)]</div>

NOTE d, p. 157

Ibid., II, 328: "His first tragedy, the *Antigone,* was performed in the third year of the 77th Olympiad." The date is approxi-

mately correct, but that this first tragedy was the *Antigone* is completely wrong. Samuel Petit, whom Winckelmann quotes in a note, did not say this at all, but expressly puts the *Antigone* in the third year of the 84th Olympiad. The following year Sophocles went to Samos with Pericles, and the date of this expedition can be accurately determined. In my *Life of Sophocles* I show, by a comparison with a passage from the elder Pliny, that the first tragedy of this poet was, in all probability, the *Triptolemus*. Pliny is speaking of the different qualities of grain in different countries (XVIII. 12, p. 107, ed. Hard.), and concludes:

> Hae fuere sententiae, Alexandro magno regnante, cum clarissima fuit Graecia, atque in toto terrarum orbe potentissima; ita tamen ut ante mortem eius annis fere CXLV Sophocles poeta in fabula Triptolemo frumentum Italicum ante cuncta laudaverit, ad verbum translata sententia:

> Et fortunatam Italiam frumento canêre candido.*

It is true that no specific mention of Sophocles' first tragedy is made here, but the passage does prove that the date, which Plutarch, the Scholiast, and the Arundelian marbles unanimously place in the 77th Olympiad, coincides so perfectly with the year which Pliny assigns to the *Triptolemus* that we must recognize this last as being Sophocles' first tragedy. The calculation is a simple matter. Alexander died in the 114th Olympiad; 145 years are equal to 36 Olympiads plus one year, and if we subtract this amount from the total, we have 77 left. Thus, Sophocles' *Triptolemus* falls in the 77th Olympiad. Since it was in this same Olympiad and, as I prove, in the last year of it that his tragedy falls, we may naturally conclude that they were one and the same work. I also show at the same time that Petit might have spared himself the trouble of writing the entire half of the chapter of his *Miscellanea* (Bk. III, chap. 18) which Winckelmann quotes. It is unnecessary to alter the passage in Plutarch (which Petit wishes to amend) to the *demotion,* or ἀνέψιος, instead of the archon *Aphepsion.* He needed only to go from the third to the fourth year of the

77th Olympiad to have found that the archon of this year is called Aphepsion by ancient authors just as often as Phaedon, if not oftener. He is called Phaedon by Diodorus Siculus, Dionysius Halicarnassus, and the anonymous author of the calendar of the Olympiads. On the other hand, he is called Aphepsion on the Arundelian marbles, by Apollodorus, and by Diogenes Laertius, who quotes the latter. Plutarch, however, uses both names: Phaedon in his life of Theseus, and Aphepsion in his life of Cimon. Palmerius' conjecture is therefore probable: "Aphepsionem et Phaedonem Archontas fuisse eponymos; scilicet uno in magistratu mortuo, suffectus fuit alter" † (*Excercit.*, p. 452 [*Exercitationes in optimos autores graecos,* published in 1668]). I take this opportunity to recall that Winckelmann has let another error concerning Sophocles creep into his first work on the imitation of Greek works in art (p. 8): "The most beautiful young people danced unclad on the stage, and Sophocles, the great Sophocles, was, in his youth, the first to show this spectacle to his fellow citizens." Sophocles never danced naked on the stage, but he did dance around the trophies after the victory of Salamis. According to some, he was naked when he did so; but others say that he was clad (Athenaeus, Bk. I, p. m. 20). Sophocles was among the youths brought to Salamis for safety; and it was here on this island that the tragic muse chose to assemble her three favorites in a gradation anticipating their later development: bold Aeschylus helped to achieve victory, youthful Sophocles danced around the trophies, and Euripides was born on that fortunate island on the very day of the victory.

* ["This was the prevalent opinion during the reign of Alexander the Great, when Greece was the most renowned and the mightiest land on all the earth; so that some 145 years before Alexander's death the poet Sophocles, in his tragedy *Triptolemus*, praised Italic grain above all other kinds with the literally translated words:

'And they celebrated Italia in song, which was
so blessed by splendid grain.' "]

† ["Aphepsion and Phaedon were eponymous Archons, since the one had died in office and the other had been chosen as his successor."]

BIOGRAPHICAL NOTES

BIOGRAPHICAL NOTES

ADDISON, JOSEPH (1662-1719), English scholar, poet, and statesman, best known as editor of the *Spectator*. In 1721, two years after the poet's death, his executor Tickell published his *Dialogues upon the usefulness of ancient medals especially in relation to the Latin and Greek poets*. In this work Addison discusses the value of ancient coins in illustrating passages in poetry that refer to "details of dress, or ornament, or equipment, or other matters which the ancient poet would assume to be familiar to the reader of his own time and hence not describe fully enough to be altogether clear to a modern reader" (Howard, p. lxxii). Lessing objects to Addison's lack of discrimination in finding parallels between the figures on coins and those described by the poet. (For a more detailed discussion of Lessing's criticism of Addison, see Blümner, pp. 547ff.)

AGAMEMNON. One of the Greek heroes before Troy. Banned from his native Mycenae by Thyestes, he and his brother Menelaus fled to Sparta, where Menelaus married Helen and Agamemnon married Clytemnestra. After Agamemnon's re-turn to Mycenae, where he soon became one of the most powerful kings in Greece, Helen was carried off to Troy and Agamemnon was given command of the Greek army sent to rescue her. He proved himself one of the bravest warriors in the struggle against the Trojans, but his arrogance ultimately brought great grief to the Greeks in that he aroused the anger of the mighty Achilles. His return home and his death at the hands of his wife are described in Aeschylus' tragedy, *Agamemnon*.

AJAX. Ajax the Great, son of Telamon, king of Salamis, was considered the mightiest hero of the Greek army next to Achilles. During the Trojan war he fought a duel with Hector and rescued the body of Achilles, but when he laid claim to Achilles' weapons they were refused him and given to Odysseus instead. Enraged at this disgrace, Ajax attempted to murder the leaders of the army, but the goddess Athena caused him to become insane and to attack the herds and herdsmen instead. When he regained his senses, he plunged his sword, a gift from Hector, into his own breast in atone-

ment for the slaughter. His death is described in Sophocles' tragedy, *Aias*.

ALBANI, ALEXANDER. A prince of the Roman Catholic church, a patron and friend of WINCKEL-MANN (q.v.). Born in 1692, he became a cardinal and head librarian in 1721. His home, the Villa Albani, is one of the most famous art treasuries in Rome.

ANACREON. Greek lyric poet (*c.* 572 - *c.* 488 B.C.), born at Teos on he coast of the Aegean Sea. Anacreon's monodies (songs for a single voice), extant only in fragments, celebrate for the most part wine and love. Written for court society, they show a considerable wit and gaiety and an almost perfect sense of form. Anacreon's poetry inspired a host of imitators, the so-called "Anacreontic poets." In Germany an Anacreontic school flourished in the eighteenth century (Gleim, Uz, Hagedorn), and in England Thomas Moore translated the *Odes of Anacreon* in 1800.

ANTENOR. In the *Iliad,* an old Trojan who attempted to bring about a reconciliation between the Greeks and his own countrymen.

APELLES AND PROTOGENES. Greek painters of the fourth century B.C. According to Pliny (*Natural History* XXXV. 79), Apelles is the author of a number of works on the theory of painting, and Suidas mentions Protogenes as the author of works

περὶ γραφικῆς καὶ σχημάτων, "on the art of painting and poetry."

APOLLONIUS AND TAURISCUS (first century B.C.). Greek sculptors born at Tralles in Asia Minor. The Farnese Bull group is perhaps the most famous work of the two brothers.

APOLLONIUS OF RHODES, born about 270 B.C., wrote the important epic *Argonautica,* a learned work that was much admired in its time and later imitated by Valerius Flaccus.

ARCESILAUS. Greek sculptor of the first century B.C., known for his statue of the Venus Genitrix.

ARCHELAUS. Son of Apollonius of Priene, possibly from the second century B.C. He is the sculptor of the bas-relief, "Apotheosis of Homer."

ARIOSTO, LODOVICO (1474-1533). Italian poet and author of the *Orlando Furioso.*

ARISTOMENES. The traditional hero of the Second Messenian War (seventh century B.C.).

ASINIUS POLLIO (76 B.C. - A.D. 4). Roman statesman, historian, and poet. After the year 40 B.C., he devoted himself almost exclusively to literary interests and to patronizing younger talented poets.

BACCHUS. Dionysus, or Bacchus, was the god of fertility and growth. Later he came to be associated with the vine and wine. Possibly of Thracian origin, he was thought in

primitive times to have the form of a bull or goat.

BANIER, ANTOINE (1673-1741). French archaeologist.

BAUMGARTEN, ALEXANDER GOTT-LIEB (1714-62), was professor of philosophy at the University of Frankfurt on the Oder. His unfinished *Aesthetica* (2 vols., 1750-58) established him as the founder and leader of a new science in Germany, that of aesthetics, but aside from a definition of beauty and the term "aesthetics" itself, the work contains little of permanent value. Of greater importance is Baumgarten's earliest work, the *Reflections on Poetry (Meditationes Philosophicae de nonnullis ad poema pertinentibus;* 1st ed., 1735), available in a recent English translation by K. Aschenbrenner and W. B. Holther (Berkeley and Los Angeles, 1954). For a relatively comprehensive and recent commentary on Baumgarten, see Ernst Cassirer's *Die Philosophie der Aufklärung* (Tübingen, 1932) chap. 7, sec. 5, English translation by F. C. A. Koelln and J. P. Pettegrove (Princeton, 1951).

BODEN, BENJAMIN (1737-82). Author of *De umbra poetica dissertationes* (Wittenberg, 1764).

BREITINGER, JOHANN JAKOB. Born in Zürich in 1701, was co-author, with Johann Jakob Bodmer, of *Discourse der Mahlern (Discourses of the Painters),* a book in four parts which was an obvious imitation of the English "moral weekly," the *Spectator*. The word "painters" in the title does not imply any special interest in painting as such, but simply indicates that the authors considered poetry a form of painting. The stated purpose of the *Discourses* was to discuss moral and aesthetic questions and to instill in their readers a love for poetry. Just as important, however, was their desire to combat the influence of French "intellectual appreciation" of poetry, defended in Germany by Gottsched, and to stress the importance of the imagination and the realm of the supernatural in poetry. Breitinger's most significant work is his *Kritische Dichtkunst (Critical Poetics,* 1740). In spite of a rather frequent use of the Horatian *ut pictura poesis* and such statements as "poetry is a constant and vast painting," his *Kritische Dichtkunst* is important in that it attempts to make some clear distinction between painting and poetry. (See the sections on Breitinger in Bächtold's *Geschichte der deutschen Literatur in der Schweiz* [Frauenfeld, 1892]. See also Introduction, p. xxvii.)

BRUMOY, PIERRE (1688-1742). French Jesuit and scholar, best known for his *Théâtre des Grecs* (1730), which contains translations and analyses of Greek tragedies, and extensive notes on Greek theatre.

CALLITELES. Son and disciple of ONATAS (q.v.).

CATULLUS. Gaius Valerius Catullus (84-54 B.C.) was a Roman lyric, erotic, and epigrammatic poet.

CAYLUS, COUNT. Anne Claude Philippe de Tubières (1692-1765), French art critic and patron of painters. In 1757, he published his *Tableaux tirés de l'Iliade, de l'Odyssée, d'Homère et de l'Énéide de Virgile, avec des observations générales sur le costume.*

CERES. In Roman mythology, the goddess of grain. Ceres is the Roman version of the Greek Demeter. The cult of Ceres had its origin in the fifth century B.C. during a famine in Rome, but it remained more Greek than Roman in nature.

CHABRIAS. An Athenian general of the fourth century B.C. After attaining a name for himself in Thrace, he went to Cyprus to aid Euorgoras in his struggle against the Persians. In 378 B.C., when Thebes and Athens were united against Sparta, he was sent to aid the army of Thebes, which was hard pressed by the Spartan king Agesilaus. It was in this battle that Chabrias introduced the new method of fighting described by Cornelius Nepos in his *Life of Chabrias.*

In his *Antiquarische Briefe* (38th letter), Lessing withdraws his conjecture that the "Borghese Gladiator" represents Chabrias in the attitude of re-

pulsing the attack of Agesilaus in the battle of Thebes. His emendation of Nepos' Latin text has proven to be unjustifiable, and the present opinion about the statue is this: it represents a warrior with raised shield and sword who is attacking a horseman, or at least an enemy standing in a higher place than himself.

The statue, made around 100 B.C., is now in the Louvre. It is the work of the Greek sculptor Agasias, son of Dositheos. The name "Borghese Gladiator" comes from the fact that it was for many years in the Palazzo Borghese in Rome.

CHATEAUBRUN, JEAN BAPTISTE VIVIER DE (1686-1775), member of the French Academy and author of several tragedies. His *Philoctete,* to which Lessing refers, was written in 1755.

CHESTERFIELD, PHILIP DORMER STANHOPE, EARL OF (1694-1773). English statesman and man of letters.

CHIFFLETIUS. Jean Chifflet, a French antiquary of the seventeenth century.

CLEMENS ALEXANDRINUS, TITUS FLAVIUS (c. A.D. 150-220), Greek church father. Founder of the Alexandrian school of philosophy.

CLEYN, FRANZ (1590-1658). A German painter and engraver. He was born in Rostock in Mecklenburg, lived in Copenhagen and Rome for a number of years, and eventually moved to London. Some commenta-

tors, notably Witkowski, mistakenly refer to Cleyn as an English painter.

CODINUS, GEORGIUS. A Greek scholar of the fifteenth century who wrote on the history and architecture of Constantinople.

CYDIPPE. In Greek legend, the young Acontius of Ceos, while at the festival of Artemis at Delos, saw a wellborn Athenian maiden whose name was Cydippe. He fell in love with her, and threw an apple at her feet on which were the words, "I swear to wed Acontius." By picking up the apple and reading the words, Cydippe bound herself to him. However, she fell ill before the wedding took place, and the mysterious malady was repeated as often as Cydippe became betrothed. Finally, the Delphic oracle solved the difficulty, and she was able to marry Acontius.

DACIER, ANDRÉ (husband of Anne Lefèvre Dacier) translated Aristotle's *Poetics* in 1692 and treated the question of Achilles' shield in his commentary.

DACIER, MADAME. Anne Lefèvre (1651-1720), afterward wife of André Dacier, was well known for her translations of Latin and Greek writers, especially Homer, Terence, Anacreon, and Sappho. In her *Considérations sur les causes de la corruption du goût* (Paris, 1714), she defended Homer against the attacks of Houdart de Lamotte, and again in 1716, in *Homère défendu*, against HARDOUIN (q.v.).

DIOGENES. Greek sculptor during the time of Augustus. He is responsible for the sculptured work of the Pantheon.

DIONYSIUS HALICARNASSUS. Greek scholar, lived in Rome (30-8 B.C.) and wrote a history of Rome, *Roman Antiquities*.

DOLCE, LODOVICO (1508-66). Italian poet and scholar, and an ardent admirer of ARIOSTO (q.v.). In 1557 he published his *Dialogue on Painting (Dialogo delle pittura, intitolato l'Aretino)* which discusses in dialogue form the comparative merits of Raphael and Michelangelo and the essentials of painting. (See Introduction, p. xv.)

DONATUS, TIBERIUS CLAUDIUS. Flourished about A.D. 400, wrote a commentary on Virgil's *Aeneid*, called *Interpretationes Vergilianae*, in 12 books.

ECHION. Most commentators are agreed that this is the famous Greek painter Aëtion (see Blümner, pp. 725, 731), who probably lived in the time of Alexander the Great. His picture, *nova nupta* ("The Bride"), which Pliny mentions (XXXV. 78), was famed as a perfect expression of chaste modesty.

ERESICHTHON, son of Triopas, king of Thessaly, offended CERES (q.v.) by felling trees in a grove sacred to her. The goddess then sent an OREAD (q.v.) to Fames (Hunger) to ask her

to enter the entrails of the offender. In his hymn to Ceres the Greek poet Callimachus (born in Cyrene in North Africa, died about 230 B.C. in Alexandria) describes the agonies endured by Eresichthon.

GALE, THOMAS (1635-1702). English philologist.

GARRICK, DAVID (1716-79). His fame as an actor began with his interpretation of Shakespeare's *Richard III* in 1741. His reputation had also spread to Germany, and at the writing of the *Laocoön* Garrick had just undertaken an acting tour of the continent. Lessing uses his name as the greatest representative of his art.

GEDOIN. Nicolas Gedoyn (1667-1774) was a French scholar who, as Lessing indicates, translated Pausanias.

GESNER, JOHANN MATTHIAS (1691-1761) was professor of rhetoric at Göttingen. A famous scholar and humanist, he was the author of *Novus linguae et eruditionis Romanae thesaurus,* a four-volume work which appeared in Leipzig in 1747-48.

GORIUS. Antonio Francesco Gorio (1691-1757), an Italian antiquary, published the *Museum Etruscum.*

GRUTER, JANUS (1560-1627). Dutch philologist and editor of a famous collection of neo-Latin poets.

HAGEDORN, CHRISTIAN LUDWIG VON (1713-80). Highly cultivated art critic, director of the Saxon academies of art, and author of *Betrachtungen über die Malerei (Observations on Painting,* 1762). He belonged to the small but influential group of men in Dresden who attempted to dissuade the German public from their worship of baroque and rococo styles. The leader of this group, Adam Friedrich Oeser (1717-99), greatly influenced Winckelmann's (q.v.) *Gedanken über die Nachahmung der griechischen Werke in der Malerei und der Bildhauerkunst.*

HARDOUIN, JEAN. French scholar, lived from 1640 to 1728. His edition of Pliny, to which Lessing refers, was published in Paris in 1685.

HARPIES. These avenging demons, represented as birds of prey with the heads of maidens, human arms with huge claws, are known chiefly through the story of a blind seer, Phineus. In order to please his second wife, he had his sons by his first wife blinded. As punishment, the gods sent the Harpies to torture him by defiling his food or snatching it from him. They were driven away by the Argonauts.

HECTOR, son of King Priam of Troy, was the chief hero among the Trojans. He was killed by Achilles, who threw his body before the bier of Patroclus (whom Hector had slain in combat) and decreed that it be left there as food for the dogs.

HESIOD. Greek poet of the eighth

century B.C. He was the author of an epic poem, *Works and Days*. The work to which Lessing alludes is 'Ἀσπὶς 'Ηρακλέους, a description of Hercules' shield.

HOGARTH, WILLIAM (1697-1764), "the celebrated English painter and engraver, published, in 1753, a work on the *Analysis of Beauty*, in which he represented the curve as the line of beauty. Mylius, a friend of Lessing, translated it into German in 1754 under the title *Zergliederung der Schönheit*. In chapter 11 ('On Proportion') he speaks of the statue of the Apollo Belvedere which forms part of the Vatican, together with the group of Laocoön and the statue of Antinous" (Hamann, p. 280).

HYPSIPYLE. Daughter of Thoas, king of Lemnos. In his version of the story, VALERIUS FLACCUS (q.v.) tells us that Hypsipyle disguised her father as Bacchus in order to help him escape.

HUYSUM, JAN VAN (1682-1749), Dutch painter celebrated for his still lifes of fruits and flowers.

IALYSUS. The founder of Rhodes who, in the second millennium B.C., gave his name to one of the three principal cities of the island.

JUNIUS. Franciscus Junius (François du Jon, 1589-1678), a German scholar whose work, *De pictura veterum* (*On the Painting of the Ancients*), written in 1637, was for more than a century the only one of its kind and was used extensively by WINCKELMANN (q.v.) in his own research.

KLEIST, EWALD CHRISTIAN VON (1715-59). Generally associated with the descriptive poetry so popular in Germany in the eighteenth century, his *Frühling* (*Spring*) was written in 1749 and betrays an unusually heavy debt to JAMES THOMSON (q.v.), by way of Brockes' German translation. The fact that Lessing was an intimate friend of the young Prussian officer-poet lends considerable weight to his statements about the planned changes in the *Frühling* poem.

KLOTZ, CHRISTIAN ADOLPH (1738-71). Professor of philosophy at the University of Göttingen, later professor of oratory at Halle. Klotz proved himself a competent scholar with such works as *Opuscula varii argumenti* and *Opuscula philologica et oratoria*, but his vanity led him into bitter quarrels with his scholarly opponents. Lessing waged a literary war against him, chiefly through his *Briefe antiquarischen Inhalts* (*Letters on Antique Subjects*), and demolished his fame as a scholar.

KÜHN, JOACHIM (1647-97). Lessing frequently refers to Kühn's editions of Aelian and Pausanias. Since Kühn wrote in Latin, the form of this scholar's name which Lessing cites is

usually Kuhnius (abbreviated to Kuhn.).

LA METTRIE, JULIEN OFFROY DE (1709-51). An eighteenth-century French physician and materialist philosopher. His ambition was to be compared with Democritus of Abdera, a contemporary of Socrates who was called the "laughing philosopher."

LEODEGARII. Leodegarius is the Latin name of the French philologist Léger Duchesne (d. 1588).

LICETUS. Fortunio Liceto, Italian physician and antiquary, died c. 1656.

LONGINUS, DIONYSIUS CASSIUS (A.D. 213-273). Platonic philosopher and historian, and supposed author of a treatise, *On the Sublime.* It was translated by Boileau in 1674 and was quite popular in Lessing's time. (For a discussion of date and authorship of this treatise, see G. M. A. Grube's Introduction in Longinus, *On Great Writing,* "Library of Liberal Arts," No. 79 [New York, 1957], pp. xvii-xxi.)

LUCIAN. Greek poet (born c. A.D. 120), author of critical and biographical works, poems, and dialogues. Of these, the latter are perhaps the best known. The dialogue to which Lessing refers bears the title Αἱ Εἰκόνες, "The Pictures."

LUCRETIUS. Titus Lucretius Carus (95-51 B.C.) is the author of the didactic poem *De rerum natura* (*On the Nature of Things*).

LYCOPHRON. A poet who lived in Alexandria during the time of Ptolemy Philadelphus (third century B.C.). The work to which Lessing alludes is the only one of the many he composed which has been preserved: the so-called *Alexandra,* or *Cassandra,* a long iambic monologue filled with mythological learning. In it Cassandra prophesies the fall of Troy.

LYSIPPUS. Greek sculptor (c. 330 B.C.), famous for his *Apoxyomenos* and his statues of Alexander the Great.

MACROBIUS, AMBROSIUS THEODOSIUS. Latin writer of the fifth century A.D.

MAFFEI, FRANCESCO SCIPIONE (1675-1755). Italian poet and archaeologist. His tragedy *Merope* inspired Voltaire to write his *Mérope.*

MANASSES, CONSTANTINUS. Greek chronicler of the twelfth century, who wrote a chronicle of the world, in verse, down to the year A.D. 1081.

MARLIANI, BARTHOLOMEW. Milanese antiquary of the sixteenth century.

MARMONTEL, JEAN FRANÇOIS (1723-99). French poet and critic, author of tragedies and comedies, the *Contes Moraux,* and *Poétique Française.*

MAZZUOLI, FRA (1503-40), often called "Il Parmigianino" from his birthplace, Parma, was a painter and engraver of the

Lombard school. It is not known to which work Lessing refers.

MEDEA. Daughter of Aeëtes, king of Colchis. She helped Jason capture the Golden Fleece, then married him and went with him to Iolchos. After ten years of marriage, Jason put her aside in order to marry Creusa, daughter of King Creon. In revenge Medea sent her rival a poisoned garment as a wedding present, and then murdered her own children in Jason's presence. Two Medea tragedies from ancient times have been preserved (Euripides and Seneca), and in modern times Corneille and Grillparzer have treated this theme.

MELEAGER. In Greek mythology, Meleager was the son of King Oeneus of Calydon and his queen Althaea. At his birth it was proclaimed that he would die when a piece of wood then burning in the fireplace was completely consumed. When Althaea heard this, she snatched the wood from the fire and preserved it in a chest. When, in later years, Meleager arranged a wild boar hunt and gave the victor's prize, the boar's skin, to Atalanta, Althaea's brothers attempted to take the prize from Atalanta. In the quarrel which ensued Meleager killed the brothers. His mother then cursed him and threw the piece of wood on which his life depended into the fire. While the wood was burning Meleager suffered sympathetic pains, and when it was consumed he died. (See *Meyers Konversationslexikon* [6th ed., 1906], XIII, 576.)

MENDELSSOHN, MOSES (1729-86). A philosopher whose *Rhapsodie* and *Über die Empfindungen* (*Letters on the Emotions*) had considerable influence on Lessing's psychology of aesthetics, especially as it is treated in his *Laocoön* (see Introduction, pp. xix-xx).

MENELAUS. Son of Atreus and older brother of Agamemnon who married Helen of Sparta and later inherited the kingdom. When Paris abducted Helen, Menelaus went to Troy with Odysseus to rescue her and was able to overcome Paris in combat.

MENGS, ANTON RAPHAEL (1728-79). Painter and art critic, and a close friend of Winckelmann, was born in Bohemia and spent many years in Rome. He is noted for his allegorical paintings and his great emphasis on technique.

METRODORUS. An Athenian artist and member of the Atomistic school (*fl.* 168 B.C.). Pliny (*Natural History* XXXV. 135) relates how Aemilius Paullus asked the Athenians to send him a good tutor for his children and a painter to decorate his house, whereupon Metrodorus was sent to fill both offices, since he was at once a painter and a philosopher.

MEURSIUS. Jans de Meurs, or Johannes van Meurs (1579-1639), a famous Dutch philologist and professor of history at Leyden.

MYRON. Greek sculptor, flourished about 450 B.C. An innovator in composition, two of his major works survive, the Discobolus and "Athena and Marsyas."

MONTFAUCON, BERNARD DE (1655-1741). A French antiquarian, whose *Antiquité expliquée* appeared in 1719-24 in fifteen volumes.

NICIAS. Athenian painter about 350 B.C., friend of Praxiteles.

NONNUS. A Greek poet of the late fourth century A.D., author of the *Dionysiaca*.

NUMA POMPILIUS. The legendary second king of Rome, supposed to have ruled 715-672 B.C.

ONATAS. Greek sculptor of the first half of the fifth century B.C. and head of the Aeginean school.

OREADS. In Greek mythology, the mountain nymphs, one of the three major groups of minor goddesses. In art they were generally depicted as young and beautiful maidens.

OVID (43 B.C. - A.D. 17). In the *Metamorphoses* of this famous Roman poet the story of Cephalus and his wife Procris is told. The jealous Procris once followed Cephalus on a hunt into the forest, for she had been told that her husband would call out the name of a nymph in longing desire. Cephalus became tired from the hunt and called out *aura*, by which he meant not a sylvan nymph, but a cooling breeze, which he hoped would refresh him. When Procris heard the word *aura*, however, she was overcome with jealousy and sorrow and uttered a deep sigh. Cephalus heard the sound and, believing it to be a deer, hurled his spear at it, thus killing his own wife. In his remorse he threw himself from the Leucadian rock into the sea.

PALNATOKO. A hero of Danish history and legend, often called the Nordic William Tell. According to the *Jomswikinga Saga* (chapter 14), an epic poem of the thirteenth century, he is supposed to have lived in the latter half of the tenth century. After being exiled from his native soil, he settled on the coast of the Baltic Sea, where he built the fortress of Jomsburgh. Legend has it that he was forced by King Harold to shoot an apple off his son's head. After the feat he killed Harold in revenge.

PANTHEA. A woman of Smyrna, mistress of the emperor Lucius Verus (A.D. 130-69).

PASITELES. Greek sculptor and writer on art who flourished in Rome in the first century B.C. The best known of his works depicts Roscius (a famous Roman actor) as a child entangled in the coils of a serpent.

PAUSON. An Athenian painter of the second half of the fifth century B.C. In two plays of Aristophanes (*Plutus* and *Acharnenses*), he is ridiculed for his poverty. Aristotle, in his *Poetics,* compares him unfavorably with a contemporary painter, Polygnotus. Pauson, Aristotle says, painted men below reality (χείρους), i.e., less noble than they are, while Polygnotus depicted them above nature (κρείττους), i.e., idealized.

PENELOPE. Wife of Odysseus, mother of Telemachus.

PENTHESILEA. Queen of the Amazons. She came to the aid of the Trojans but was killed by Achilles.

PERRAULT, CHARLES (1628-1703), poet and critic, from 1671 a member of the French Academy. He is the author of a four-volume work, *Parallèle des anciens et des modernes* (1688-96).

PETRONIUS. Titus Petronius Arbiter was forced by Nero to commit suicide in A.D. 67. In his verse and prose novel, *Satyricon,* Petronius introduces a poet by the name of Eumolpus, who describes a number of famous paintings which hung in a gallery at Naples.

PHIDIAS. Athenian sculptor of the fifth century B.C. Supervised the design of sculpture on the Parthenon.

PHILOSTRATUS. Flavius Philostratus of Lemnos, a philosopher who flourished about A.D. 200, was reputed to possess magical powers. His two most important works are a life of Apollonius of Tyana, and the *Heroicus,* a history of the heroes of the Trojan War.

POLYCLETUS (Polycleitus). Greek sculptor who flourished in the middle and the second half of the fifth century B.C.

POLYGNOTUS. Greek painter of the fifth century B.C. The two paintings at Delphi, which Lessing discusses, depicted the capture of Troy and the departure of the Greeks, and the descent of Odysseus into the nether world.

PORDENONE, GIOVANNI ANTONIO DA (1483-1539). A Venetian painter, also known by his real name, Giovanni Antonio de' Sacchi.

POSIDONIUS. Greek sculptor. Except for one brief mention in Pliny, nothing is known of him.

PRAXITELES. Athenian sculptor, active about the middle of the fourth century B.C.; with SCOPAS (q.v.), a leader of the younger Attic school. A prolific artist, his best-known works include several Aphrodites and "Hermes with the Infant Dionysus."

PRIAPUS. A fertility god and the god of vineyards. He nearly caught Venus by surprise while she was sleeping in a garden.

PYREICUS (Piraeicus). Very little is known of this painter, who probably lived in the fourth century B.C. He is mentioned

by two writers, Pliny and Propertius, and was noted for his interiors and scenes of low life.

PYTHAGORAS LEONTINUS. Greek sculptor from Rhegium, lived between 480 and 420 B.C.

QUINTUS CALABER. Also called Quintus Smyrnaeus, this Greek poet, who probably flourished toward the end of the fourth century A.D., wrote a sequel to Homer's *Iliad* under the title Περὶ τῶν παραλειπομένων Ὁμήρῳ ("On Things Omitted by Homer"). It dealt with the Trojan War from the death of Hector until the return of the Greeks.

RICHARDSON, JONATHAN (1655-1745). A well-known English portrait painter, the author of two volumes of poems and four works on art. These last appeared in a French translation in 1728, and it was this version with which Lessing was acquainted. The first of the four, *Essay on the Theory of Painting* (1715), was for many years the standard work in aesthetics in England.

SACCHI, ANDREA (1599-1661). Celebrated Italian painter, flourished in Rome.

SADOLETUS, JACOBUS (1477-1547), Latinist and poet, born at Modena, Italy, and known as an ardent supporter of the papacy. He served for a time as secretary to Leo X and was afterward made a cardinal. When the Laocoön group was discovered he wrote a poem describing it, which Lessing

quotes in its entirety in a footnote (see Appendix Note b, p. 178).

SANADON, NOEL ETIENNE (1616-1733). French philologist.

SAPPHO. Greek lyric poetess, flourished about 500 B.C.

SCALIGER, JULIUS CAESAR (1484-1558) of Padua, a famous philologist and author of one of the earliest treatises on the science of poetry, *Poetices libri VII*, published in 1561. He is called the elder to distinguish him from his son Justus Josephus Scaliger (1540-1609).

SCOPAS. Greek sculptor, born shortly before 400 B.C. in Paros. He and PRAXITELES (q.v.) were the leaders of the young Attic school. Among his better known works are the transporting of Achilles to the island of Leuce, and the Caledonian boar hunt.

SERVIUS. Roman scholar of the fourth century A.D. who wrote a commentary on Virgil.

SMITH, ADAM (1723-90), began his career as an aesthetic philosopher. His *Wealth of Nations,* a comprehensive "science" of economics which appeared in 1776, established his fame.

SPENCE, JOSEPH, born in Winchester in 1698, was professor of poetry at Oxford from 1728 to 1738. His *Polymetis,* written in dialogues, was published in 1747.

STOSCH, BARON PHILIPP VON (1691-1757), a Prussian noble who spent most of his life in

Italy, commissioned as an agent for his government. He was an authority on ancient art, and left, at his death, a fine collection of jewels and cameos, which was catalogued by Winckelmann. The collection was sold to Frederick the Great by Stosch's heir, and is now located in Berlin.

STRONGYLION. Athenian sculptor who lived about 400 B.C. Nero is said to have been especially fond of his statue of an Amazon. Another famous work by Strongylion was his Trojan horse. Lessing has mistakenly put this sculptor in a much later period, i.e., in the first century B.C., an error which he seems to have taken over from Winckelmann's *Geschichte der Kunst* (II, 382).

SYLVIA. Rhea Sylvia, a Vestal virgin, was the mother of Romulus and Remus.

TERENTIANUS. Some commentators take Terentianus to be only a fictitious name, while others identify him as Terentianus Maurus, author of *De Metris,* a poem written about the end of the third century A.D.

TERRASSON, JEAN (1670-1750). Renowned scholar and member of the French Academy, published his *Dissertations critiques sur l'Iliade d'Homère* in 1715.

THEODORUS. It is conjectured that Theodorus was the Greek rhetor from Gadara, who lived during the time of Tiberius

(cf. Blümner, p. 680; Hamann, p. 295), but this must be considered very uncertain.

THERSITES. One of the Greeks before Troy, held in contempt by the Greeks themselves and ridiculed for his ugliness.

THOMSON, JAMES. The poet Thomson (1700-1748) is considered the chief representative of the genre of descriptive poetry in eighteenth-century English literature. His *Seasons,* four poems in blank verse constituting an interpretation of the spirit of the four seasons, appeared in 1726. The work found an enthusiastic reception in England, principally because its admirable nature descriptions were in such sharp contrast to the artificiality of the rococo style then in fashion. While the wild enthusiasm caused by the publication of the *Seasons* was relatively short-lived in England itself, the work (which was translated into German by Brockes in 1745) enjoyed more than just a passing vogue in Germany. For a number of years, it was considered the model of all descriptive poetry, and at least two prominent eighteenth-century German men of letters, Albrecht von Haller and Ewald von Kleist, were deeply influenced by Thomson. So firmly had descriptive poetry entrenched itself in the literature of Lessing's time that Lessing's own earlier works betray unmistakable evidence of

the attempt to "paint poetically." However, just when it seemed that poetry was falling into complete dependence on painting, Winckelmann's treatise on the imitation of the ancients in painting and poetry appeared (1754), with its plea for idealized nature, whose subject was not nature itself, but the human form. It remained for Lessing's *Laocoön* to restore the balance between the visual arts and poetry and to define the domains of the two arts.

TIMANTHES. Greek painter who flourished at Sicyon about 400 B.C.

TIMOCLES and TIMARCHIDES. These two sculptors jointly produced a statue of Asclepius about 160 B.C.

TIMOMACHUS. A celebrated painter from Byzantium who lived at the end of the fourth century B.C. Pliny places him in the time of Julius Caesar, who bought his two most famous pictures, the "Ajax" and the "Medea," and had them placed in the temple of Venus Genetrix (Pliny, XXXV. 11). It is more probable, however, that Timomachus belongs to the time of the successors of Alexander. Pliny doubtless confused the time of the purchase of the paintings with the period in which the painter actually lived. (See Blümner, p. 522.)

TIZIANO VECELLIO (1477-1576), familiarly known as Titian, famous painter of the Venetian school. Lessing was acquainted with the painting of the prodigal son only from Richardson's description of it (in the *Traité de la peinture*, p. 43). The original is now believed to be the work of Bonifazio. (See Blümner, p. 622; Howard, p. 395.)

VALERIUS FLACCUS. Roman poet who died A.D. 89. He is well known as the author of the *Argonautica*. JOSEPH SPENCE (q.v.) quotes from this work in the sixth dialogue of his *Polymetis*.

VALERIUS MAXIMUS. A Roman historian who lived in the first century after Christ. He dedicated his *Factorum et dictorum memorabilium libri IX*, a collection of famous deeds and sayings, to the emperor Tiberius.

VILLENEUVE, JEAN BOIVIN DE (1649-1724) was a member of the French Academy and author of *Apologie d'Homère et du bouclier d'Achille* (1715).

WINCKELMANN, JOHANN JOACHIM (1717-68), the first competent historian of ancient art and considered by many to be the father of classical archaeology. In Dresden, the home of rococo art, he wrote his *Gedanken über die Nachahmung der griechischen Werke in der Malerei und Bildhauerkunst* (*Thoughts on the Imitation of Greek Works in Painting and Sculpture*, 1754) as a protest

against the frivolous and ostentatious styles of painting of his day. The new and important message expressed in this work is that the only perfect art is that of ancient Greece. To arrive at perfection, modern art must hence turn back to the "noble simplicity and quiet grandeur" (*edle Einfalt und stille Grösse*) of the ancients, a phrase which Lessing quotes and which played so important a role in eighteenth-century aesthetics. For an evaluation of Winckelmann's service to aesthetics, see Bernard Bosanquet, *A History of Aesthetics* (2nd ed., 1904; reprinted, New York, 1957). See especially pp. 239-54.

WYCHERLEY, WILLIAM (1640-1715), English playwright, author of racy comedies, e.g., *The Country Wife* (1675) and *The Plain Dealer* (1677).

ZEUXIS. Greek painter, flourished about 400 B.C.

ACKNOWLEDGMENTS

The author acknowledges with gratitude permission to reprint excerpts from the following sources:

Homer's *Iliad,* translated by Richmond Lattimore, reprinted by permission of The University of Chicago Press. Copyright 1951 by The University of Chicago.

Ovid, *Metamorphoses,* translated by Horace Gregory. Copyright 1958 by The Viking Press, and reprinted with their permission.

Petronius, *Satyricon,* translated by William Arrowsmith, reprinted by permission of The University of Michigan Press. Copyright 1959 by William Arrowsmith.

The Satires of Juvenal, translated by Rolfe Humphries, published by the Indiana University Press, and reprinted by their permission.

Vergil's Aeneid, translated by T. H. Delabère-May, edited by Moses Hadas. Reprinted by permission of the publisher, Bantam Books, Inc.

Virgil's Works: The Aeneid, Eclogues, and Georgics, translated by J. W. Mackail. Reprinted by permission of the publisher, Random House, Inc.

The Laocoön Group (frontispiece), Vatican Museum, Rome (Alinari–Scala).